ISLAMIC JEWELRY in THE METROPOLITAN MUSEUM of ART

Published with the aid of a grant from the

HAGOP KEVORKIAN FUND, New York

ISLAMIC JEWELRY IN THE METROPOLITAN MUSEUM OF ART

MARILYN JENKINS

Associate Curator, Islamic Art
The Metropolitan Museum of Art

MANUEL KEENE

Formerly Research Associate, Islamic Art
The Metropolitan Museum of Art

The Metropolitan Museum of Art, New York

PUBLISHED BY
The Metropolitan Museum of Art, New York
Bradford D. Kelleher, Publisher
John P. O'Neill, Editor in Chief
Emily Walter, Editor
Roberta Savage, Designer

Model for TA 7 and drawings by Manuel Keene
Map by Kathleen Borowik
Photographs by Lynton Gardiner, Photograph Studio,
 The Metropolitan Museum of Art

Type set by Dumar Typesetting, Inc., Dayton, Ohio
Printed by Colorcraft Lithographers, Inc., New York, N.Y.

Cover illustration: Gold Roundel. Iran, 11th century (no. 24)

LIBRARY OF CONGRESS CATALOGING IN PUBLICATION DATA

Metropolitan Museum of Art (New York, N.Y.)
 Islamic jewelry in the Metropolitan Museum of
Art.

 Bibliography: p.
 Includes index.
 1. Jewelry, Islamic. 2. Jewelry—New York (N.Y.)
3. Metropolitan Museum of Art (New York, N.Y.)
I. Jenkins, Marilyn, 1940- . II. Keene, Manuel,
1941- . III. Title.
NK7308.9.M47 1982 739.27′0917′67107401471 82-8142
ISBN 0-87099-326-7 AACR2
ISBN 0-87099-327-5 (pbk.)

Contents

Acknowledgments

The original inspiration for this book came from the late Richard Ettinghausen, Consultative Chairman of the Department of Islamic Art until his death in 1979, who suggested we write the article "Djawhar" ("Jewel") for the *Encyclopaedia of Islam*. It was out of this article that the idea for the present work evolved. Maurice S. Dimand, one of Dr. Ettinghausen's predecessors as curator in the department, not only added many pieces to the jewelry collection but his early interest in the subject resulted in his booklet on the jewelry of the Near East. One of the most significant efforts of Charles K. Wilkinson, also formerly a curator in the department, is represented by the very important material he and his colleagues unearthed at Nishapur while conducting the Museum's excavations there in the 1930s and 1940s.

Many people outside the Museum also contributed to this project. Donors to the collection are of primary importance, but their number dictates that their names be confined to the credit lines in the entries. The Hess Foundation provided funds to purchase five gold objects that added immeasurably to the study of early and late medieval Islamic jewelry. Patti Cadby Birch lent her important jewelry photograph archives for study by the authors. Habib Anavian, Henry Anavian, Joseph Benjaminoff, Alice Heeramaneck, and Yahooda Shenass graciously allowed the authors to photograph important jewelry from their collections. 'Abd al-Ra'uf 'Ali Yusuf, Director of the Islamic Museum, Cairo, and Muhammad al-Kholy, Curator of Islamic Art at the National Museum, Damascus, put the collections of their respective institutions at the disposal of Dr. Jenkins; and Helen Philon, Curator of Islamic Art at the Benaki Museum, Athens, provided the authors with photographs of that collection. Mr. Keene's research was greatly enhanced by his study of the collection at the Walters Art Gallery, Baltimore, a study made possible by the generosity of that institution's then director, Richard Randall; and both authors enjoyed profitable hours studying the collection of the Freer Gallery of Art, Washington, D.C., through the good offices of Esin Atil, Curator of Islamic Art. Robert Kulicke and Jean Stark, leaders of a New York renaissance of classical techniques in the jewelry art, are, along with their students, responsible in large measure for the breadth and depth of the authors' technical knowledge.

Oleg Grabar of Harvard University and several of his students, as well as Michael G. Morony of the University of California at Los Angeles, made available to the authors certain translations of important original sources and pointed out relevant passages therein. Maan Madina of Columbia University provided a translation of an article on little-known jewelry from Iraq.

Zdenka Munzer, a volunteer at the Museum, was of constant and willing help with essential translations and with bibliographical matters. The Department of Greek and Roman Art was helpful in various ways, including the transference of an object to the Islamic Department. The Department of Ancient Near Eastern Art and the Department of Medieval Art each granted permission to publish objects in their respective collections. Colleagues in the Conservation Department, among whom we may mention Pieter Meyers, James H. Frantz, Yale Kneeland, and Richard E. Stone, contributed significantly to our understanding of the pieces in the collection as well as to their condition and appearance. Great expertise and patience were expended by the staff of the Photograph Studio under its manager, Mark D. Cooper, and photographer Lynton Gardiner worked particularly closely with the authors. Mary Pernot and Mary S. Eigsti contributed cheerful and intelligent help with the logistics of putting together the manuscript, which included assembling illustrative material and assistance in compiling the Bibliography. The Editorial Department, under John P. O'Neill, Editor in Chief, provided much needed moral support and expert guidance. And our editor, Emily Walter, contributed that invaluable element of independent, trained, and perspicacious attention which turns a manuscript that makes sense to the authors into an approachable and internally consistent unit that makes sense to any intelligent reader.

Finally, the authors would like to thank the president and trustees of The Hagop Kevorkian Fund for their generosity in supporting the publication of this work on such a little-studied subject.

Marilyn Jenkins
Manuel Keene

Introduction

The geographical vastness of the Muslim world and the myriad historical and cultural developments that have taken place there during its more than thirteen hundred years of artistic production make any attempt to survey even one of the arts of Islam a complex affair. Two important factors, however, combine to mitigate the complexities that might otherwise frustrate such an attempt. First, the religion of Islam and the society and culture associated with it unified regions as far apart as Spain and Malaysia, bringing a cohesion that is remarkable considering the geographic, political, economic, ethnic, and linguistic variety encompassed. Second, the Islamic empire inherited regions in which significant stylistic amalgamation had already taken place, and itself unified an unprecedented expanse of the earth's surface; this further facilitated cultural exchange through trade and travel, which resulted in a remarkable spreading and sharing of styles and techniques. In this dynamic, ongoing process, stylistic amalgams interacted with one another, subsequently giving rise to ever new stylistic syntheses.

India serves well as a paradigm of this evolutionary process. Despite enormous and inexplicable chronological gaps in the extant jewelry of India, it is clear that the subcontinent is home to a jewelry-making tradition that is unique in the variety of its forms and techniques, a high percentage of which are living embodiments of ancient and medieval traditions. India was also increasingly impinged upon by Islamic styles over a period of some one thousand years. The combining of a remarkable amount of artistic invention in jewelry making with an equally remarkable fidelity to inherited traditions characterizes this evolutionary process. Thus, despite the unparalleled richness of indigenous creativity evidenced by representations of jewelry in paintings and on sculptures, as well as by extant jewelry, the impact of, for example, Hellenistic styles and technique following the conquests of Alexander the Great in the fourth century B.C. can be seen not only in Indian jewelry of immediately succeeding centuries (e.g., the material from the Taxila excavations) but also in that of the eighteenth, nineteenth, and twentieth centuries. And again, despite the absence of known extant Indian jewelry dating from the first centuries A.D. to the seventeenth century, it can be assumed that successive waves of Islamic influence were felt, starting perhaps as early as the eighth century A.D. Islamic style was itself by this time an amalgam that included elements from a wide variety of sources—probably including Indian traditions reemerging in new contexts.

Early Islamic jewelry therefore reflects, technically as well as aesthetically and stylistically, the ancient, classical, Byzantine, Sasanian, and other traditions that survived in the regions which formed the Islamic empire. Like the changes

that evolved in Indian jewelry, changes in Islamic jewelry as a whole reflect the impact of stimuli from neighboring cultures. This was a cumulative, continuous process that over the centuries resulted in the apparent paradox of, on the one hand, increasing synthesis of styles and, on the other, the development of ever greater regional characteristics.

Among the more salient technical features of Islamic jewelry was the tendency to lightweight construction in silver and especially in gold. This was manifested in hollow boxlike construction and in the unparalleled development of the art of filigree. Aesthetically, the Islamic jeweler's highest priority was beauty of overall design and harmony of color. The same impulse inspired all the arts of Islam, so that no matter how intricate the ornamental design of a carpet, an inlaid vessel, or a tiled building, detail never became an end in itself. Similarly, despite the fineness of the filigree and granulation work on a Fatimid jewelry piece, or the legendary size and value of the emeralds, rubies, or pearls in an Abbasid or Mughal piece, the main concern was always the coordination and orchestration of elements to create an overall effect—remarkably, one in which clarity of detail was not sacrificed to complexity of design. Further demonstration of this aesthetic is the fact that often the maker of a finely worked gold piece would use, in place of precious or semiprecious stones, materials such as glazed quartz or glass, which had the requisite color although virtually no intrinsic value (see nos. 25 and 30).

The dating of Islamic jewelry presents a variety of problems. For one thing, there are only a small number of controlled excavations and datable finds. In addition, Islamic representations are such as to make their use as documentation from which to learn about the nature of Islamic jewelry frustrating in most cases—with the notable exception of Mughal Indian miniatures. Representations in Islamic art beginning in the earliest centuries do occasionally provide some clues, however, and these have been used for illustrative purposes.

Although many Islamic objects bear dating inscriptions, often accompanied by the artist's name and occasionally with some indication of the place of his birth or where he worked, such information is not supplied in known jewelry inscriptions (with the exception of sealstones), despite the fact that they often form an important part of the decoration. Dating inscriptions do occur on a number of notable precious stones (especially well represented in the Iranian National Treasure) but they do not pre-date the fifteenth century, and invariably the stones on which they occur are either remounted in nineteenth- or twentieth-century settings or they have been removed from their original settings and remain as loose stones. That many of these stones were used earlier in a variety of jewelry pieces can hardly be doubted, although this cannot be documented. Literary descriptions of ninth-century necklaces, for example, accord with necklaces represented in seventeenth-century Indian miniatures. These were often comprised of large pearls and precious stones strung in various sequences and typically having a pendant stone or pearl as centerpiece. This necklace design is an almost universal one, and because there is no indication of place of manufacture and because such stones were typically polished rather than cut in characteristic forms, they were simply restrung from generation to generation, thus obliterating much of the history with which we are concerned.

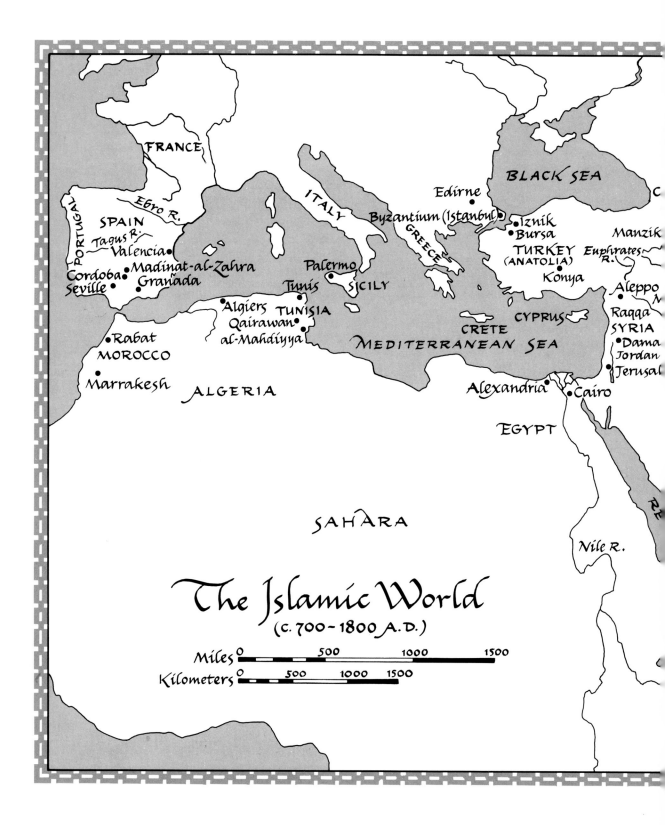

FRANCE

BLACK SEA

Edirne

Byzantium (Istanbul)

ITALY

GREECE

Iznik

Bursa

Manzik

TURKEY
(ANATOLIA)

Euphrates
R.

Ebro R.

SPAIN

PORTUGAL

Tagus R.

Valencia

Madinat-al-Zahra

Cordoba

Granada

Seville

Palermo

SICILY

Tunis

Algiers

TUNISIA

Qairawan

al-Mahdiyya

Konya

Aleppo

Raqqa

SYRIA

Dama

Jordan

Jerusal

CRETE

CYPRUS

MEDITERRANEAN SEA

Rabat

MOROCCO

Marrakesh

ALGERIA

Alexandria

Cairo

EGYPT

RE

SAHARA

Nile R.

The Islamic World
(c. 700 – 1800 A.D.)

Miles 0 500 1000 1500

Kilometers 0 500 1000 1500

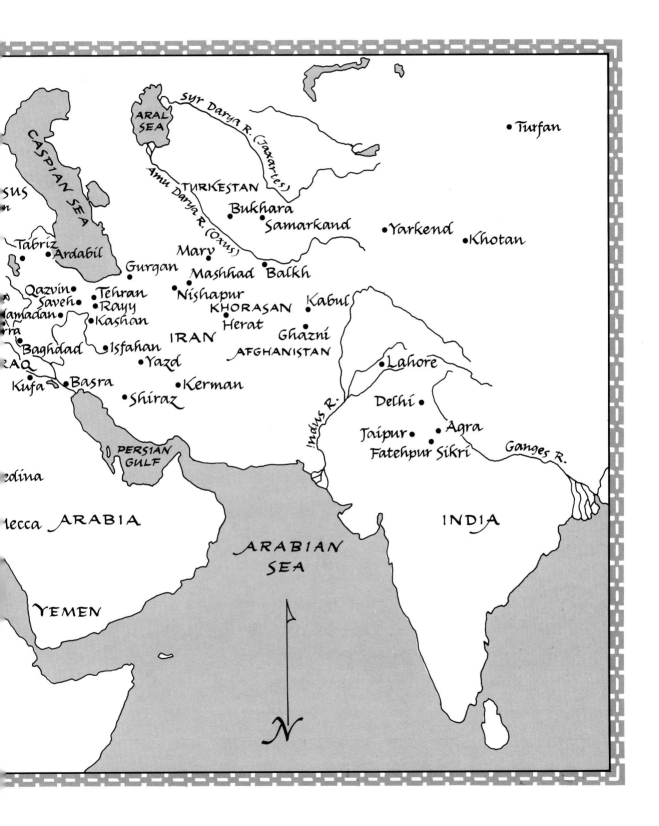

CASPIAN SEA

ARAL SEA

Syr Darya R. (Jaxartes)

• Turfan

Amu Darya R. (Oxus)

TURKESTAN

• Bukhara
• Samarkand

• Yarkend
• Khotan

SUS
n

• Tabriz
• Ardabil

• Mary

• Gurgan

• Mashhad • Balkh

• Qazvin
• Saveh
• Tehran
• Rayy

• Nishapur

KHORASAN

• Kabul

Iamadan

• Kashan

• Herat

• Ghazni

AFGHANISTAN

RA

IRAN

• Isfahan

• Lahore

RAQ

• Baghdad

• Yazd

• Delhi

Kufa
• Basra

• Kerman

Indus R.

Jaipur •
• Agra
Fatehpur Sikri

Ganges R.

• Shiraz

PERSIAN
GULF

edina

lecca ARABIA

INDIA

YEMEN

ARABIAN
SEA

N

EARLY ISLAMIC JEWELRY
7th–10th Century

As far as we know, nothing from the earliest period of Islamic jewelry survives intact. Our knowledge of this work is deduced from pictorial and sculptural representations and from descriptions in literary works that indicate some of the traditions from which early Islamic jewelry developed. The ball-shape earrings depicted on a sculpture from the Umayyad desert palace Khirbat al-Mafjar (Hamilton, 1959, no. 4, pl. XXII) and the teardrop-shape examples in the paintings at Samarra, the temporary Abbasid capital (Herzfeld, 1927, vol. 3, pl. LXXI top), are close stylistically to those found on Sasanian rock reliefs (Fukai and Horiuchi, 1972, vol. 2, pl. IX) and other Sasanian representations (Pope, 1938, vol. 4, pl. 251f, h, j, k, n, o; Harper, 1966, pl. opp. p. 137). Sasanian prototypes can also be found for some of the head ornaments depicted as late as A.D. 1009 in a copy of al-Sufi's *Book of Fixed Stars* (Wellesz, 1959, fig. 10), as well as for the belt fittings depicted in a wall painting from Nishapur datable to before A.D. 1000 (Fukai and Horiuchi, 1972, vol. 1, pl. LXIV; Hauser and Wilkinson, 1942, fig. 45).

The heart-shape pendants worn by one of the female figures depicted in a wall painting at Qusayr Amra, another eighth-century desert retreat (Almagro et al., 1975, pl. XXVII top), bear close comparison with Roman pieces (Oberlin, 1961, fig. 68), as does the shorter necklace of oval elements worn by the same figure (Pollak, 1903, no. 396, pl. XVI). The heart motif was enormously popular in Sasanian Iran; indeed, the most famous Sasanian jewel—a pectoral found in a grave at Wolfsheim—has a heart-shape garnet set in a gold element that echoes its form (Pope, 1938, vol. 4, pl. 249a; Essen, 1962, no. 454; Böhner, Ellmers, and Wiedemann, 1972, p. 52, pl. opp. p. 52).

A scalloped and jeweled necklace worn by one of the male figures in a Qusayr Amra painting (Almagro et al., 1975, pl. XI), as well as one consisting of a series of pendant elements adorning a female figure (Almagro et al., 1975, pl. IX), seems to have close Byzantine parallels (Greifenhagen, 1970, vol. 1, pl. 49; Dimand, 1944, fig. 2). It is likely that the vogue for breast ornaments held in place by crossed straps, seen often on the figures at Qusayr Amra (Almagro et al., 1975, pl. XVII top), entered the Islamic repertoire from the West (for a Hellenistic example, see Hoffman and Davidson, 1965, p. 9, fig. D), although they were certainly known in India as early as the second century B.C. (Swarup, 1957, pls. 88 left, 104 left) and as late as the seventeenth century (see figure of child, bottom of fig. 13, page 107). The type of waist ornament seen at Qusayr Amra may also ultimately be of Indian origin (Almagro et al., 1975, pl. IXa).

Having seen how close in style the pieces depicted in early Islamic representations often are to their presumed models from pre-Islamic times, we are tempted to speculate that to some extent the apparent scarcity of early Islamic jewelry may be due to our lack of knowledge, and that many of the pieces now classified as Roman, Byzantine, and Sasanian are in fact Islamic (Jenkins and Keene, 1982).

1a. **Silver Ring** *(upper left)*
Iran, probably Nishapur, 9th–11th century
Cast or forged from ingot, fabricated from
 sheet, and set with turquoise
Width 25.4 mm
Excavations of The Metropolitan Museum of
 Art
Rogers Fund, 1939 (40.170.202)

1b. **Silver Ring** *(upper center)*
Iran, probably Nishapur, 9th–11th century
Cast or forged from ingot, fabricated from
 sheet, and set with carnelian
Width 22.2 mm
Excavations of The Metropolitan Museum of
 Art
Rogers Fund, 1937 (40.170.201)

1c. **Silver Ring** *(upper right)*
Iran, probably Nishapur, 9th–11th century
Fabricated from sheet, formerly set with stone
Width 23.8 mm
Excavations of The Metropolitan Museum of
 Art
Rogers Fund, 1938 (39.40.124)

1d. **Silver Ring** *(lower left)*
Iran, probably Nishapur, 9th–11th century
Forged from ingot and fabricated from sheet,
 formerly set with stone
Width 26.2 mm
Excavations of The Metropolitan Museum of
 Art
Rogers Fund, 1938 (39.40.123)

1e. **Gold Ring** *(lower center)*
Iran, probably Nishapur, 9th–11th century
Fabricated from sheet, formerly set with stone
Width 15.9 mm
Excavations of The Metropolitan Museum of
 Art
Rogers Fund, 1937 (40.170.156)

1f. **Cast Bronze Ring** *(lower right)*
Iran, probably Nishapur, 9th–11th century
Width 17.5 mm
Excavations of The Metropolitan Museum of
 Art
Rogers Fund, 1938 (39.40.125)

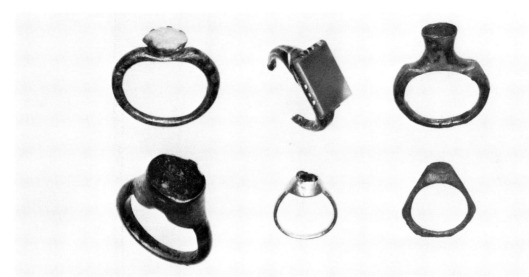

Among the finds of the Museum's excavations at Nishapur are several types of jewelry elements, and although they are limited in range, they constitute the bulk of the Metropolitan's early Islamic jewelry.

These six rings form an important group within the body of Nishapur jewelry, since they offer a glimpse of the historical progression out of the pre-Islamic past toward the more characteristic and fully developed style of later centuries.

Although varying in technique and design, nos. 1a, 1b, and 1c, all of which have Roman precedents, may be regarded as a group (Marshall, 1907, nos. 526, 188; Pollak, 1903, nos. 452, 453). Although hollow, like most of the Roman versions of this high-shouldered type, no. 1c seems the most developed along lines that certain medieval Islamic rings would follow. An almost identical ring, set with a faceted rock crystal stone cut in a way very similar to the pale amethyst no. 4b, was found in Crete (*Collection Hélène Stathatos*, vol. 2 [1957], p. 28 and pl. II, nos. 9, 10). Exaggeratedly high bezels on hollow rings were apparently extremely popular in Iran from the tenth century to the twelfth, judging from the number of extant examples, most of which are in private collections and unpublished.

The silver ring no. 1d represents a rather unskilled approach to a ring design whose culmination may be seen in no. 1e. The simpler approach of the former involves only the attachment of a sheet-constructed conical bezel to a separately made solid shank, whereas the latter is sheet constructed and hollow throughout, with no apparent seams except in a small area along the inside of the rolled shank. The form of the bezel, particularly the rounded bottom contour, bespeaks high mastery of this construction; and if, as seems probable, the shank and bezel were constructed from one piece of sheet, the technical achievement of its maker is indeed remarkable. To judge from the quality of the few remnants of goldwork in the collection from the Nishapur excavations (including the crescent-shape pendant no. 5), the number and quality of pieces reportedly and probably from Nishapur (including nos. 20b, 20c, 23, and 28), and Nishapur's status as a great center of art, there is little reason to consider this ring as other than locally made.

The bronze ring no. 1f, like nos. 1a–1c, has quite obvious Roman antecedents (Marshall, 1907, nos. 640, 563; and especially Dalton, 1901, no. 48). Surely an inexpensive product in its day, this ring illustrates the availability of good, even striking design to those on the lower end of the socioeconomic scale.

2. Gold Ring

Iran, reportedly from Gurgan, late 10th to 11th
century (?)
Forged from ingot, fabricated from sheet, and
set with sapphire
Maximum width of shank 17.5 mm
Rogers Fund, 1952 (52.32.4)

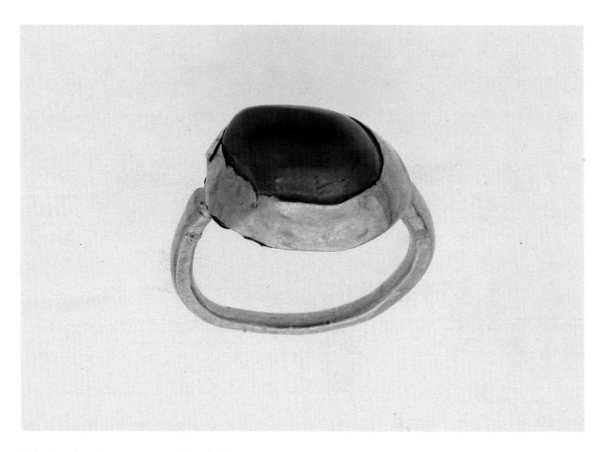

This piece is perhaps representative of a later phase
in the development of such rings as no. 1e, or perhaps
it was made by a less skillful artist. Although the
sapphire is probably not of royal quality, the cutter
obviously favored weight and color over symmetry
of form or flawlessness. The asymmetry of the stone
has posed a problem that the goldsmith has overcome
by offsetting the bezel on the shank to better center
the luminous blue mass of the stone.

3a. **Jet Seal** *(center)*
Iran, probably Nishapur, 10th–11th century
Form and inscription cut from block
11.9 x 10.3 x 20.6 mm
Excavations of The Metropolitan Museum of
 Art
Rogers Fund, 1936 (39.40.141)

3b. **Carnelian Ring Sealstone** *(upper left)*
Iran, probably Nishapur, 10th–11th century
Form and inscription cut from block with
 abrasive tools
12.7 x 10.3 x 2.4 mm
Excavations of The Metropolitan Museum of
 Art
Rogers Fund, 1937 (40.170.158)

3c. **Turquoise Ring Sealstone** *(upper right)*
Iran, probably Nishapur, 10th–11th century
Form and inscription cut from block with
 abrasive tools
9.5 x 4.8 x 2.4 mm
Excavations of The Metropolitan Museum of
 Art
Rogers Fund, 1947 (48.101.68)

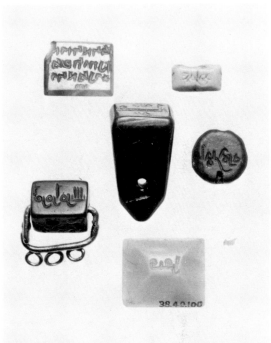

3d. **Lapis Lazuli Bead Sealstone** *(right)*
Iran, probably Nishapur, 10th–11th century
Form, inscription, and hole cut from block
 with abrasive tools
Diameter 9.5 mm
Excavations of The Metropolitan Museum of
 Art
Rogers Fund, 1937 (38.40.98)

3e. **Carnelian Ring Sealstone** *(bottom)*
Iran, probably Nishapur, 10th–11th century
Form and inscription cut from block with
 abrasive tools
15 x 12.7 x 4.8 mm
Excavations of The Metropolitan Museum of
 Art
Rogers Fund, 1937 (38.40.100)

3f. **Hematite Sealstone with Gold Fitting**
(lower left)
Iran, possibly Nishapur, 10th–11th century
Stone form and inscription cut from block with
 abrasive tools; gold fitting fabricated from
 wire
10.3 x 7.1 x 7.1 mm
Fletcher Fund, 1975 (1975.118)

The personal seal, which served in the Near East long before the advent of Islam as an individual official signature (as well as a very effective means of securing goods), was essential to the conducting of business affairs. According to tradition, the prophet Muhammad was told that his letters to foreign rulers would be taken seriously only if stamped with a personal seal. He thereupon ordered a seal made in the form of a ring (Allan, 1978). Whether or not this story is true, the seal ring was certainly the most common way to carry a seal. Sometimes the inscription was cut into the metallic top of the ring, although it was probably more common for the inscription to be cut into a stone that was then set in the usual manner. Among the many stones employed as seals, carnelian was by far the most popular. We do not know whether this was, as Pliny (citing Zenothemis, p. 235) affirmed, because it did not pull away the wax upon which it was being impressed. Certainly carnelian has other qualities that recommend it for this use: availability, toughness, and resistance to abrasion. Seals were also commonly applied to clay and, after application of ink to the surface of the seal, to paper.

Early Islamic sealstones were made from many kinds of stones and came in many forms, although both materials and forms were more varied than the examples illustrated here suggest. These stones, with one exception, are all known to have come from Nishapur.

The jet seal at the center (no. 3a), pierced for suspension—perhaps around the wrist or neck—by a cord, bears no name but rather the common Islamic phrase تتو[كل] على الله ("Re[ly] on God"), which was often inscribed on sealstones in this general period, in many cases shortened to the abbreviated تتو ("Re[ly]"), typically in conjunction with the name of the owner of the seal.

The sealstone at the upper left (no. 3b) is made of fine dark red but highly translucent carnelian and is unusual among Islamic-style sealstones of this period for being inscribed in Hebrew. The form of the stone is characteristic of those from Iran of the tenth and eleventh centuries; note, for instance, the similarity in form between this stone and no. 1b. Literally hundreds of sealstones are known from the tenth, eleventh, and twelfth centuries with this form and

similar proportions. The form was also known as far away as Algeria.* The present stone is also unusual in the amount and type of information it supplies. A reading of the inscription was kindly offered by Christopher Brunner:

'wzr'dl	proper name
sštwhtn	father's name plus suffix of attribution, -n/ān
wr'stẏ	"prepared, fashioned" (?)
yhẏ	("function uncertain")

If the third line does indeed read "prepared, fashioned," there is a good possibility that the "yhẏ" is the name of the seal cutter, perhaps some equivalent of the Arabic name "Yahyā"; indeed, on certain Arab-Sasanian coins the mintmaster's name is inscribed in abbreviated form. Closer in time to our seal, there is at least one case of a die cutter whose signature appears on coins (Miles, 1938, pp. 100–3; Bier, 1979, pp. 243–56).

Another apparently unique sealstone of this period from the Nishapur excavations (MMA 40.170.159) is a finely formed elliptical flat stone inscribed in Pahlavi: "Bōrānēn, son of Būnen" (Brunner, 1978, pp. 21, 147, 130).

The tiny stone at the upper right (no. 3c) is made of fine turquoise most probably mined near Nishapur in an area renowned since ancient times for producing a hard, sky-blue variety of the stone. It is inscribed simply but in lively style: "Muhammad [i]bn Ahmad." Abrasion through wear has muted the details and reduced the depth of the inscription, the relative softness of turquoise being one reason it was seldom used for seals.

Lapis lazuli, another relatively soft stone, furnished the material for the bead at the center right (no. 3d), which has obviously and not surprisingly been subjected to less wear than the turquoise ring stone. The bead is inscribed: "Ahmad [i]bn Hamza." Another bead with a mirror-reverse inscription (as yet undeciphered), and therefore one that was presumably

*See Golvin, 1965, pl. CIII, no. 10, inscribed "Muhammad son of Yūsuf," incorrectly deciphered (p. 267) as "Khirch ou Hirich . . . ou autre chose. . . ." In addition, the style of the inscription is not entirely dissimilar to that of inscriptions on Iranian stones of the period.

used as a seal, is a spheroid of jet, probably of the eighth or ninth century (MMA 40.170.407).

The inscription on the pink carnelian stone (no. 3e) is a single word, presumably a name. Possible readings are very numerous given the fact that there are five consonants and an absence not only of vowels (not uncommon in Arabic inscriptions and texts) but also of diacriticals, as is often the case with such early "Kufic" inscriptions. Here one suspects some sort of Turkic name.

Hematite enjoyed considerable popularity as a sealstone in pre-Islamic times and continued to be used for Islamic seals. Unique in our experience, however, are the form and imagery of no. 3f. Three of the four principal faces of the prism bear "inscriptions," although one of these has five lines of pseudo-Kufic script that say nothing at all. The face most visible in the illustration carries the admonition: "He believes [truly] who believes in God." The other inscribed face has three lines that begin at the top "al-Hasan al-Husayn 'Ali" and apparently continue with a listing of the Shi'ite imams. The collection contains another square-prism-shape sealstone of different proportions that also swivels on its axis (MMA 41.160.336), and another of related form—a three-sided, gabled, prism-shape seal of bronze (MMA 93.17.112).

Barely visible on the face at the bottom of no. 3f is the charming image of a lion with a scorpion (fig. 1). The conjunction of the lion and the scorpion must have held special significance in this period because the same combination appears on the obverse of each of two circular pendants from the Nishapur excavations (nos. 7a and 7b).

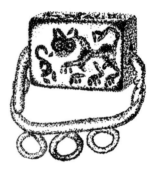

Fig. 1. Image of lion and scorpion on hematite sealstone with gold fitting (no. 3f).

4a. Rock Crystal Ring Sealstone *(center)*

Iran, probably Nishapur, probably 10th
century
Cut and polished on rotary flat lap
11.1 x 9.5 x 4.8 mm
Gift of Mr. and Mrs. Habib Anavian, 1980
(1980.231)

4b, 4c. Two Amethyst Ring Stones

Iran, probably Nishapur, probably 10th
century
Cut and polished on rotary flat lap
Left: 12.7 x 11.1 x 7.1 mm;
right: 11.1 x 7.1 x 4.8 mm
Excavations of The Metropolitan Museum
of Art
Rogers Fund, 1947 (48.101.62a, b)

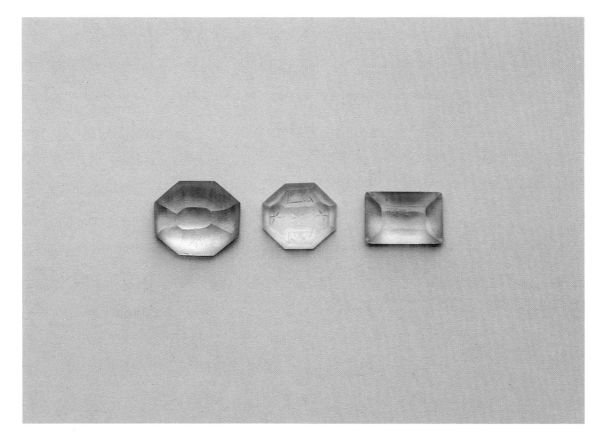

The rock crystal stone at the center offers, without
any supplementary data, proof of the existence of
resolute, complex, symmetrical faceting of stones in
early Islamic Iran. The content of the inscription is
of a simple, pious nature ("[Whatever] [G]od wills"
[?], see TA 9, page 149) and thus of no historical
significance, but the style of the inscription is datable,
probably to the tenth century A.D., not later than the
eleventh.

The approach to faceting manifested in the form
of the stone is highly consistent with the contem-
poraneous use in Nishapur of polyhedral forms.
Similar in form to this stone are such hardstone beads
as MMA 48.101.203 (see no. 11), as well as several
of the jet beads on strand MMA 40.170.697 (also
no. 11). The closest parallel, however, is MMA
40.170.282, a small bronze coin weight from the

excavations (Allan, 1982, no. 127, and TA 10, page
149). The beads, the present sealstone, and its related
bronze weights (a second coin weight, identical to
MMA 40.170.282, is in a private collection) were
apparently inspired by the form of the (small) rhom-
bicuboctahedron (TA 11, page 150), a form that has
an octagonal cross section made up of eight square
faces in series at the "waist," from which four squares
and four triangles slope to form the "shoulders" and
a square at each end. This form is one of the semi-
regular solids whose discovery is credited to Archi-
medes. It can be cut from a solid cube by truncating
equally the edges and corners so that all resultant
edges are equal in length, as shown by Kepler (Heath,
1921, pp. 99–101). Ultimately, of course, this form,
like all regular and semiregular solids, is based on the
sphere, a fact that suggests the intriguing possibility

5. Gold Pendant

Iran, probably Nishapur, 9th–10th century
Fabricated from sheet and half-round wire
15.9 x 15.9 x 4.8 mm
Excavations of The Metropolitan Museum of Art
Rogers Fund, 1937 (40.170.155)

that advanced theoretical geometry filtered down to the level of the craftsman in this Iranian school of polyhedral art of the tenth, eleventh, and twelfth centuries, for it was the tenth-century mathematician al-Buzjani (d. 998 A.D.) who located the corners of a regular polyhedron with a single span of the compass on the surface of a sphere (Suter, 1927, p. 257; see also Keene, 1981, pp. 30–38).

The rock crystal sealstone (4a) is, in effect, one end of an elongated (small) rhombicuboctahedron, except that there is a further truncation of the edges, resulting in the would-be-squares having six sides and the would-be triangles having five.

Analogies of form between these stones, on the one hand, and between no. 4c and numerous tenth- and eleventh-century ring stones, on the other (the latter datable through their seal inscriptions or their settings), provide further geographic and chronological context for the amethysts.

One type of ring into which such stones as this may have been set is exemplified by no. 1c, another by a medieval Iranian ring (Féhervári and Safadi, 1981, p. 126, no. 60b).

Additional support for the likelihood that these stones were cut locally, at Nishapur, is the similarity of material to that of bead MMA 48.101.89 (no. 11, upper left), whose form is closely paralleled by that of a number of glass beads from the excavations.

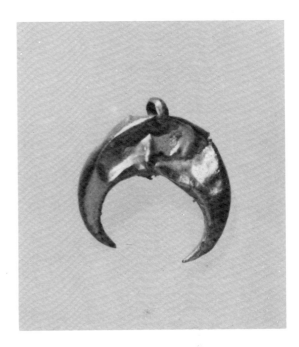

Crescent-shape pendants have enjoyed a long popularity in several cultures. A beautiful hollow but heavily granulated Babylonian example from Dilbat, Iraq, dating to the second century B.C., is in the Metropolitan Museum (MMA 47.1, Maxwell-Hyslop, 1971, fig. 63a, b; ibid., pp. 149–51). Any sizable sampling of Hellenistic and especially Roman jewelry will contain a number of crescent-shape pendants (Hoffman and Davidson, 1965, nos. 33, 34; Bloomington, 1973, nos. 51a, 70a, 76a, 146a, 150b). An early Islamic example, excavated by the Metropolitan's Iranian expedition at Qasr-i Abu Nasr near Shiraz, consists primarily of a piece of thickish flat sheet and in no part involves hollow construction (MMA 34.107.95). Crescent forms are ubiquitous in contemporary traditional jewelry of the Near East.

Although badly crushed, this example from Nishapur has a volumetric and sculpturally satisfying form. Like no. 1e, it is a marvel of the folding of thin gold sheet to form a hollow curving shape.

6. Tin Pendant

Egypt, reportedly from Magaga, 9th century
Cast (roundel) and fabricated from sheet (bail)
Diameter 47.6 mm, thickness .8 mm
Rogers Fund, 1912 (12.182.111)

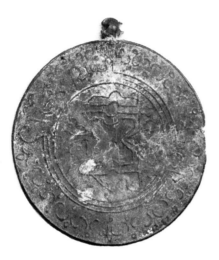

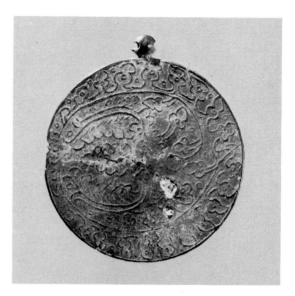

Highly interesting in terms of material, epigraphy, and decoration, this small pendant has at different times been thought to be bronze or silver, and has been dated from the pre-Islamic period in Egypt to the thirteenth century. That it is tin was proved by X-ray fluorescence tests made in the Metropolitan's conservation research lab; and that it is ninth-century Egyptian has been ascertained by epigraphic and decorative comparisons with an extensive series of dated Egyptian pieces, most notably funerary stelae and woodwork now in the Museum of Islamic Art, Cairo.

An epigraphic feature popular in ninth-century stelae is the nonfunctional arch (here gabled) in the middle of the word "Allah" at the center of the pendant. A sample survey of the many volumes devoted to the extensive series of similar stelae in the Museum of Islamic Art (Hawary, Rached, and Wiet, 1932–42) yields a great many parallels to our inscription. The closest parallels are to inscriptions of the first half of the ninth century; those of the late ninth and early tenth centuries depart increasingly from the form seen here. Particularly close is an inscription on a tombstone dated A.D. 844 (ibid., vol. 1, pl. XLV, no. 1268), which has not only the arch usually present

but also arches in the vertical shafts similar to those in our example. Another tombstone inscription with arches in the vertical shafts is dated A.D. 820 (ibid., pl. XV, no. 1506/581). Further confirmation of the date are the many ninth-century parallels with the palmettes on the reverse of the pendant.

The phrase "And God will suffice you against them [the unbelievers]," from chapter 2, verse 137 of the Koran, forms a border on the obverse. Otherwise unknown on pendants, this inscription probably served a talismanic function, as did certain popular inscriptions on pendants and amulets throughout Islamic history. For reasons not altogether clear this phrase seems almost invariably to have been used as a border on other decorative objects, the letters modified to assume the form desired by the artist. The closest parallels to the border on this pendant are on a pair of ninth-century wood panels in the Museum of Islamic Art (David-Weill, 1931, pl. I, nos. 6852, 6854).

A peculiarity of the inscription on no. 6 that makes it particularly difficult to read (aside from the confusion of line with mass) is that it is written in mirror reverse, a practice normally seen only on seals.

7a. Bronze Pendant *(obverse)*

Iran, probably Nishapur, 10th century
Cast and engraved
Diameter 23.8 mm, thickness 2.4 mm
Excavations of The Metropolitan Museum
 of Art
Rogers Fund, 1939 (40.170.245)

7b. Silver Pendant *(reverse)*

Iran, probably Nishapur, 10th century
Cast and engraved
Diameter 19 mm, thickness .8 mm
Excavations of The Metropolitan Museum
 of Art
Rogers Fund, 1937 (40.170.246)

Similar in general type to no. 6 and also decorated with intriguing imagery, these two pendants have essentially the same elements but in slightly different arrangements. The conjunction of the lion and the scorpion (cf. no. 3f) with what appear to be crossed compasses leads to conjecture that some special significance was intended. The "inscriptions" on both these pendants shed no light on the matter, since they are merely decorative pseudo-writing, a feature common to ninth- and tenth-century Islamic objects, especially those from Nishapur.

8a. Uncut, Natural, Doubly Terminated Black Quartz Crystal

Length 14.3 mm
Purchased by subscription, 1896 (96.9.470c)

8b. Soft Green Stone (Steatite?) Pendant

Iran, probably Nishapur, 9th–10th century
Cut from massive block, bored for suspension
22.2 x 9.5 x 8.7 mm
Excavations of The Metropolitan Museum
 of Art
Rogers Fund, 1939 (48.101.240)

8c. Rock Crystal Pendant

Iran, probably Nishapur, 9th–10th century
Cut from massive block, wheel-cut linear deco-
 ration, and drilled for suspension (top part
 of suspension projection, seen here at bot-
 tom, broken away)
15.9 x 9.5 x 7.9 mm
Excavations of The Metropolitan Museum
 of Art
Rogers Fund, 1947 (48.101.200)

8d. Fragmentary Jet Pendant

Iran, Nishapur, 9th–10th century
Cut from massive block, incised and bored for
 suspension
41.3 x 22.2 x 20.6 mm
Excavations of The Metropolitan Museum
 of Art
Rogers Fund, 1937 (40.170.404)

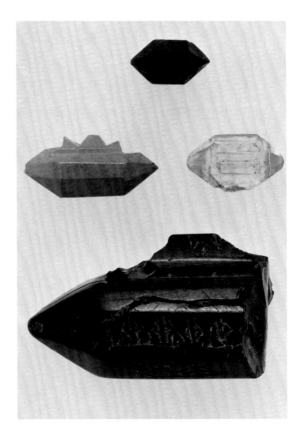

The type of pendant represented by nos. 8b, 8c, and 8d, from the Nishapur excavations, offers a striking example of the influence of natural crystal forms on facet-cut stone forms (and through these, on cast as well as fabricated metal). We feel quite secure in pointing to the doubly terminated quartz crystal, beautifully exemplified by 8a, as the inspiration, since its form is characteristic for quartz; and while the example shown here is probably from Italy, such crystals are known from, among other places, Turkey and New York State. The source of inspiration seems sure, in spite of the fact that many of these pendants (including the three above) are in fact octagonal rather than hexagonal prisms (the latter being the invariable habit of the natural quartz crystal). The occurrence of the octagonal form must be due simply to the ease with which it can be cut and the pleasing effect it gives. For there are no natural crystals of octagonal prism form, not to mention those that are doubly terminated. Furthermore, among the known pendants of this type, the hexagonal section is more common than the octagonal. Two other jet examples were excavated at Nishapur, one hexagonal and one octagonal (exp. neg. no. 39N588). Also known are a carnelian example acquired in Isfahan and two cast bronze examples acquired in Kabul but reportedly from Balkh (private collection, New York). All are hexagonal with the exception of one of the bronze pieces, which is an irregular pentagon, a form also without parallel in nature.

Two Indian necklaces in the Metropolitan, probably dating from the nineteenth century (MMA 15.95.80 and MMA 15.95.127), have hollow sheetfabricated gold hexagonal pendants; a necklace with twenty-four solid cast-silver pendants, perhaps twentieth century but remarkably similar to the medieval bronze examples from Kabul, is in a private collection; and twentieth-century photographs of Indians in native costume indicate a continued use of the hexagonal form for pendants (Bhushan, 1958, pl. L left and right).

9a. Glazed White Quartz Pendant

Iran, probably Nishapur, 11th–12th century
Roughly chipped to form, drilled, polished,
 and covered with vitreous glaze
17.5 x 9.5 x 5.6 mm
Excavations of The Metropolitan Museum
 of Art
Rogers Fund, 1947 (48.101.194b)

9b. Black Jasper Pendant

Iran, probably Nishapur, 10th–11th century
Cut from massive block, drilled for suspension
23.8 x 11.1 x 6.4 mm
Excavations of The Metropolitan Museum
 of Art
Rogers Fund, 1947 (48.101.91i)

9c. Banded Black and White Jaspachate Pendant

Iran, probably Nishapur, 10th–11th century
Cut from massive block, drilled for suspension
18.2 x 11.9 x 3.9 mm
Excavations of The Metropolitan Museum
 of Art
Rogers Fund, 1947 (48.101.91h)

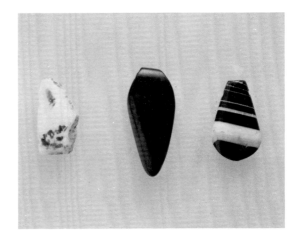

Such simple if not universal pendant forms as nos. 9a–9c would normally pose great problems of attribution were it not for certain circumstances that help to establish a geographical and chronological context. The fact, in and of itself, that all three pendants were excavated at the same location is not necessarily an accurate indication of date or place of origin, since objects from ancient times were often used in later years and since objects from recent times often are mixed in with excavated material. Of particular interest are the remnants of turquoise- and cobalt-colored glazes on the surface of the white quartz pendant (no. 9a); in certain varieties of Afghan lapis lazuli, these two blues are mixed in a similar manner, and it is not unlikely that this was originally a very respectable imitation of that stone. The glazing of white quartz was in vogue in Iran about the eleventh and twelfth centuries, presumably concurrent with the rediscovery of the secret of making "faience," or man-made composite frit-fused ceramic bodies. The glaze on no. 9a and other similar beads (usually turquoise in color) seems close to that on the composite-bodied ceramic wares made at Nishapur. Since a number of glazed white quartz beads were found in the Metropolitan's excavations at Nishapur, it is probable that they were made locally in the eleventh century or in the twelfth.

 Glazed rock crystal beads were also found in these excavations. On one of these (MMA 48.101.88), the

Fig. 2. Stucco Figure

Iran, 10th–11th century

Molded or modeled, carved and painted in
polychrome

Height 119.4 cm

Cora Timken Burnett Collection of Persian
Miniatures and Other Persian Art
Objects

Bequest of Cora Timken Burnett, 1956
(57.51.18)

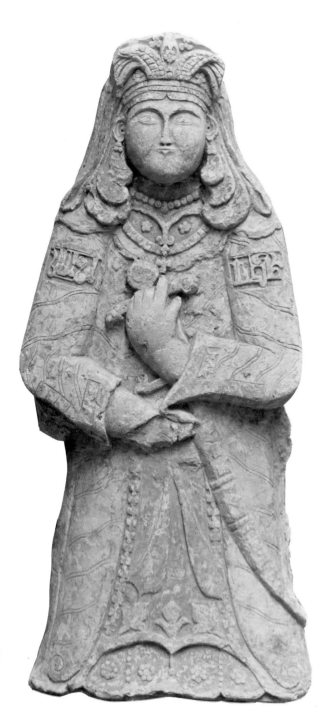

formerly turquoise-colored glaze has decomposed
to a greenish beige; a small rock crystal cabochon
(MMA 48.101.63), glazed with a pale transparent
middle blue, creates a very creditable impression of
sapphire. Further evidence that such imitation was
practiced are the numerous passages in the literature
of early Islamic mineralogy indicating that pearls and
precious stones were intentionally faked during this
period. It seems highly likely that a large percentage
of early glass colors were made in imitation of natural
stones (see no. 11: 48.101.86a, b; 48.101.90c, o, q, u;
and 48.101.192c, e). Literary evidence also sug-
gests that the early Chinese were duped by the
Syrians, who sold them glass as precious stones
(Hobson, 1912, p. 138).

The glazing of quartz might seem miraculous,
since it would be expected that sufficient heat to fuse
the glass would at least cause the stone to crack; but
as Lucas informs us (1934, pp. 107, 375; 1936, p.
150, n. 3), glazing on stones was practiced in Egypt
from predynastic times until at least the Twelfth
Dynasty. These stones included not only steatite
(which is practically impervious to heat) but also
quartz rock and rock crystal, and the glazes, accord-
ing to Lucas, were alkaline-fluxed. It is assumed that
they were of a very low-firing variety.

The medieval Persian use of the type of pendant
represented by no. 9b and especially by no. 9c is ex-
emplified by the near life–size stucco statue (fig. 2).
Although our attribution is much earlier than the
conventional one ascribed to such figures, we feel, on
the basis of epigraphy, that this sculpture and its com-
panion (MMA 67.119) date from the late tenth cen-
tury or early eleventh. Elements of decoration—
such as the rosettes—also bear close analogy with
those on the painted stucco niches from Nishapur
(MMA 38.40.249–252, Hauser, Upton, and Wilkin-
son, 1938, figs. 4–6; for MMA 38.40.252, Dimand,
1944, fig. 12). Probably the most significant parallels
to these figures are the painted representations of
such retainers lining the walls of the throne room of
the early eleventh-century Ghaznavid palace at
Lashkari Bazar in present-day Afghanistan (Schlum-
berger, 1952; Otto-Dorn, 1967, pl. on p. 105).

10. Banded Agate Pendant

Iran, probably Nishapur, probably 9th–10th
century
Cut from massive block, drilled for suspension
25.4 x 17.5 x 5.6 mm
Excavations of The Metropolitan Museum
of Art
Rogers Fund, 1947 (48.101.80)

Fig. 3. Stucco Figurine

Iran, Nishapur, perhaps 9th–10th century
Modeled, carved (?), and painted in poly-
chrome
Height 15.5 cm
Excavations of The Metropolitan Museum
of Art
Rogers Fund, 1937 (38.40.235a–c)

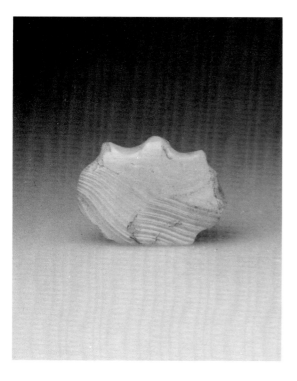

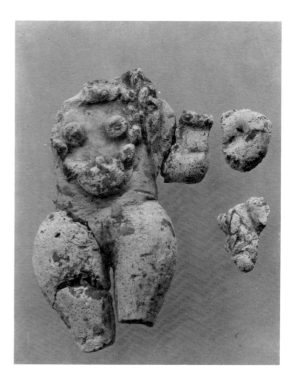

This stucco figurine is another example of how sculp-
ture can provide historical context. The pendant type
represented by no. 10 enjoyed long and widespread
popularity and is seen here adorning the torso of a
figurine dating to about the ninth century or the
tenth.

Jade pendants of essentially the same form are also
known, decorated in a style typical of seventeenth-
and eighteenth-century Iran, as are jade pendants
decorated in a Mughal Indian style. In fact, were it
not for the evidence supplied by our plaster lady, it
would be tempting to regard this pendant as a late
intrusion in the Nishapur material, despite the fact
that its lapidary character is best paralleled in the
early material.

11. Group of Stone, Jet, and Glass Beads*

Iran, probably Nishapur, 9th–12th century
Cut and bored; glass molded
Rock crystal bead at upper center, 25.4 x
 11.1 x 9.5 mm
Excavations of The Metropolitan Museum
 of Art
Rogers Fund, 1939 and 1947

We have already explored the possible origins of colors used for glass in the imitation of natural stones in our discussion of the glazed white quartz pendant no. 9a (see also Keene, 1981; TA 12 and TA 13 for a photograph and drawing of the carnelian bead MMA 48.101.82, right center; and nos. 4a–4c for reference to the rock crystal bead MMA 48.101.203, center, and to several beads in strand MMA 40.170.697).

Although we have discussed the glazing technique used for the rock crystal bead MMA 48.101.88 (see no. 9a), its form (the same as that of a large bead to the right of center on strand MMA 40.70.697) suggests that it too was inspired by the form of a natural crystal—in this case, the sapphire (Webster, 1962, pl. III top). Here again, as with the quartz crystal-form pendants (nos. 8b–8d), the probable source is hexagonal, while some of the cut stones (including the rock crystal and jet beads) are octagonal, as well as other shapes. Several similar carnelian beads (some apparently hexagonal, others octagonal) were found in an eleventh-century Fatimid hoard in Caesarea (Katz, Kahane, and Broshi, 1968, colorpl. p. 128).

Another method of decorating hardstone beads that involves heat, practiced since the fourth millennium B.C. and still known in Iran and India in modern times (Beck, 1933; Mackay, 1933), is exemplified by the strand of carnelian beads (MMA 40.170.693), as well as by a single bead also from Nishapur (MMA 48.101.198). Technically, this method involves painting a soda compound on the surface of the stone and then heating it to a few hun-

dred degrees Fahrenheit. This causes a kind of decomposition of the surface that leaves it white. The decoration is permanent, and in the better examples —especially the ancient ones—it can be quite effective.

Paint has been applied not only to the rust red bead (MMA 48.101.75c) but also to the jet beads in strand MMA 40.170.696. The jet beads are also ornamented with Arabic inscriptions: those on the smallest and middle-size beads repeat the Arabic word [الله] الملك ("Sovereignty [belongs to God]"), while the inscription on the largest bead forms no word and is merely decorative.

One form of Muslim jewelry associated primarily with men is the subḥa, or strand of prayer beads, which usually has thirty-three or ninety-nine beads to facilitate the recitation of the ninety-nine "beautiful names" of God. Such beads have been made of a wide variety of materials—seeds, wood, bone, and semiprecious stones, as well as the most valuable precious stones and pearls. A number of beads seen here were probably elements on strands of prayer beads; in particular, the pendant bead on the carnelian strand MMA 48.101.70 is of the size and form commonly used as the chief spacer and "handle," by which the user knew by touch that he had finished the circuit.

It should also be pointed out that the stringing of these beads is modern and their arrangement on the strand does not represent an attempt to re-create their original order or even to suggest their original association.

*See page 32 for key to illustration.

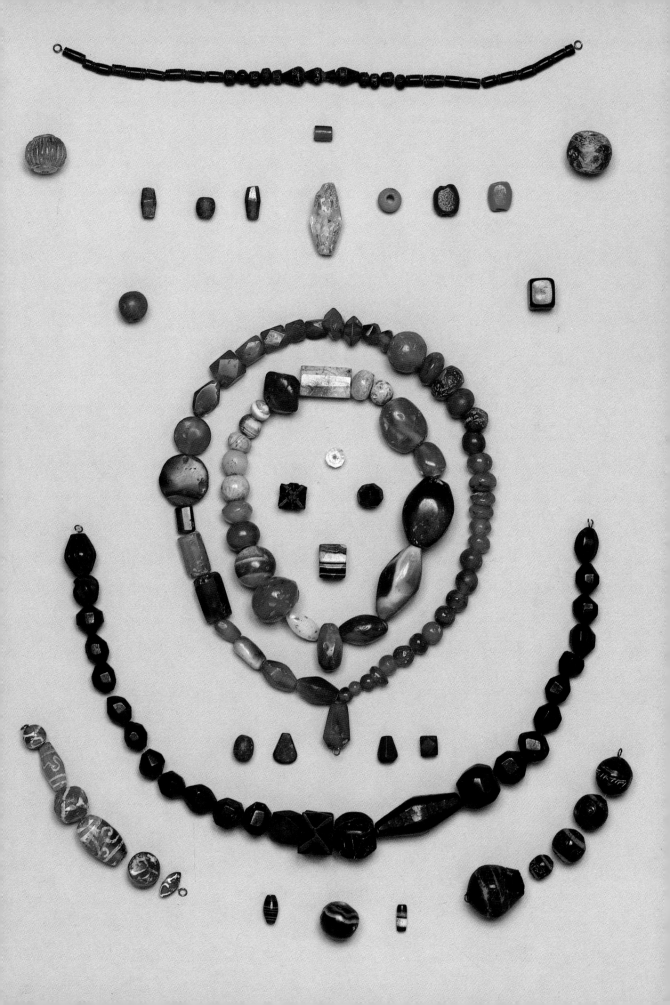

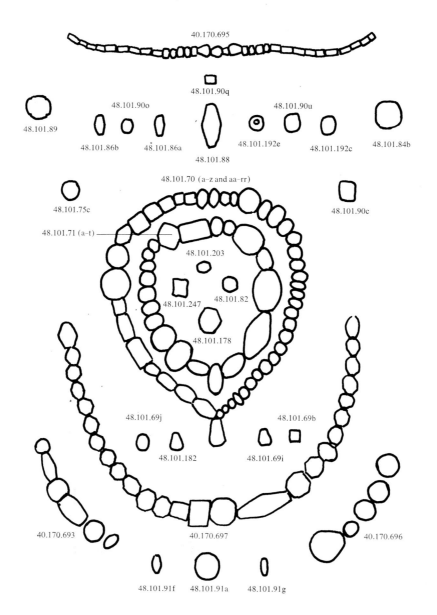

40.170.695

48.101.90q

48.101.89

48.101.90o

48.101.90u

48.101.86b 48.101.86a

48.101.88

48.101.192e

48.101.192c

48.101.84b

48.101.70 (a–z and aa–rr)

48.101.75c

48.101.90c

48.101.71 (a–t)

48.101.203

48.101.247 48.101.82

48.101.178

48.101.69j

48.101.69b

48.101.182 48.101.69i

40.170.693

40.170.697

40.170.696

48.101.91f 48.101.91a 48.101.91g

40.170.693	Strand of carnelian beads, cut from block, bored, etched with painted-on soda compound. Length as shown 73 mm	
40.170.695	Strand of jet beads, cut from block, bored, incised and painted. Length overall approximately 19 cm	
40.170.696	Strand of jet beads, cut from block, bored, incised and painted. Largest bead, 20.16 x 19 mm	
40.170.697	Strand of jet beads, cut from block, bored. Length overall approximately 31.8 cm	
48.101.69b	Lapis lazuli bead, cut from block, bored. 7.1 x 6.4 x 5.6 mm	
48.101.69i	Lapis lazuli bead, cut from block, bored. 9.5 x 7.1 x 6.4 mm	
48.101.69j	Lapis lazuli bead, cut from block, bored. 7.9 x 7.9 mm	
48.101.70	(a–z and aa–rr) Strand of carnelian beads, cut from block, bored. Maximum dimensions as shown 14 x 11.4 cm	
48.101.71	(a–t) Strand of beads, various chalcedonies, cut from block, bored. Maximum dimensions as shown 92.1 x 76.2 mm	

48.101.75c	Bead of soft gritty tan stone (earthenware?), cut from block, bored (or molded?), and painted. 11 x 10.3 mm
48.101.82	Carnelian bead, cut from block (cut and polished on flat lap), bored. 10.3 x 7.9 mm
48.101.84b	"Millefiori" glass bead, gathered from different colored glasses and marvered. 15.9 x 12.7 mm
48.101.86a	Transparent green glass bead, cut and polished on flat lap. 11.1 x 6.4 mm
48.101.86b	Transparent green glass bead, cut and polished on flat lap. 11.1 x 6.4 mm
48.101.88	Rock crystal bead, cut from block, bored, covered with vitreous glaze. 25.4 x 11.1 x 9.5 mm
48.101.89	Amethyst bead, cut from block, bored. 15 x 12.7 mm
48.101.90c	Transparent purple glass bead, molded. 10.3 x 9.5 x 8.7 mm
48.101.90o	Transparent red glass bead, molded. 7.1 x 7.1 mm
48.101.90q	Glass bead, transparent green over opaque yellow core, molded. 6.4 x 4.8 mm
48.101.90u	Translucent cobalt blue glass bead, molded. 11.1 x 9.5 x 6.4 mm

48.101.91a	Black and white jaspachate bead, cut from block, bored. 14.3 x 12.7 mm
48.101.91f	Black and white jaspachate bead, cut from block, bored. 9.5 x 4.8 mm
48.101.91g	Black and white jaspachate bead, cut from block, bored. 9.5 x 3.9 mm
48.101.178	Bead of soft black and white stone (alabaster?), cut from block, bored. 12.7 x 11.1 x 10.3 mm
48.101.182	Lapis lazuli bead, cut from block, bored. 10.3 x 8.7 x 3.2 mm
48.101.192c	Translucent turquoise-colored glass bead, molded. 10.3 x 9.5 x 5.6 mm
48.101.192e	Opaque turquoise-colored glass bead, molded. 8.7 x 6.4 mm
48.101.203	Rock crystal bead, cut from block, bored. 7.1 x 4.8 mm
48.101.247	Jet bead in the form of a "stella octangula" (two symmetrically interpenetrated tetrahedra), cut from block, bored. Diameter 9.5 mm

12. Nephrite Belt Fitting

Iran, possibly Nishapur, 9th–10th century
Cut from massive block, drilled for attachment
 to straps
37.3 x 31.8 x 6.4 mm
Excavations of The Metropolitan Museum
 of Art
Rogers Fund, 1947 (48.101.197)

The type of belt fitting that is attached to a flexible belt and from which are suspended short straps, also bearing fittings, was popular in pre-Islamic Iran, as is well attested by, for example, the reliefs at Taq-i-Bustan (Fukai and Horiuchi, 1972, vol. 1, pl. LXIV). This pendant-strap type continued in use in early Islamic times, as shown by a wall painting from Samarra (Herzfeld, 1927, pl. LXV right). But particularly similar in form to no. 12 is the belt fitting on the representation of a mounted warrior in a wall painting of the ninth century or tenth excavated at Nishapur (Hauser and Wilkinson, 1942, pp. 116–18, fig. 45), which tempts us to associate the plaque found at Nishapur even more closely with that great center of the lapidary arts.

Our nephrite belt fitting antedates by five hundred years the earliest previously known groups of Islamic jades, which include not only vessels but also, for ex-

ample, the type of sealstone exemplified by the magnificent gold ring no. 56a. The likelihood of Iranian or even Nishapuri manufacture does not seem remote given the Iranian and Iraqi pictorial evidence cited and the number and quality of what are surely local lapidary objects unearthed at Nishapur. It is probably merely a matter of accident that no other jade pieces were retrieved by the Museum's excavations there. A mate identical to the present piece was seen on the Tehran art market in 1978. It should be noted that Nishapur has long been a rich source for illicit excavation.

13. Thirty-seven Fittings from a Belt

Probably Iraq or Iran, 9th century
Cast bronze
Each element 46 x 41.3 mm
Gift of Mr. and Mrs. Everett Birch, 1981
 (1981.232.5a–kk)

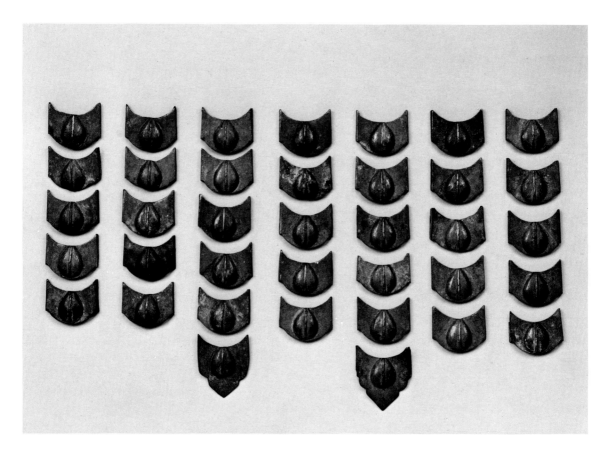

This set of belt fittings bears close comparison to those depicted in the above-mentioned painting from Samarra (Herzfeld, 1927, pl. LXV right). Using the depiction as a stylistic guideline, we may conjecture that elements such as these were used both on belts and as attachments to their pendant straps.

Belts of this general type continued in use through the fourteenth century but appear to have been superseded in the fifteenth by a new type that remained in vogue in Iran for centuries to come (see fig. 9, page 101).

14. Cast Bronze Belt Fitting

Iran, probably Nishapur, 10th century
28.6 x 17.5 mm
Excavations of The Metropolitan Museum
 of Art
Rogers Fund, 1939 (40.170.215)

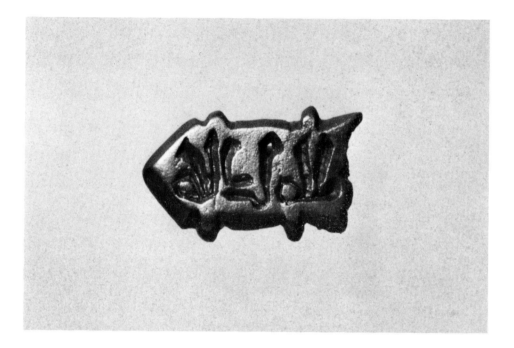

The representation of a mounted warrior in a wall
painting excavated at Nishapur (Hauser and Wilkin-
son, 1942, pp. 116–18, fig. 45) provides a probable
context for the present piece (as well as for no. 12),
since pieces of this shape are shown as the terminal
fittings for the vertical straps suspended from the
warrior's belt. No. 14 has a nearly identical mate
(MMA 40.17.214), also found in the Nishapur ex-
cavations. Like a number of other fittings excavated
there, these pieces are hollow at the back and fitted
with posts that presumably acted as rivets for attach-
ment to straps. These belt fittings may very well have
been attached horizontally to the belt, since in that
position their inscriptions ("Sovereignty belongs to
God") would have been more easily read (London,
1976, no. 274, illus. p. 167).

15. Gold and Sard Earring

Iran, probably Nishapur, 9th–10th century

Gold component fabricated from sheet and
 wire; bead cut from massive block and drilled

Diameter of bead 6.4 mm

Excavations of The Metropolitan Museum
 of Art

Rogers Fund, 1939 (40.170.153)

Were it not for the hollow sphere for the insertion of
the end of the ear wire, which forms a kind of clasp
popular on medieval Islamic earrings, no. 15 would
seem to represent a type of earring so simple and uni-
versal in design as to be nonspecific in terms of date
and place of manufacture. A similar earring in bronze
(although having no clasp), from as early as the fifth
or sixth century B.C., is in the British Museum.

The Nishapur excavations, however, unearthed
another earring virtually identical to no. 15 (exp.
neg. no. 39N585, no. 1, now in the Archaeological
Museum, Tehran), as well as an example of the type
in which hollow gold balls are strung on a continuous
heavy wire (exp. neg. no. 39N585, no. 3, also in
Tehran; see also nos. 20b, 20c, 21a, 21b). It is not
improbable that this last type is a later stage in the
evolution of the type represented by no. 15, since
this would have involved only the transformation of
the stone bead into a series of gold ones. If indeed
some such process did occur, the importance of no.
15 could hardly be greater, considering the wide-
spread popularity of the later, more developed type
not only in Iran but also in large areas of southern
Russia and eastern Europe.

EARLY MEDIEVAL JEWELRY
11th–13th Century

Once we move into the early medieval period, not only are there many more pieces of extant jewelry than in the early Islamic period, but it is possible on the whole to establish firmer dates for them. The reasons for the survival of relatively large groups of these objects continue to elude us, and our understanding of the lines of development that brought this art to such brilliant flowering remains incomplete. The leap from early Islamic to early medieval jewelry often seems great indeed.

The Museum's collection of jewelry from the eleventh century to the thirteenth is its most comprehensive, following that of the eighteenth and nineteenth centuries, and among these objects are some of the period's most marvelous known examples. Nevertheless, despite the fact that this period is so richly represented, many questions remain unanswered, and explanations necessarily involve a certain amount of speculation. The history of early medieval jewelry is firmly anchored in at least two important areas—northeastern Iran and Egypt during the first half of the eleventh century—and pieces from these areas provide solid foundations around which a number of mutually consistent groups can be formed. The jewelry that originated in these areas will therefore be cited as points of reference for discussion of other early medieval jewelry in the Museum's collection in an attempt to give a broad picture of the gold and silver jewelry of Egypt, Greater Syria, Mesopotamia, and Greater Iran during the eleventh, twelfth, and thirteenth centuries.

16. Gold Armlet

Iran, first half 11th century

Fabricated from sheet with applied twisted wire
 and granulation; originally set with stones

Maximum diameter 10.5 cm, height at clasp
 50.8 mm

Harris Brisbane Dick Fund, 1957 (57.88a–c)

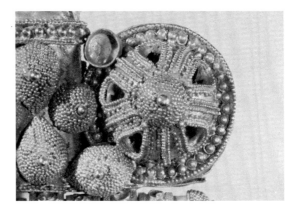

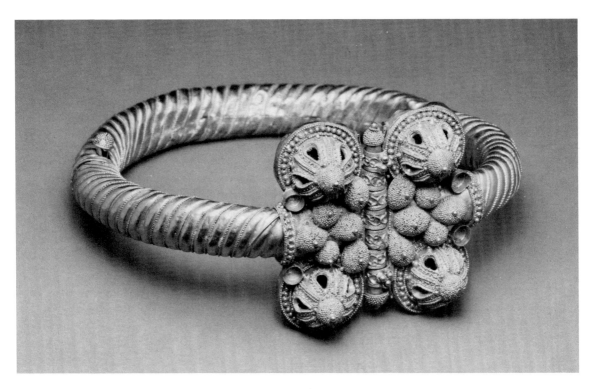

The pivotal pieces for the study of early medieval
jewelry in Greater Iran are armlet no. 16, illustrated
above, and its mate in the Freer Gallery of Art,
Washington, D.C. (58.6). Each of the four hemi-
spheres flanking the clasp bears at its base a flat disk
of thin gold that was decorated by pouncing it over a
coin bearing the name of the Abbasid caliph al-Qadir
Billah (991–1031). The late George Miles believed
the style of the coins used was that of those minted in
the years 999–1000, 1007, and 1028, during the rule
of Mahmud of Ghazni, and that they were probably
struck in the mint of Nishapur. It is our opinion that
the gold disks were most probably pounced over rel-
atively new coins and therefore a dating to the first
half of the eleventh century is secure, particularly
since this is corroborated by other related pieces, in-
cluding those with dodecahedral and icosahedral ele-
ments (see nos. 20b and 20c).

There are a large number of extant bracelets in
both gold and silver that are analogous to this pair,
although none is as fine or as elaborate (Segall, 1938,
no. 225; Paris, 1977, no. 362; nos. 17 and 18 below).
The main characteristics of this group are the four
hemispheres flanking the clasp and the tapering of the
shank toward the clasp—the former being plain or
having a twisted effect; or, alternatively, a nontapered
shank is subdivided into ball-shape sections (see
no. 17).

Pre-Islamic jewelry forms can be seen in these
bracelets, indicating continued conservatism and tra-
ditionalism in the art. Examples of coins and imita-
tion coins on jewelry are quite numerous in the
Byzantine period. The twisted effect of the shank
must ultimately derive from Greek bracelets with
similar shanks. Those with shanks subdivided into
ball-shape sections must have had as their models
Roman rings and bracelets (London, 1977, nos. 171,
172; Hoffman and Davidson, 1965, no. 61b; Oberlin,
1961, nos. 2, 3, 107).

17. Silver Bracelet

Iran, 11th century
Fabricated from sheet, decorated with plain
 and twisted wire, granulation, and niello inlay
Maximum diameter 12.5 cm, height at clasp
 38.1 mm
Gift of Mr. and Mrs. Everett Birch, 1981
 (1981.232.3)

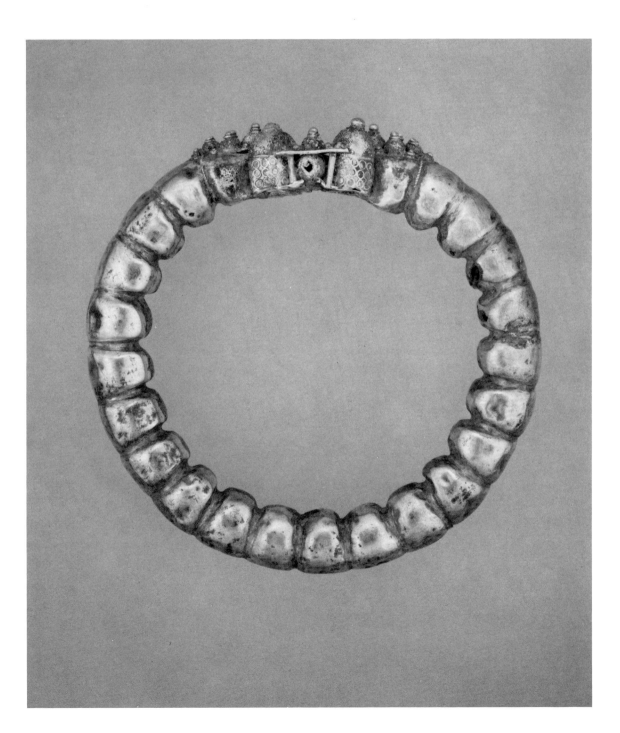

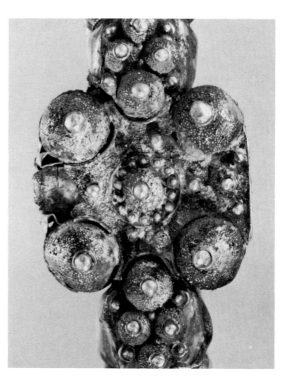

To our knowledge unique, this silver bracelet is closely related to no. 16. Not only does it share the main characteristics of the group exemplified by the Metropolitan and Freer Gallery pair, but it also incorporates many secondary features. As is typical for this group, most of the decoration is lavished on the clasp. Like no. 16, the bracelet has a rectangular clasp area with a large dome at each corner. Each dome is covered completely with granulation and surmounted by a single large shot set on a plain wire circle. Each dome is set on a high drum decorated with plain wire circles and backed with a twisted wire decoration of four circles circumscribed in a larger circle. Smaller but otherwise identical hemispheres (one of which is missing) are placed on each end of the clasp pin, between each of the large domes, on the two sections of the shank flanking the clasp, and in the center of the clasp ringed by shot, each of which is set on a plain wire circle. The entire remaining surface of the clasp is covered with granulation and highlighted with symmetrically placed shot. The stylistic device of totally covering a hemispherical surface with granulation is seen also on no. 16, as is that of a framing ring formed by shot set on a plain wire circle. The former device seems to be an exceptionally rare one in Islamic jewelry, which perhaps indicates that it is peculiar to a specific time and place (see also Segall, 1938, no. 280). The nontapering shank consists of twenty-three ball-shape sections executed in repoussé—four bearing decoration in niello inlay, two having a fish design, and two with an eight-petal rosette circumscribed in a circle.

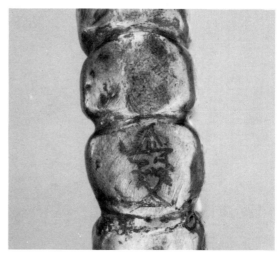

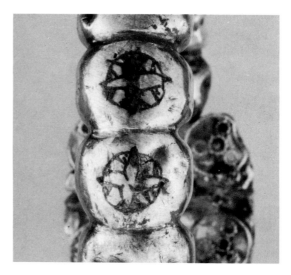

18. Silver Armlet

Eastern (?) Iran, first half 11th century
Fabricated from sheet
Width 98.4 mm
Rogers Fund, 1948 (48.98.13)

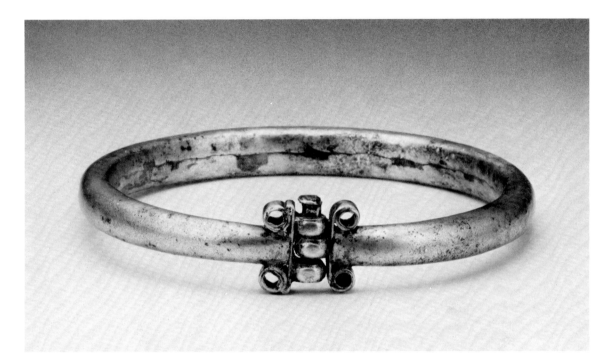

The third bracelet in the collection of the Metropolitan Museum of the general type epitomized by no. 16 is made of silver, as is no. 17.

A peculiarity of construction (shared with no. 16) so distinctive as to be considered a hallmark of the jewelry of Iran in the first half of the eleventh century is the strip of sheet (seen most clearly on the left) that perpendicularly terminates the shank, the ends then doubling back upon themselves by 180 degrees before beginning an inward spiral. It is not unusual for a strip of spiraled sheet to perpendicularly terminate an element such as a bracelet shank, but the doubling back is not known outside this period or in non-Iranian pieces.

The vogue in the eleventh century for armlets and anklets with tapered shanks and large, decorated central clasps is corroborated by illustrations in the A.D. 1009 manuscript of al-Sufi's *Book of the Fixed Stars*, now in the Bodleian Library, Oxford (Wellesz, 1959, pls. 5, 6, figs. 10, 11). A quite similar if not identical piece has been seen on the Tehran art market in recent years.

19. Silver Bracelet

Greater Iran, 11th century
Fabricated from sheet, decorated with wire and
 chased and punched design
Maximum diameter 11.4 cm
Gift of Mr. and Mrs. Everett Birch, 1981
 (1981.232.4)

Before this piece came to light medieval Islamic bracelets of this type were unknown in either silver or gold, although their existence is alluded to in several early medieval book illustrations. The early eleventh-century al-Sufi manuscript in the Bodleian Library, mentioned above, pictures Andromeda wearing a pair of such bracelets, one on each arm (Wellesz, 1959, fig. 10).

It is notable that the number of silver jewelry objects surviving from the medieval period is relatively small compared to the number of extant gold pieces, contrary to what might be expected. One may conjecture that because silver was less valuable than gold and silver jewelry less highly prized, objects of silver were more likely to be melted down when a specific jewelry design became outmoded or when there was a general shortage of silver in the community. The ratio of silver pieces to gold in the Museum's collection therefore reflects the actual ratio of extant pieces.

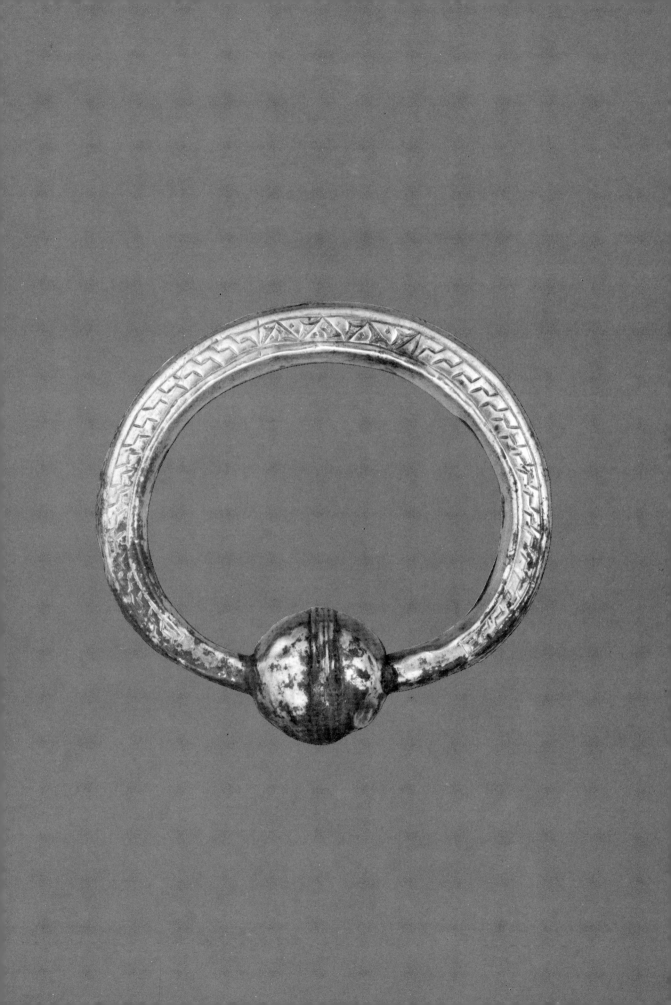

20a. Gold Earring

Iran, first half 11th century
Fabricated entirely from wire and granules
Height 36.5 mm
Purchase, Richard S. Perkins Gift, Rogers
 Fund, Louis E. and Theresa S. Seley Pur-
 chase Fund for Islamic Art, and Norbert
 Schimmel, Jack A. Josephson and Edward
 Ablat Gifts, 1979 (1979.7.4)

20b. Gold Earring

Iran, first half 11th century
Fabricated entirely from sheet, wire, and
 granules
Height 31.8 mm
Purchase, Norbert Schimmel Gift, in appre-
 ciation of Richard Ettinghausen's curator-
 ship, 1979 (1979.96)

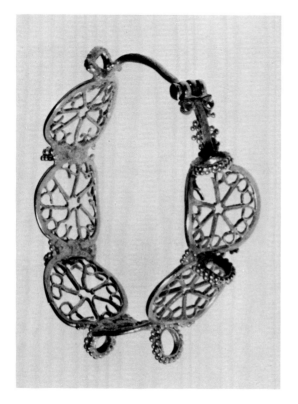

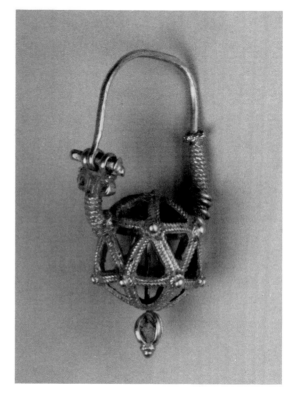

Elements with perpendicular terminations that dou-
ble back upon themselves before spiraling inward
(see nos. 16 and 18) are found on three other objects
in the Museum's collection.

The first is a single earring (no. 20a) that might
easily have been considered Byzantine and about five
hundred years older than it actually is were it not for
the termination at the clasp. Similar heart-shape ele-
ments, formed by strips of flat wire the ends of which
terminate in circles, are very common on Byzantine
gold jewelry of the sixth and seventh centuries
(Bloomington, 1973, no. 111).

The outward-projecting loops of wire, each bear-
ing two staggered rows of granules, presumably held
a string of precious or semiprecious stones and pearls
—another feature associated with Byzantine jewelry
that is quite common on early medieval Islamic jew-
elry (for MMA 17.190.1671, see Lepage, 1971,
p. 20, fig. 33).

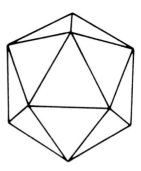

Fig. 4. Perspective drawing of the icosahedron, one
of the "Platonic" regular solids, with 20 tri-
angular faces.

20c. Pair of Gold Earrings

Iran, first half 11th century

Fabricated from sheet with applied twisted
and plain wire, hollow hemispheres and
granulation

Height 34.9 mm

Purchase, Richard S. Perkins Gift, Rogers
Fund, Louis E. and Theresa S. Seley Pur-
chase Fund for Islamic Art, and Norbert
Schimmel, Jack A. Josephson and Edward
Ablat Gifts, 1979 (1979.7.3a, b)

Fig. 5. Perspective drawing of the pentagonal do-
decahedron, one of the "Platonic" regular
solids, with 12 pentagonal faces.

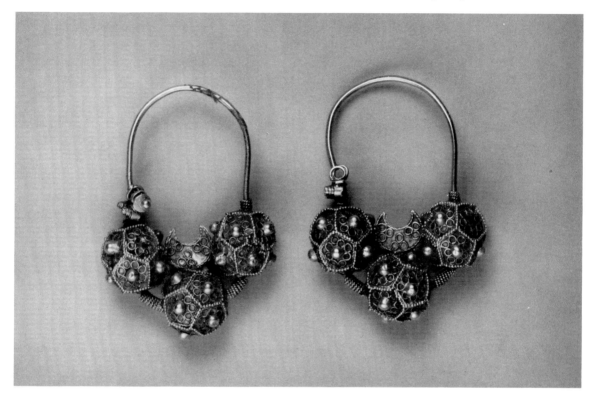

Additional indications of both the date and the
geographical origin of pieces exhibiting the peculiar
reflexive spiral termination are furnished by nos. 20b
and 20c.

In the broadest terms these earrings belong to a
varied and numerous family popular in Iran as well
as eastern Europe from about the ninth century
through the thirteenth, in which some type of hollow
gold or silver bead, usually one or three in number, is
threaded onto a heavy wire that extends around from
the clasp to form the ear wire. The present examples
are striking for the rigorous and precise rendition of
regular polyhedral forms—in the one case the icosa-
hedron (fig. 4), and in the other two the pentagonal
dodecahedron (fig. 5), proclaiming the Iranian fasci-
nation with such forms during the tenth, eleventh,
and twelfth centuries (Keene, 1981, pp. 30–38).
Both these so-called polyhedral forms are actually
illusions since they are in fact created by the strategic

placement of wires, grains, and so forth, on the sur-
face of a hollow sphere, the edges and apexes of the
polygon thus disguising a spherical form.

One other similar *à jour* icosahedral earring has
been seen on the European art market, whereas the
two dodecahedral ones are so far unique in our expe-
rience; both forms, however, are known in other Ira-
nian objects of the eleventh and/or twelfth century,
and this school of polyhedral forms is particularly in
evidence in the Nishapur material. It is therefore
likely that these earrings as well as related ones were
made at Nishapur. Keeping in mind the association
of the bracelets with the reflexive spiral terminations
(nos. 16 and 18) with eastern Iran, we are tempted to
think of this feature as indicative of eastern Iranian
manufacture. This conclusion is, however, tempered
by the fact that both the "Byzantine-style" earring
(no. 20a) and the silver bracelet (no. 18) are reported
to have come from Azerbaijan (northwestern Iran).

21a. **Pair of Gold Earrings** *(upper left)*
Greater Iran, reportedly from Gurgan,
 11th–13th century
Fabricated entirely from wire and granules
Height 39.7 mm
Rogers Fund, 1952 (52.4.5, 6)

21b. **Pair of Gold Earrings** *(upper right)*
Greater Iran, reportedly from Gurgan,
 11th–13th century
Fabricated entirely from sheet and wire;
 originally set with stones
Height 38.1 mm; 31.8 mm
Rogers Fund, 1952 (52.4.7, 8)

21c. **Pair of Gold Earrings** *(lower left)*
Greater Iran, reportedly from Gurgan,
 11th–13th century
Fabricated entirely from sheet and wire
Height 33.3 mm; 30.2 mm
Rogers Fund, 1952 (52.4.1,2)

21d. **Pair of Gold Earrings** *(lower right)*
Greater Iran, reportedly from Gurgan,
 11th–13th century
Fabricated from sheet, decorated with twisted
 wire and plain-and-twisted wire, and set
 with glazed quartz
Height 36.5 mm
Rogers Fund, 1952 (52.4.11,12)

Two of the four earrings illustrated here bear strong points of comparison with either the "dated" bracelets (no. 16 and Freer Gallery 58.6) or one or more of the earrings that are associated with them (nos. 20a, 20b, and 20c). No. 21c, which originally must have been set with a stone or a piece of glass, bears strips of flattened wire forming heart-shape elements identical to those on no. 20a. Such strips are also present on the clasp of the "dated" bracelets, where, instead of forming heart-shape elements terminating in circles, flat strips are arranged in S-shape designs terminating in circles. The cage pendant from the hoop of this earring is very similar to the one on the single earring no. 20b. The three loops at the base of the earring originally must have held pendant elements.

No. 21b, which also must have been set with a stone or a piece of glass, may be compared to no. 20c. Twisted wire cylinders between each of the three elements are found on both pairs of earrings, and the method of construction is the same: the heavy round ear wire serves also as the stringing wire for the three beads and passes through the center of each.

The relation of no. 21d to no. 21c is evident, even as regards the element that originally projected from the hoop. The stone in this case is quartz glazed to imitate turquoise. The bead at the back of the earring is very similar to the three comprising no. 21a. The latter pair, as with nos. 21b and 20c, is constructed of three beads strung on the continuous heavy ear wire and separated by a spacer—in this case a bead constructed solely of large grains.

It is often difficult to determine whether pieces of different quality but of the same general type are contemporaneous or whether the finer pieces precede or succeed those of lesser quality. We cannot, for instance, determine on which side of the datable group nos. 21a–21d fall. What can be said, however, is that there are many variations of the three-bead or three-element earring in early medieval Iran; a large number of similar earrings found in Russian excavations (in the region between the Sea of Azov and Moscow) have been dated between 1170 and 1240, mainly on the basis of associated coin hoards (e.g., Korzukhina, 1954, pls. XXXI, XXXIII, XLV, XLVIII). This evidence, together with that put forward here, suggests a date safely within the early medieval period—i.e., from the eleventh century to the thirteenth, and an origin in Greater Iran.

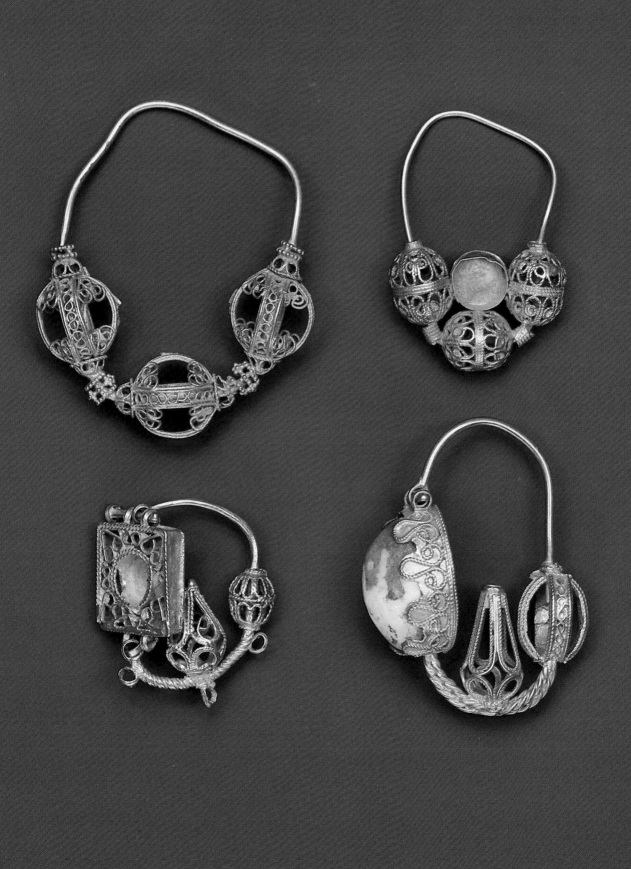

22. Pair of Gold Bracelets

Greater Iran, reportedly from Gurgan,
 11th–12th century
Fabricated from sheet and twisted wire,
 decorated with engraving
Maximum diameter 57.6 mm; 55.6 mm
Rogers Fund, 1952 (52.32.2,3)

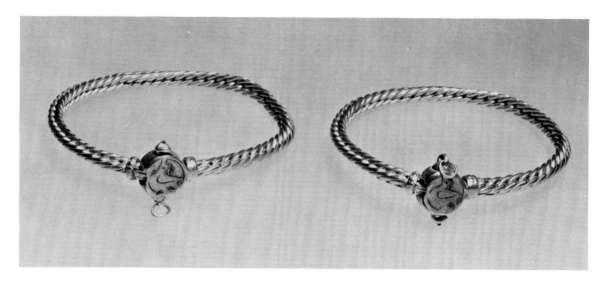

The pair of earrings set with glazed quartz in imitation of turquoise (no. 21d) incorporates a feature also seen on this pair of bracelets: four round wires twisted into a triangular configuration (see also page 145). Another bracelet in the Metropolitan (MMA 1980.541.1) is almost identical to this pair except for the configuration of its shank. Here, the stiff but flexible band serves as the shank, whereas on the earrings it forms the lower part of the hoop. Each of the tabular, box-constructed clasps bears a duck with upturned beak as its sole decoration. This provides internal evidence for the date of manufacture through a stylistic similarity to other such representations—perhaps most significantly, those on a gold bowl forming part of a hoard now in the British Museum. Supposedly found near Nihavand in western Iran, this material has been dated to the eleventh or twelfth century based on epigraphic as well as other evidence (Gray, 1938–39, pp. 73–79).

23. Three Gold Necklace Elements

Greater Iran, 11th–13th century
Fabricated solely from wire
Length of each element 90.5 mm
Purchase, Richard S. Perkins Gift, Rogers
 Fund, Louis E. and Theresa S. Seley Purchase
 Fund for Islamic Art, and Norbert Schimmel,
 Jack A. Josephson and Edward Alblat Gifts,
 1979 (1979.7.2a-c)

Early medieval jewelers were more conservative in their use of gold than in their use of time. This fact often resulted in the production of relatively large, laboriously constructed, elaborate pieces of jewelry made with very little of the most precious of metals.

The series of three hollow, flexible, gold mesh necklace elements illustrates this point very well. Athough these are, to our knowledge, unique examples of this specific structure, they constitute an important link between the ancient and the late Islamic practice of employing flexible, hollow, material-efficient structures for jewelry elements (see TA 4 and TA 5, page 145).

The original necklace was perhaps comprised of more such elements, or, alternatively, these that survived were separated by other elements of a different character—perhaps precious or semiprecious stones or pearls. The central curved element differs slightly from the other two in its use—in the borders between the hemispheres and the plaited sections—of flat wires forming S-curves terminating in circles, a feature that connects these elements to the "dated" bracelets (no. 16 and Freer Gallery 58.6).

Although this type of necklace was unknown before these elements came to light, its existence was indicated in several early medieval book illustrations (Rice, 1958, fig. 1). These illustrations do not contain sufficient detail to determine the construction of the necklaces depicted, but what is visible is consistent with the elements in question, suggesting the way in which they were used and corroborating their general time frame.

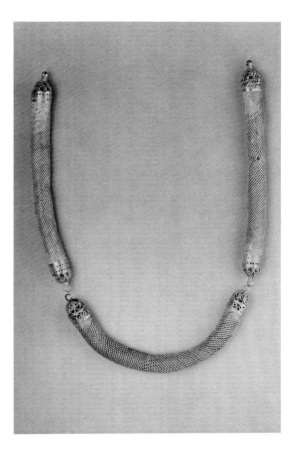

24. Gold Roundel

Iran, 11th century

Fabricated from sheet and wire and decorated
 with filigree and granulation; originally set
 with stone

Diameter 71.5 mm, maximum thickness
 5.6 mm

Ex coll.: Mrs. Christian R. Holmes

The Nasli Heeramaneck Collection, Gift of
 Alice Heeramaneck, 1980 (1980.344)

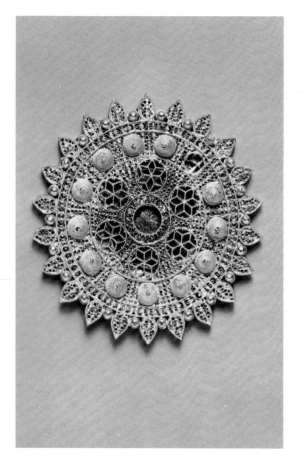 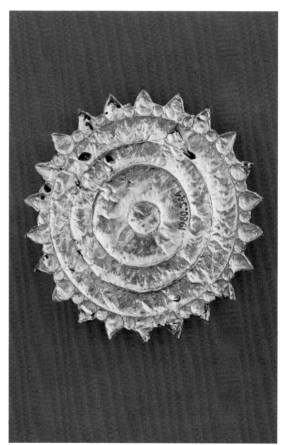

This gold roundel, like the three flexible necklace elements (no. 23), enlarges our understanding of the nature of medieval Islamic jewelry. An object of marvelous delicacy and beauty, it is important in that it combines features associated with Iran with features previously thought confined to work produced in the Syro-Egyptian region.

Most characteristically Syro-Egyptian is the filigree construction laid on a backing of narrow strips of gold. The strips in this piece, however, are very thin and arranged in a regular radial pattern, whereas in Egyptian and Syrian Fatimid pieces (see nos. 47–51d), the strips are thicker, they vary in their dimensions, and they are placed strategically to support the filigree but in such a way as to appear haphazard. Be-

cause of a denser surface in Fatimid filigree, the backing strips are less visible from the front than they are in the present piece. Another distinction is that Fatimid filigree designs are typically composed of foliate arabesques of doubled twisted wire filling variously shaped compartments, a technique that, combined with the denser surface, gives a heavier and warmer effect. There are, furthermore, no known Fatimid pieces with an element comparable to the solid sheet-constructed back or to the concentric rings of narrow sheet separating front from back.

Several features on the roundel compare closely with those on other Iranian pieces, including the S-curves terminating in circles (cf. nos. 16 and 23) and the openwork patterns of 60-degree and 120-degree

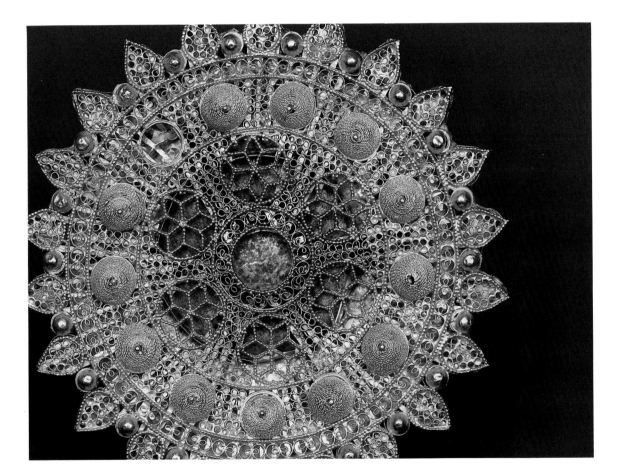

lozenges similar to those on no. 31, where the wires are six-petal rosettes of doubled plain round wires, and those on no. 32, where the structure is the same but the wires are twisted. Doubled plain round wires are also used on the present piece as the base on which the large hemispherical bosses rest.

The original function of this roundel is not known. There is a small hole (about 1 mm in diameter) laterally through each of the points bordering the perimeter through which a wire or string holding a pearl or precious-stone bead was almost certainly threaded. It is unlikely that the piece was a pendant since its design is radially symmetrical, and there is no indication of how it might have been attached; its extreme delicacy would seem to rule out its having

been attached to a belt, even a belt of cloth. Possibly it was sewn onto some article of clothing through the holes in each of its bordering points.

An identical piece, surely by the same hand, has been identified as a bracteate (Pope, 1945, pl. 31e) and dated to the Achaemenid or pre-Achaemenid period, partly because it is thought to have been excavated at Assur. The diameter of the bracteate is given as 2¼ inches (64 mm), but because of the similarity of detail in the two pieces, including even the number of S-curves in the narrow borders around the central hole and around the outside of the large wire-covered bosses, one must conclude that the pieces are identical in size as well.

25. Gold Bracelet

Greater Iran, probably 12th century
Fabricated from sheet, decorated with
 bitumen-highlighted incising, granulation,
 and repoussé, set with glazed quartz, ruby,
 garnet, and, originally, two other stones
Maximum diameter 76.2 mm
Harris Brisbane Dick Fund, 1959 (59.84)

This gold bracelet, which has a very close parallel in
the Museum of Fine Arts, Boston (65.249), incor-
porates a number of features frequently found in
early medieval Iranian jewelry that have not been
seen in the pieces dealt with thus far. It is constructed
solely of thin sheet that has been worked in repoussé,
granulated, incised, and partially highlighted with
bitumen. The shape of the clasp and shank, the con-
figuration of the granulation, and the epigraphic dec-
oration highlighted with bitumen are closely par-
alleled on a pair of bracelets shared between the
Freer Gallery of Art, Washington, D.C. (50.21),
and the Museum of Fine Arts, Boston (65.247).
This is also the first time we have seen stones
(including another glazed quartz) held in place with
the heavy claws so typical of Persian jewelry of this
period. The incised and bitumen-highlighted epi-
graphic and vegetal decoration places the bracelet
very neatly in the early medieval period, most likely
in the twelfth century.

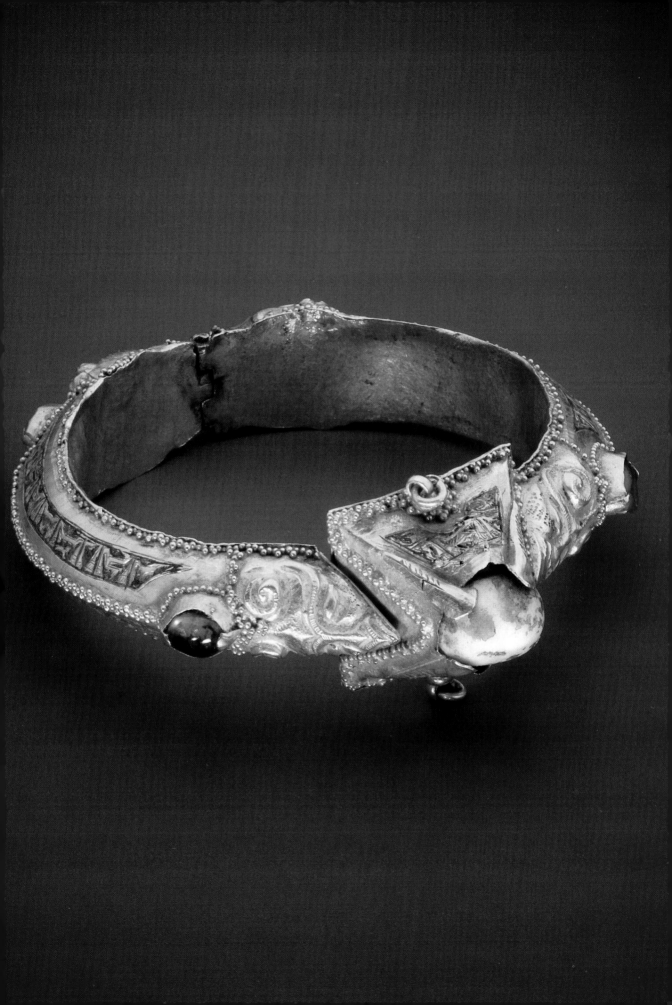

26. Gold Pendant

Greater Iran, 11th century
Fabricated from sheet, decorated with
 bitumen-highlighted incising, twisted wire,
 and granulation, set with garnets, turquoise,
 and other precious stones, probably
 tourmalines
79.4 x 47.6 mm
Purchase, Richard S. Perkins Gift, 1977
 (1977.9)

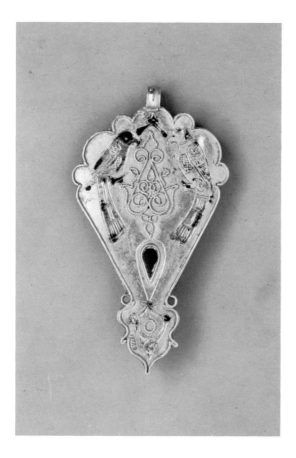

The granulated treatment of the border on the ob-
verse, the settings with heavy claws, and the incised
and bitumen-highlighted decoration of both the ob-
verse and the reverse relate this pendant to no. 25.
Another similar pendant, also in the Museum's col-
lection (MMA 1980.541.3), is less elaborate in shape
and decoration.

On the reverse of no. 26 a double twisted wire
decoration is laid on the gold sheet. This method of
decorating a plain gold surface, although not found
exclusively in Iran, was very popular in this area
during the early medieval period: it can be seen on
no. 21d, as well as on a pair of earrings found in the
Russian excavations mentioned earlier (Korzukhina,
1954, pl. LX).

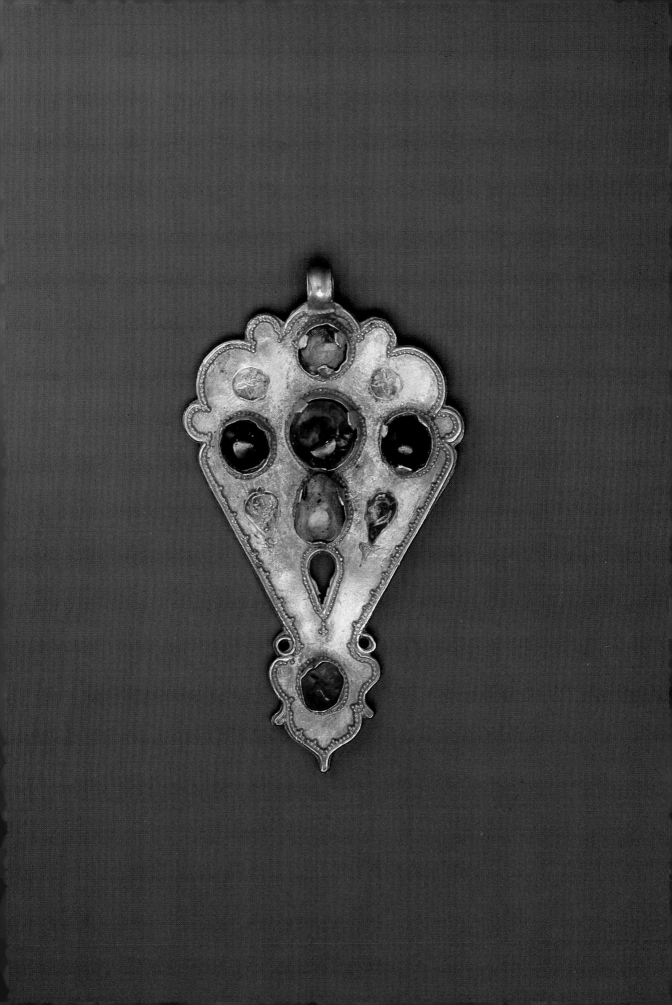

27. Three Gold Elements

Greater Iran, 12th century
Fabricated from sheet and wire, decorated with
 plain and twisted wire
26 x 26 mm; 26 x 26 mm; 33 x 20 mm
The Nasli Heeramaneck Collection, Gift of
 Alice Heeramaneck, 1980
 (1980.541.11,12,13)

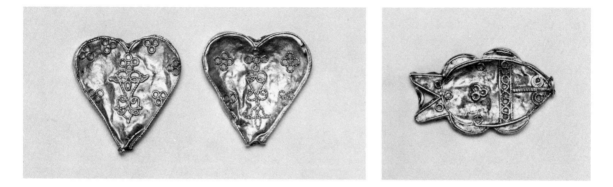

Because these heart-shape elements bear designs on both the obverse and the reverse that are very similar to the design on the reverse of pendant no. 26, and because the boxlike construction of these elements, as well as of the fish-shape element, is used also for no. 21c—an earring that is likewise decorated with twisted wire—we are confident that the present elements can be attributed to the same geographic area as the pendant and the earring.

All these elements, with two holes for stringing, must have been part of a necklace, either as one of many such elements or as necklace terminals. Only three other single, and sizable, early medieval heart-shape elements are known to us—none of them Iranian, but rather of Egyptian or Greater Syrian manufacture, and none of which functioned as an integral part of a necklace. Two are identical in size and surmount pins (L. A. Mayer Memorial Institute for Islamic Art, Jerusalem, J26), and a third, larger but very similar example bears elements pendant from chains (National Museum, Damascus, 58814). The only parallel for the fish-shape element is to be found in the five triple-fish elements reportedly from Madinat al-Zahra, Spain, now in the Walters Art Gallery, Baltimore (57.1596.1–45; Ross, 1940, p. 166; Jenkins, in press, fig. 22a, b).

28. Gold Hair Ornament

Greater Iran, 12th century

Fabricated from sheet, decorated with granulation, set with garnets and turquoise

Length 68.3 mm, diameter 7.9 mm

Purchase, Norbert Schimmel Gift, in appreciation of Richard Ettinghausen's curatorship, 1979 (1979.95)

Ornaments of circular section that slip over a lock of hair had a long history in the area covered here during the pre-Islamic era, and the use of tubular hair ornaments has survived in traditional Middle Eastern costume. This gold hair ornament, like bracelet no. 25 and pendant no. 26, is constructed essentially of gold sheet. The setting of each of the nine stones is surrounded by granulation, a feature found also on the bracelet and the pendant.

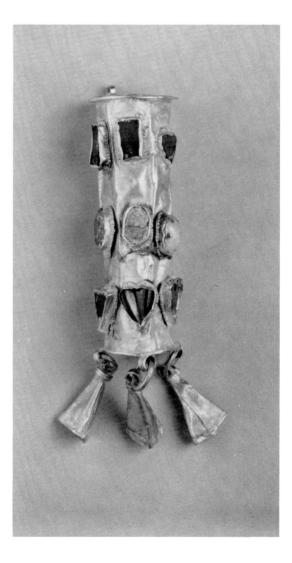

29. Gold Bracelet

Greater Iran, reportedly from Gurgan, 12th
 century
Fabricated from sheet, decorated with
 bitumen-highlighted incising, twisted wire,
 and granulation; originally set with stones
Diameter 50.8 mm
Rogers Fund, 1952 (52.32.1)

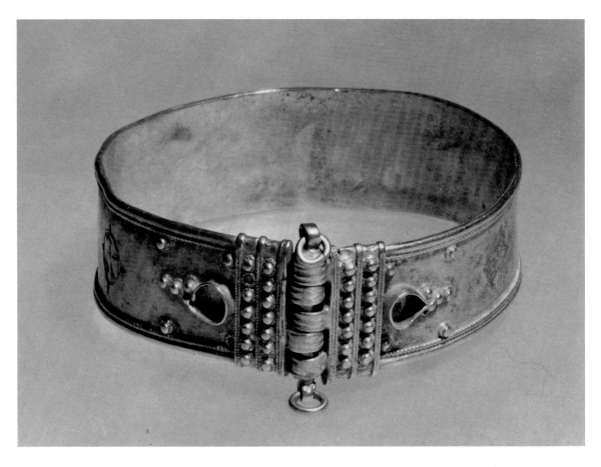

Bracelet no. 29 must certainly be grouped with nos.
25, 26, and 28 since it shares with one or more of
them the same technique of sheet construction,
incised and bitumen-highlighted designs (in this
case epigraphic), and twisted wire decoration.
Others of the type are known, including one in the
Museum (MMA 1980.541.2) with stones in settings
very similar to those on nos. 25 and 26.

30. Two Gold Elements

Greater Iran, 12th–13th century
Fabricated from sheet, decorated in pierced
 repoussé and granulation, set with glass
Length 31.8 mm
Gift of J. Pierpont Morgan, 1917
 (17.192.82,83)

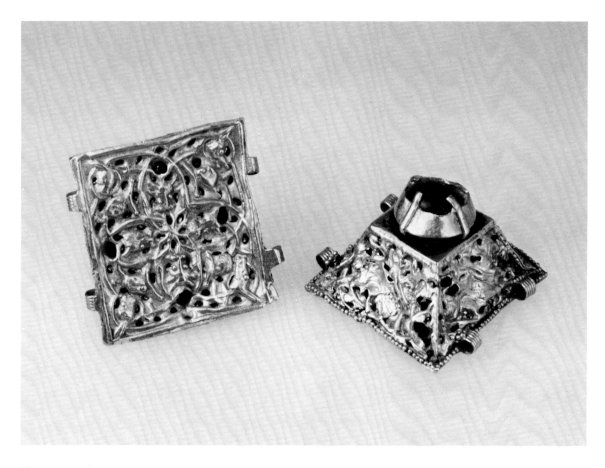

The truncated pyramidal form seen on bracelet no. 25 is also seen on these two elements that were probably part of a bracelet. On the reverse is a design of a repoussé and pierced zoomorphic arabesque (*waq-waq*). A repoussé and pierced griffin stalks on each of its four sides. The base of the obverse is outlined with a row of granules. These elements are not dissimilar in both technique and iconography to two belt fittings in the Museum für Islamische Kunst, Berlin (Berlin, 1971, no. 373).

The pair of bracelets owned by the Museum of Fine Arts, Boston, and the Freer Gallery of Art, Washington, D.C. (see page 40), bear on the reverse of their pyramidal elements similar griffins incised and highlighted with bitumen. This parallel further

strengthens the connection between the present gold elements and no. 25.

Each of the elements is set with a piece of glass, thus demonstrating that the artist was concerned with color rather than with the intrinsic value of the stone.

31. Gold Ring

Greater Iran, 12th–13th century
Cast, fabricated, and engraved
Diameter 22.2 mm, diameter of bezel 19.8 mm
Gift of Mr. and Mrs. Everett Birch, 1976
(1976.405)

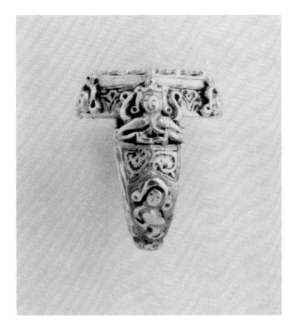 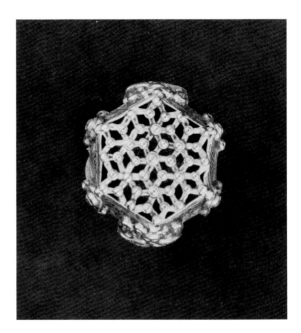

It would seem that the type of ring exemplified by no. 31 did not come into vogue in the Islamic world until the second half of the twelfth century. Once introduced, however, it enjoyed great popularity and variety. The most essential features of this ring type are a cast shank—often with anthropomorphic terminals—and a polygonal bezel. Its prototypes are to be found in Greek as well as Roman rings (Marshall, 1907, fig. 61, pl. XVI). No. 31 is a particularly fine example, with four of the six corners of the bezel decorated with human heads, the crown consisting of a repeating geometric pattern executed in openwork filigree and granulation, and the shank bearing harpies and terminating in double-bodied harpies. The three other known examples of this type are in the Metropolitan Museum (MMA 48.154.10), the L. A. Mayer Memorial Institute for Islamic Art, Jerusalem (J9468), and the Museum of Fine Arts, Boston (65.254). Although not as elaborate as the present example, many rings of a related type were found in the Russian excavations mentioned earlier, whose finds are placed between the 1170s and 1240 (e.g., Korzukhina, 1954, pls. XXXVII[3], XXXVIII[3], XLV[4]).

32. Pair of Gold Hair Ornaments with Bronze Core

Greater Iran, reportedly from Gurgan,
 12th–13th century
Fabricated from sheet, decorated with twisted
 wire and granulation, and, originally, col-
 ored cloth
Length 69.9 mm, diameter 20.63 mm: length
 73 mm, diameter 20.6 mm
Rogers Fund, 1952 (52.32.9,10)

The geometric design on these two hair ornaments, as well as its mode of execution, is identical to that on no. 31, suggesting that they date to the same period, if not to the same workshop (see also Paris, 1977, no. 360). There was originally, between the bronze core and the gold exterior of each ornament, a piece of textile that was probably brightly colored. These textiles, like the semiprecious stones on hair ornament no. 28, must have further enhanced the effect of these striking pieces when they were worn around a long, thick lock of hair. More subtle in decoration than either no. 28 or the present pair is another pair in the Metropolitan's collection (MMA 1980.541.4,5) that bears in the center of each element a repoussé design of an Arabic inscription in Naskhi script reading العزّ والاقبال ("Glory and Prosperity . . ."), bordered by lappets.

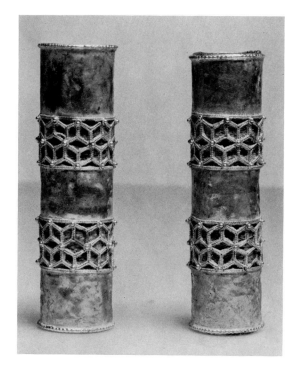

33a. Gold Ring

Greater Iran, reportedly from Gurgan,
 12th–13th century
Cast and fabricated from sheet, decorated
 with engraving, and set with carnelian
 sealstone
Diameter 22.2 mm
Rogers Fund, 1952 (52.32.5)

33b. Gold Ring

Greater Iran, reportedly from Gurgan,
 11th–12th century
Fabricated from sheet, engraved, and set
 with turquoise
Diameter 22.2 mm
Rogers Fund, 1952 (52.32.6)

33c. Gold Ring

Greater Iran, 12th century
Cast and fabricated from sheet, decorated
 with bitumen-highlighted incising, and set
 with tourmaline bead
Diameter 20 mm
The Nasli Heeramaneck Collection, Gift of
 Alice Heeramaneck, 1980 (1980.541.6)

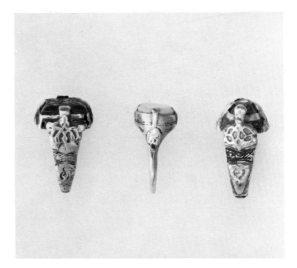

Two other medieval Iranian ring types are repre-
sented by nos. 33a–33c. The shanks of nos. 33a and
33c are not unrelated to the shank of no. 31,
although they are less elaborate (Segall, 1938, no.
306, pl. 59; Korzukhina, 1954, no. 13, pl. XXIX).
The heavy setting claws on all three rings, as well as
the style of the rectangular sealstone of no. 33a, are
further confirmations of the date and place of origin.
The conjunction of a ring and its original sealstone,
as in the latter case, is valuable in that each part helps
to provide a context for the other. This is the earliest
sealstone in the Museum's collection that bears a
cursive script, the previously discussed examples
(nos. 3a–3f) having employed various types of the
more rectilinear "Kufic" script. A particularly beau-
tiful example of this type, also with its original seal-
stone (of red jasper), is in the Walters Art Gallery,
Baltimore (57.59.6).

No. 33b, in contrast, harks back to the hollow gold
and silver rings from Nishapur (nos. 1a–1f), which
also show a development from Roman models. An
additional element here, however—as with a number
of other known hollow Persian rings of the period—
are the heavy claws so characteristic of this school.

34a. Gold Ring

Greater Iran, 11th–12th century
Fabricated from sheet, chased, and set with
 turquoise
Maximum diameter 34.1 mm
Gift of Mr. and Mrs. Everett Birch, 1981
 (1981.232.1)

34b. Gold Ring

Greater Iran, 11th–12th century
Fabricated from sheet, decorated with chas-
 ing, shot, and wire, and set with garnet
Maximum diameter 34.1 mm
Gift of Mr. and Mrs. Everett Birch, 1981
 (1981.232.2)

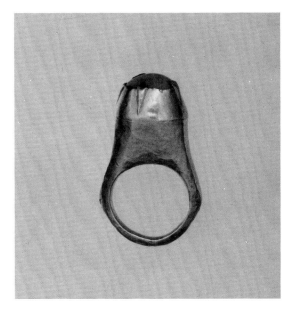

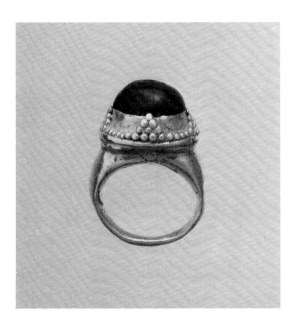

The two rings seen here represent variations on a simple but effective approach to ring design and fabrication. As with ring no. 33b, these rings hark back to early Islamic rings from Nishapur, such as nos. 1a–1f, which have been shown to have Roman antecedents.

There is no question that the hollow Seljuq ring, with its rakishly high bezel set with a turquoise held in place by heavy setting claws, grew out of rings similar to no. 1c excavated at Nishapur. Several rings similar to the present one (some with even higher bezels), including one set with a sealstone, have been seen on the New York art market in the past several years. At least two of these bear a single chased line on the upper wall of the bezel, as on ring no. 34a.

The decoration of the garnet-set ring is, to our knowledge, unique for Seljuq jewelry, but the type must have grown out of rings similar to those excavated at Nishapur. The join of the sheet-fabricated bezel to the shank is masked by a heavy gold wire that supports a row of shot which in turn supports four evenly spaced triangles, each formed of six shot; the inside of the shank beneath the bezel is decorated with a chased, stylized palmette design in what can only be called the beveled style.

35. Silver Amulet Case

Greater Iran, 11th century
Cast and decorated with gilding and niello
 inlay
31.8 x 28.6 mm
Purchase, Rogers Fund, The Friends of the
 Islamic Department Fund, and Richard
 Ettinghausen and Edward Ablat Gifts,
 1978 (1978.415)

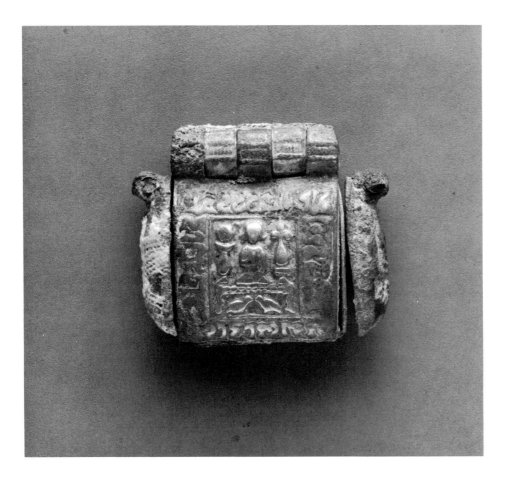

This cast amulet case is one of the few early medieval Iranian objects in the Museum's jewelry collection executed in silver. The scene on both sides (and its less complete version on the two removable end pieces) of a ruler, drinking and seated cross-legged on a throne with zoomorphic legs, flanked by vases or carafes, and with two birds beneath his throne, is typical for Persian iconography of the period. The style of the Kufic inscription that frames both scenes also conforms to such an attribution.

Gilded and bearing niello inlay, this is one of the few early medieval amulet cases preserved in public collections. There are six other extant examples with niello inlay (Pinder-Wilson, 1962, 1–2, pp. 32–34). No. 35 has the unique feature of a hinged opening as opposed to a sleeve opening held in place by friction. The purpose of this feature is generally thought to be for the insertion of a written charm, such as verses from the Koran. However, the presence in at least one case of cotton wool inside the amulet suggests that one of its functions may have been to contain scent. We know of scented necklaces in the ninth century from a passage in paragraph twenty-two of the "Chapter of the Gifts" in Al-Qadi al-Rashid ibn Zubayr's *Book of Treasures and Gifts*.

36a. Cast Bronze Belt Fitting

Greater Iran, 12th–13th century
33.3 x 39.7 mm
Purchase, Mr. and Mrs. Jerome A. Straka
 Gift, 1979 (1979.133)

36b. Cast and Gilded Bronze Belt Fitting

Greater Iran, 12th–13th century
28.6 x 42.9 mm
Gift of Arthur Jaffe, 1976 (1976.159.2)

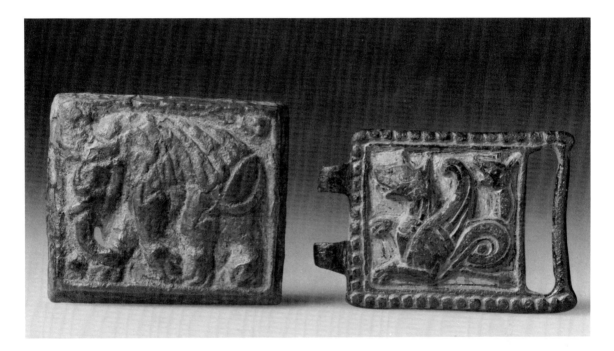

These two cast bronze fittings from early medieval
Iran represent a continuation of the type of fitting
excavated at Nishapur (see no. 14). No. 36a was
originally attached to a belt strap or to an animal
trapping. No. 36b, which is partially gilded, is an
element from a belt buckle and bears a motif of pre-
Islamic origin—that of a Senmurv. We know of only
one other example of a fitting of this particular shape
(*Collection Hélène Stathatos*, vol. 4, 1971, no. 440,
pl. X).

The objects already discussed in this chapter were made in Greater Iran. Before proceeding to the second anchor point of early medieval jewelry manufacture—in the western as opposed to the more eastern regions of the Islamic world—let us take up objects whose origin appears to be somewhere in the intervening area.

37. Gold Bracelet

Origin unknown, 12th century

Fabricated from sheet and twisted wire, decorated with twisted and plain wire, granulation, and bitumen-highlighted incising

Maximum diameter 63.5 mm

Fletcher Fund, 1976 (1976.151)

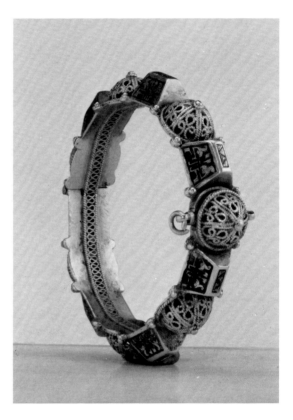

This gold bracelet bears a number of features found on Iranian objects. The filigree hemispheres are composed of a twisted wire design identical to that on the beads of earrings no. 21b and at the junctures of the ribs of no. 21a. It is identical even in the extra circle of twisted wire that is added to form a three-petal leaf within the heart-shape area. Such hemispheres are not, however, peculiar to Iran. They form spacer beads found in Syria (National Museum, Damascus, 30534) and in Caesarea (Jenkins and Keene, 1982, fig. 15); they are also found on the pair of bracelets shared by the Freer Gallery of Art, Washington, D.C., and the National Museum, Damascus (ibid., fig. 16a; Damascus, 1969, fig. 116). The truncated pyramidal units with which the filigree hemispheres alternate bear a pseudo-Kufic incised and bitumen-highlighted decoration not unlike that seen on several previously

38. Silver Pendant

Origin unknown, 12th–13th century
Cast and decorated with gilding and niello inlay
63.3 x 44.5 mm (maximum)
Rogers Fund, 1971 (1971.28)

discussed Iranian objects. However, none of the earlier mentioned pyramidal elements is elongated.

The manner of clasping is paralleled on an unquestionably Iranian pair of bracelets on the European art market about 1978, but the clasp is not distinguished from the rest of the bracelet as is usually the case in early medieval Iran. The interior of the shank is treated in an uncommonly decorative way, with a motif seen on a number of pieces found in Syria (e.g., National Museum, Damascus, 1055/4). It remains uncertain whether this bracelet is the product of early medieval Anatolia or of another area on the periphery of Iran, or whether it is an Iranian bracelet of a type that has not yet been isolated.

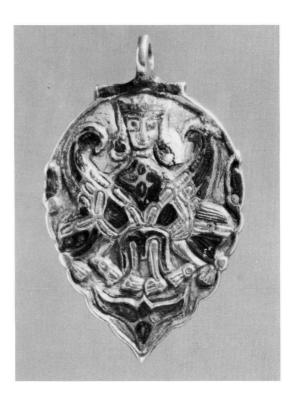

A place of manufacture somewhere to the west of Iran seems probable for this gilded and niello-decorated cast silver pendant. Although the motif of the double-bodied sphinx is related to the fantastic creatures on the cast Persian ring no. 31, the handling of the motif seems more Turkic in character, suggesting that this may be a product of al-Jazira (Upper Mesopotamia) or of Anatolia rather than of Iran.

39a. Pair of Gold Earrings

Origin unknown, 11th–13th century
Fabricated from sheet, decorated with
 twisted wire and granulation
Height 19 mm
Rogers Fund, 1935 (35.29.5,6)

39b. Pair of Gold Earrings

Origin unknown, 11th–13th century
Fabricated from sheet, pierced and decorated
 with twisted wire and granulation
Height 28.6 mm
Rogers Fund, 1970 (1970.70.1,2)

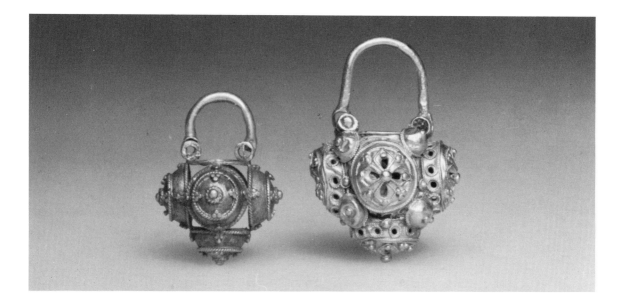

There are in the Museum two pairs of earrings and two single earrings that exemplify the so-called basket type. Each of the two pairs is constructed of five hemispheres decorated with twisted wire and granulation; each hemisphere bears four groups of three grains and is surmounted by a single grain on a twisted wire circle. The top of each earring is strengthened by means of a wide, flat ring of gold to which is attached the ear wire. The larger pair (no. 39b) bears the more complex decoration, with areas of the design pierced as on the truncated pyramidal element (no. 30), and the interstices between the large hemispheres bearing smaller versions of the same form.

The two single earrings are variations of the same type. No. 39c incorporates one small and three large hemispheres with three interstitial areas bearing the heart-shape element fashioned of flat wire seen on earrings 20a and 21c. No. 39d incorporates three hemispheres (with the same, now flattened crenelation as on no. 39c) that, together with the interstitial areas, are formed of filigree imbrication.

A number of facts pertinent to the place of origin of these earrings may here be enumerated since the basket type is usually designated as Byzantine and is assigned dates ranging from the sixth century to the eleventh. On the one hand, two other pairs of earrings (Jenkins and Keene, 1982, fig. 9; New York art market) that were undoubtedly manufactured in early medieval Iran are constructed in a way very similar to nos. 39a and 39b, including even the wide, flat ring of gold at the top; on the other, earrings found in Syria also have a similar configuration (Ross, 1978, fig. 44), have pierced decoration (National Museum, Damascus, 5882), and make structural and practical use of a wide, flat ring at the top (Ross, 1978, fig. 46). The use of small hemispheres as interstitial decoration occurs on basket earrings found in Syria as well as on those found in Iran (*Collection Hélène Stathatos*, vol. 4, 1971, p. 66, pl. XV; New York and European art markets). Further indication of the spreading of the type is an earring found in Egypt having the same crenelated edge consisting of a contiguous series of three grains as seen on nos. 39c and 39d, as well as a wide, flat ring at the top (Museum of Islamic Art, Cairo, 13280). Another earring (from Egypt) is identical to no. 39d except that the walls are formed of S-curves rather than imbrication (Museum of Islamic Art, Cairo, 1329). Another earring of this type is constructed in

39c. Gold Earring

Origin unknown, 11th–13th century
Fabricated from sheet, decorated with
 granulation, twisted and plain wire
Height 15.9 mm
The Cesnola Collection, Purchased by
 subscription, 1874–1876 (74.51.3607)

39d. Gold Earring

Origin unknown, 11th–13th century
Fabricated from wire and granules, deco-
 rated with sheet
Height 25.4 mm
Gift of J. Pierpont Morgan, 1917 (17.192.97)

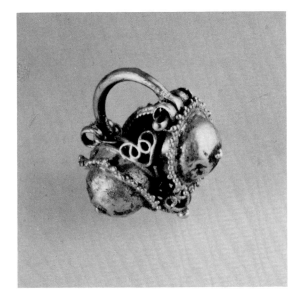

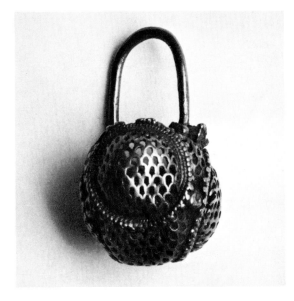

the classical Fatimid (Egyptian or Syrian) style and
technique of twisted wire filigree surmounted by a
tracery of fine granulation (Cleveland Museum of
Art, 48.21). In addition, there is a group of earrings
that show the amalgamation of the shape and imbri-
cation of no. 39d, with the typical Fatimid style and
granulated filigree technique (Segall, 1938, no. 251;
Museum of Islamic Art, Cairo, 13280).

On the basis of this information, it is clear that the
precise provenance of these earrings must remain an
open question, and the possibility must be entertained
that there was an international style in certain objects,
and that in the early medieval period the basket type
of earring in its many variations enjoyed a vogue
from Egypt to Iran.

It should be pointed out that during practically the
entire period in question (c. 1000–1258), Baghdad
was the capital of the Abbasid caliphate, as indeed it
had been since the mid-eighth century A.D. Although
the political unity of the empire had already broken
down by the beginning of the eleventh century,
Baghdad was still cultural capital *par excellence* of
the Islamic world, and many of its fashions were
emulated in the provinces. Thus, unless Iraq im-
ported all its jewelry, which seems highly unlikely,

we still must find or isolate this group, which may
very well have included some of the best pieces made
during the period and which could have given rise to
any number of provincial copies. This may in fact
account for the existence of what we have termed an
international style.

40. Pair of Gold Earrings

Probably Iran, 11th century
Fabricated from wire and sheet, decorated
 with granulation; originally outlined with
 strung pearls and/or stones
31.8 x 42.9 mm
The Nasli Heeramaneck Collection, Gift of
 Alice Heeramaneck, 1980 (1980.541.9,10)

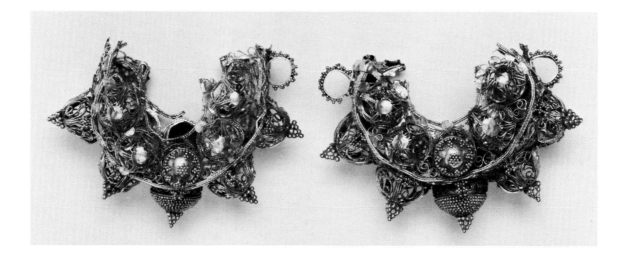

This pair of earrings incorporates a number of
features that relate them very closely to nos. 39a–39d.
The interstitial areas on the side walls, as well as the
interstitial areas along the lower edge of each of the
faces, bear the same heart-shape element fashioned
of flat wire seen on no. 39c. The sheet-constructed
hemisphere in the center of each face bears a deco-
ration of granulation very similar to that on the
five hemispheres of no. 39a. The pierced drum of the
hemisphere in the middle of the side walls is anal-
ogous to those on no. 39b.

The closest parallel to the present earrings is a pair
in the National Museum, Damascus (5929), which
also shares with them a peculiarity of construction.
The individual sections of the filigree hemispheres
are formed by means of a single wire worked into a
kind of figure eight, the upper part of which is smaller
than the lower. The wire and granulation work on
the Damascus pair, however, is much less elaborate.

As with nos. 39a–39d, the precise provenance of
the pair under discussion must remain an open ques-
tion, for not only do they have parallels with the
pair in Damascus, but the borders of the side walls
consist of flat wires forming S-curves that terminate
in circles similar to those on armlet no. 16 and the
three necklace elements no. 23 attributed to Iran.

Another feature relating this pair to Iranian pieces
is the central hemisphere on the side walls with its

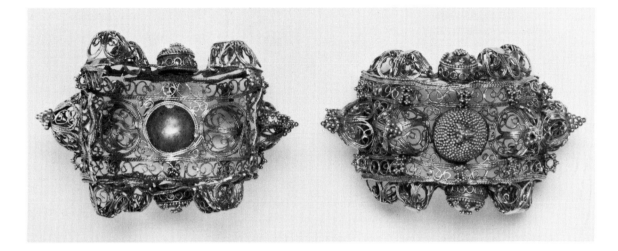

close-packed covering of grains very much in the
manner of those on armlet no. 16. Also favoring an
Iranian origin for these exquisite earrings is the
prominence and sophistication of the openwork
stacked-grain structures. The loops for an outlining
of small pearls or stones compare quite closely with
the spacers on earring no. 21a. The sixteen-grain
openwork pyramids that surmount the hemispheres
around the periphery are quite unusual in medieval
Islamic pieces but represent the continuation of an
Iranian tradition that was approximately two thou-
sand years old at the time these were made; examples
with features closely related to both the ring-shape
and the pyramidal elements were still being made in
Greater Iran in the nineteenth century, as evidenced
by Bukharan and Qajar examples (see also no. 71).
An earring of the late second or first millennium B.C.
from Marlik in the Archaeological Museum, Tehran
(7955), has a pyramid configuration of sixteen shot
used as downward-pointing termination identical to
that seen here. Otherwise the style of the earrings is
of course entirely different.

41. Two Gold Earrings

Origin unknown, 11th–13th century

Fabricated from sheet and wire, decorated with
 twisted wire, sheet-constructed hemispheres,
 and granulation

22.2 x 34.9 mm; 27 x 34.9 mm

The Nasli Heeramaneck Collection, Gift of
 Alice Heeramaneck, 1980 (1980.541.7,8)

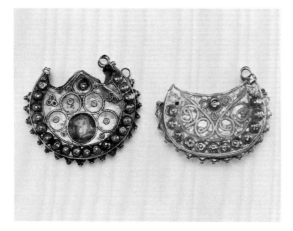 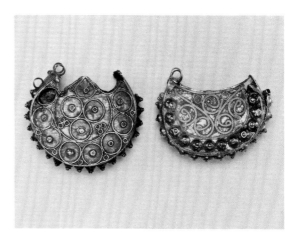

These two earrings appear to have been manufac-
tured somewhere to the west of Iran and to the east
of Egypt. Although their shapes and decorative hem-
ispheres are paralleled in several earrings in the col-
lection that are attributed to either Greater Syria or
Egypt (see nos. 48, 50a, 50b, and 51a), the boxlike
configuration constructed of sheet (as opposed to
wire with a strip support—i.e., openwork filigree) is
more typical of Iran than of Egypt or Syria, espe-
cially as here combined with twisted-wire decoration.
What appears to be the mate to the earring at the
right is in the Museum of Fine Arts, Boston, and very
close comparisons to both earrings are found in a
single earring in the Iraq Museum, Baghdad ('Umar
al-'Ali, 1974, fig. 11) and in a pair in the National
Museum, Damascus (5930, 5931).

42. Four Gold Elements

Origin unknown, 11th–12th century
Fabricated from sheet, decorated in repoussé
 with plain and twisted wire and sheet-
 constructed hemisphere
Length of teardrop-shape elements 40 mm;
 diameter of dome-shape elements 19 mm
The Nasli Heeramaneck Collection, Gift of
 Alice Heeramaneck, 1980
 (1980.541.14,15,16,17)

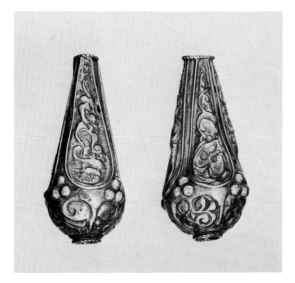

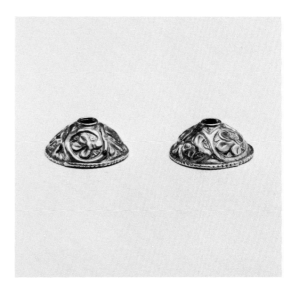

These four elements are to our knowledge unique, re-poussé decoration not having been employed on any other extant teardrop-shape elements, and the dome shape being unknown in any guise.

As was the case with the heart-shape elements in no. 27, one cannot determine whether these teardrop-shape elements were used as necklace terminals or whether there were many such elements in a particu-lar necklace. Only a few early Islamic objects bear elements of this type. Eighteen such elements on two objects in the Benaki Museum, Athens, are sheet constructed and decorated with granulation, and six other elements on the same two objects are similarly constructed and decorated with wire (Segall, 1938, figs. 278, 282), as is another in the Metropolitan (MMA 1980.541.18) which is very similar to one in the Museum of Fine Arts, Boston. A necklace in the National Museum, Damascus (3976), bears twelve teardrop-shape elements whose upper sections are sheet constructed and decorated with wire and whose lower sections are executed solely in filigree.

The dome-shape elements are, as we have said, unique and were presumably used as caps circum-scribing a stone bead. It is impossible to know whether these belonged to the same necklace as the teardrop-shape elements.

The style of the single Arabic word العزّ ("glory") in Naskhi script on one of the two teardrop-shape elements places them either in the eleventh century or in the twelfth, but their exact provenance and that of the two dome-shape elements is unknown.

43. Pair of Gold Earrings

Origin unknown, 11th–12th century
Fabricated entirely from wire (excluding
 enamel cup), set with cloisonné enamels
25.4 x 25.4 mm
Purchase, Gifts in memory of Richard Etting-
 hausen and Harris Brisbane Dick Fund,
 1979 (1979.278.1a,b)

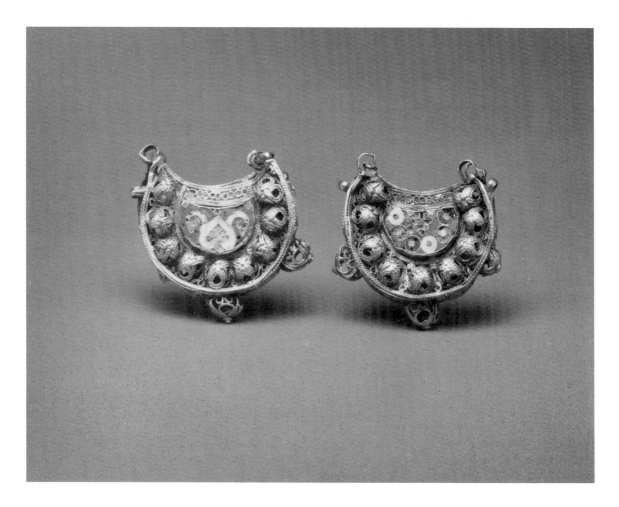

Another pair of earrings that appears to stand com-
pletely alone among extant early medieval jewelry is
illustrated here. At first glance they seem to fit very
neatly into a Fatimid Egyptian context, the shape and
layout of the *hilāl*, or crescent-shape, filigree, box-
constructed earrings being typically Fatimid. But the
method of construction employed in forming the fili-
gree hemispheres on the obverse and reverse is totally
unknown on other Islamic jewelry, and the enamels
(found here uniquely on both the obverse and re-
verse) are closer to those from southern Russia than
to those from Egypt (Korzukhina, 1954, XLIV).
Even the hemispheres on the edge, which initially

appear to be identical to those on nos. 21a and 21b
and on bracelet no. 37, exhibit a variation. Here, the
extra circle is very large so that the resulting three-
petal leaf is top-heavy.

44. Gold Bracelet

Greater Syria, 11th–12th century

Fabricated from sheet, pierced and decorated with punches, granulation, and repoussé, set with turquoise

Diameter 73 mm

Purchase, Richard S. Perkins Gift, Rogers Fund, Louis E. and Theresa S. Seley Purchase Fund for Islamic Art, and Norbert Schimmel, Jack A. Josephson and Edward Ablat Gifts, 1979 (1979.7.1)

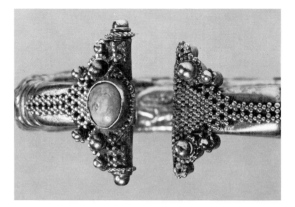

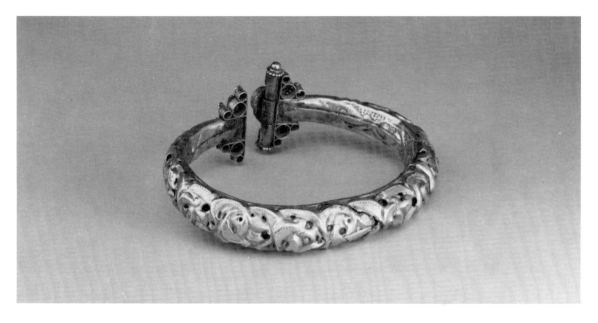

No. 44 shows a stylistic dependence on the type of hollow Iranian bracelet exemplified by the "dated" example seen earlier (no. 16); in addition, it incorporates several features found on other Iranian objects. The setting cup, for instance, is similar to those on the gold hair ornament no. 28; and some of the bracelets in the same group as no. 44 exhibit variations of the type of twisted wire shank seen on the pair of Iranian bracelets no. 22. However, it bears so many parallels to early medieval bracelets found in Syria that we feel more inclined to attribute it to that country.

The general similarities of this hollow, tapered, repoussé-decorated shank to that of no. 16 are obvious. The intricacy of the shank design, however, is unknown on early medieval Iranian hollow bracelets, whereas such shanks are quite common on hollow bracelets from Syria. Although none of the latter has the specific design found on the Museum's bracelet, some of them—including no. 45—share the same feature of outlining the decoration with punches, although there does not appear to be any piercing (National Museum, Damascus, 2842/4; Jenkins and Keene, 1982, fig. 16a; Damascus, 1969, fig. 11b; Paris, 1977, no. 359; Berlin, 1971, no. 157). The

precision and grace of the floral design on the shank of no. 44 make it stand out among all repoussé-worked medieval examples.

Another feature unknown on Iranian bracelets but often found on early medieval Syrian bracelets is the type of clasp construction, best seen from the back. Three cylinders, two small and one large, flank the ends of the shank and support at their tops three shot, which are in turn surrounded by granules. The same arrangement is found on several other bracelets (Damascus, 1969, fig. 119; *Collection Hélène Stathatos*, vol. 4, 1971, pp. 73–74, pl. XI; European art market, about 1978). The cylinders support either three hemispheres as on an example in the National Museum, Damascus (Damascus, 1969, 2799/4), or a combination of shot, hemispheres, and stones (ibid., 2800/4). Usually accompanying such an arrangement as seen here is a set stone that straddles the hinge (ibid., fig. 119). The arrangement of the granules on either side of the hinge is very closely paralleled on objects of Syrian as well as Iranian origin (Jenkins and Keene, 1982, fig. 15, see blimp-shape beads; European art market, about 1978).

45. Gold Armlet

Greater Syria, 11th–12th century
Fabricated from sheet, decorated with punches,
 granulation, twisted wire, and repoussé;
 originally set with stones
Diameter 10 cm
Harris Brisbane Dick Fund, 1958 (58.37)

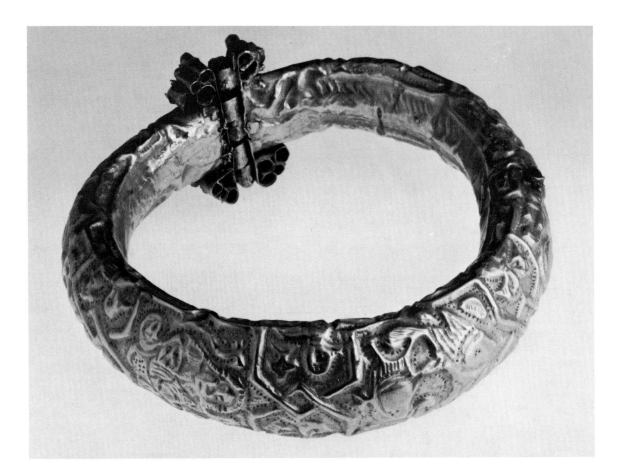

This gold armlet, although not as fine as no. 44, shares many features with it. It has a tapered shank whose repoussé design is outlined with punches; and it has the same clasp construction.

Parallels to this armlet render further support for its attribution and that of no. 44 to Greater Syria. In addition to the close correlation between the clasp on this piece (here supporting a hemisphere, shot, and, originally, two stones) and those of a number of bracelets probably of Syrian manufacture, the exact mate to this armlet is in the National Museum, Damascus (2842/4). Finally, one of another pair of bracelets (Musée du Louvre, Paris; Museum für Islamische Kunst, Berlin), which has a number of features in common with the armlet under discussion

—although it differs in that the peopled cartouche design is vertically oriented, the whole background is punched, and the clasp is not the same—came from the de Clercq Collection, which furnishes additional support for a Syrian attribution for the group (Paris, 1977, no. 359; Berlin, 1971, no. 157).

Perhaps the most significant indication of the date is the striking similarity between the style and the iconography exhibited on the shank and those found on Fatimid woodwork of the mid-eleventh century (Jenkins, 1972). Once again, there is a Roman antecedent for this type of bracelet, which bears repoussé human heads, hares, and birds in a diaper pattern (Lepage, 1971, figs. 9, 10).

46. Pair of Gold Earrings

Iraq, 11th–13th century
Fabricated from wire, decorated with granulation and sheet-constructed hemispheres; originally set with stones
28.6 x 22.2 mm
Rogers Fund, 1939 (39.157.1,2)

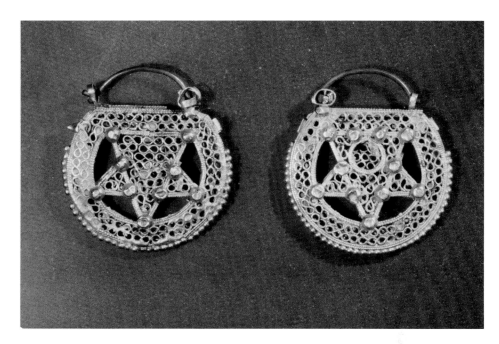

These gold earrings, whose cross section (bulging at the center and tapering to a point at the edges) is reminiscent of a type of twelfth-century Kievan earring (e.g., MMA 17.190.679, 680, 699, 707), belongs to a rare group of which only one other pair and a single earring, both in the Iraq Museum, Baghdad, are known (for the latter see 'Umar al-'Ali, 1974, fig. 8). Fortunately, the provenance of these three earrings is known, all having been found in Mesopotamia; so perhaps we are safe in assuming that Iraq is the country of origin of no. 46.

Another indication of Iraqi origin is a second pair of earrings in the Museum's collection (MMA 95.16.2,3) that, according to the dealer from whom they were purchased in 1895, were found in al-Hillah, Iraq. Although these are constructed of sheet decorated with wire, they share with the present pair their overall outline including the peculiar truncated six-point star motif, with its setting cup on the obverse.

Historically, the most pivotal pieces for the study of early medieval jewelry in the western reaches of the Islamic world are those that were discovered with eighty-two gold coins in an earthenware jar in Tunisia about fifty years ago (Marçais and Poinssot, 1952, vol. 11, fasc. 2, pp. 467–93).

Each of the coins bears the name of one of three Fatimid caliphs who ruled from Cairo, and dates to between 1003–4 and 1044–45. All but nine of the coins were minted in the Fatimid province of Ifriqiya (present-day Tunisia), and seventy percent were dated between 1038–39 and 1044–45. Marçais and Poinssot are of the opinion that the treasure was constituted in Ifriqiya and must have been buried in the summer of 1045.

Whatever the circumstances of the burial, one must assume that the latest coins can be taken as a *terminus ante quem* for the jewelry; and as all of the latter are related in construction techniques and/or iconographical motifs, one must assume that all the jewelry pieces are of more or less contemporaneous manufacture. It also seems quite likely that the jewelry and the majority of the coins must be closely related in time. While we cannot be certain whether the jewelry was made in Ifriqiya or Egypt, the fact that we know from Geniza documents (writings found in an ancient storeroom of the Synagogue of the Palestinians in Fustat, a city founded in the seventh century just south of present-day Cairo) that in the 1030s the Zirid royal family (specifically, the mother of the Fatimid caliph al-Mu'izz) imported jewels from Egypt to Tunisia makes an Egyptian origin a strong possibility (Stillman, 1973, part 1, p. 57, table 8). Thus the two bracelets, three earrings, six triangular elements, and beads found in the earthenware jar should be seen as products of the Fatimid period from before the end of the year 1045 and very likely made in Egypt.

One of the present authors has previously delineated several features characteristic of this jewelry, thus permitting a considerable broadening of the group. She has also isolated a number of subtypes using the hoard material as the point of reference and based on Marc Rosenberg's theory of the "battle of granulation and filigree" (Rosenberg, 1918, pp. 96–103; Jenkins, in press). This theory suggests a historical progression that proceeds from those pieces on which granulation consisting of grains of more than one size (most often surmounting paired twisted wires) was the dominant decorative device to those on which grains are still present on the wires but where the granulation and filigree could be said to be of equal decorative importance. Another, presumably later subtype incorporates only a small amount of granulation; and the final phase is represented by pieces that show the complete displacement of granulation by filigree. The fourteen pieces of jewelry from the Ifriqiyan hoard that are pertinent to this discussion bear no granulation, their decoration being effected solely in filigree. As such, they are

representative of Rosenberg's "last phase," in which he saw the final victory of filigree over granulation. The close similarity among the objects comprising the various subgroups makes it highly likely either that the "battle" was a quick one (at least in the case of the Fatimid school) or that the subtypes do not represent a historical progression at all, but rather different workshops.

On the basis of the arguments put forward in the Jenkins article and the earlier French work, it seems probable that nos. 47–51e (as well as many others closely related to them) were all produced in a relatively short period of time around the year 1045.

47. Gold Pendant

Egypt, 11th century
Fabricated from wire and strips of sheet, set with cloisonné enamel and turquoise; originally outlined with strung pearls and/or stones
44.5 x 34.9 mm
Bequest of Theodore M. Davis, 1915
(30.95.37)

There is one Fatimid filigree-constructed object in the Museum's collection that, like the hoard material, bears no granulation. Executed solely in filigree with a cloisonné inset, this pendant exhibits a number of other features found in the pieces from the Tunisian find, namely a boxlike construction, crescent shape, gold stringing loops (here made of fused coiled wire), openwork design with a strip support (see TA 6, page 145), S-curve filler elements, and paired twisted wires. The likelihood, therefore, is that this object must be closely contemporary with the objects found in the earthenware jar.

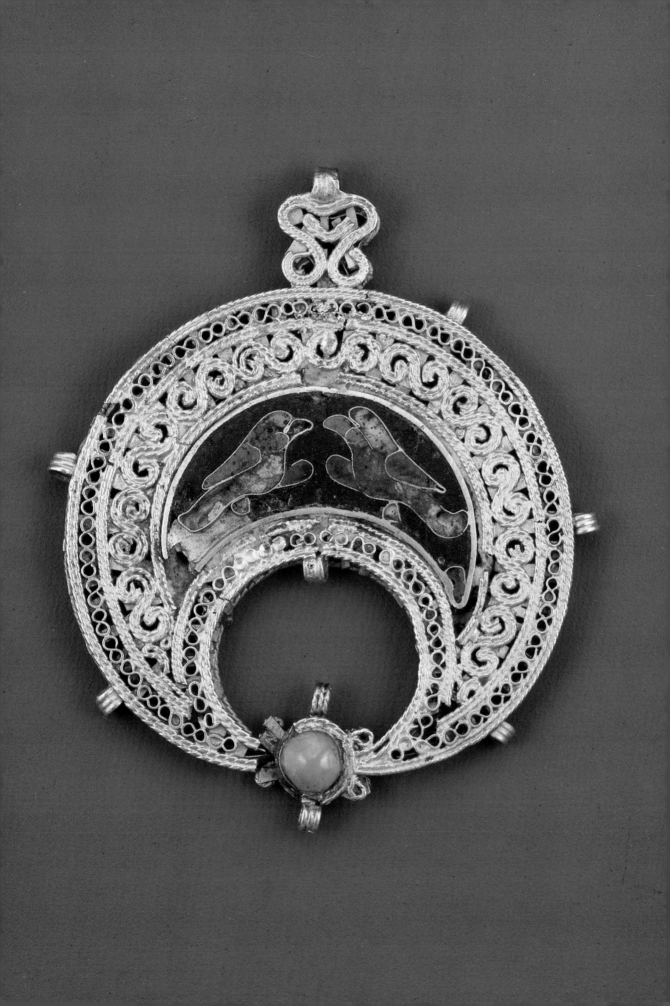

48. Pair of Gold Earrings

Egypt, 11th century

Fabricated from wire and strips of sheet, deco-
rated with granulation; originally outlined
with strung pearls and/or stones

41.3 x 27 mm

Bequest of Theodore M. Davis, 1915
(30.95.38,39)

This pair of earrings bears decoration that incorpo-
rates some shot and therefore represents a phase
slightly different from that represented by the objects
from the Tunisian hoard and pendant no. 47.

In addition to the boxlike construction, crescent
shape, gold stringing loops (here also of fused coiled
wire), openwork decoration with a strip support,
S-curves, paired twisted wires, and an arabesque
design incorporating the same trilobed floral motif
seen on the beads in the hoard, we find hemispheres
decorated with a granule soldered to a circle of
twisted wire, also found on a pair of earrings in
the Tunisian hoard.

49a. Gold Pendant

Egypt, 11th century

Fabricated from wire and strips of sheet,
 decorated with granulation; originally set
 with cloisonné enamel (on obverse) and
 outlined with strung pearls and/or stones

Height 31.8 mm

The Friends of the Islamic Department Fund,
 1974 (1974.22)

49b. Gold Ring

Egypt, 11th century

Fabricated from wire and sheet, decorated
 with granulation

Maximum diameter 23 mm

Gift of Mr. and Mrs. John J. Klejman, 1971
 (1971.165)

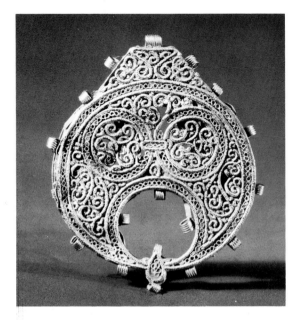

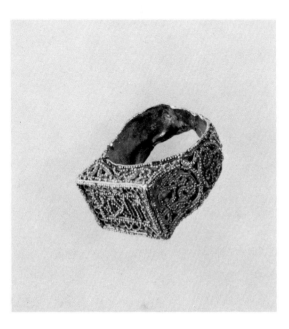

Another subtype, exemplified by this pendant and
ring, is formed by those objects on which the granules
are placed on paired wires in such a way that the
filigree and granulation could be said to be on equal
footing. All of the essential elements incorporated in
these objects, with the exception of the prominence
of the granulation seen here, have been met with
before. The strip support can be seen very clearly in
the illustration of the obverse (see TA 6, page 145),
where the original cloisonné inset has fallen out.

50a. Electrum Earring

Egypt, 11th century
Fabricated from wire and sheet, decorated
 with granulation; originally outlined with
 strung pearl and/or stones
34.9 x 19 mm
Purchase, The Louis E. and Theresa Seley
 Foundation, Inc. Gift, 1979 (1979.289a,b)

50b. Pair of Gold Earrings

Egypt, 11th century
Fabricated from wire and sheet, decorated
 with granulation; originally outlined with
 strung pearls and/or stones
34.9 x 30.2 mm
Purchase, The Seley Foundation, Inc., Jack
 A. Josephson, Mr. and Mrs. Jerome A.
 Straka and Edward Ablat Gifts, and
 Rogers Fund, 1978 (1978.142.1,2)

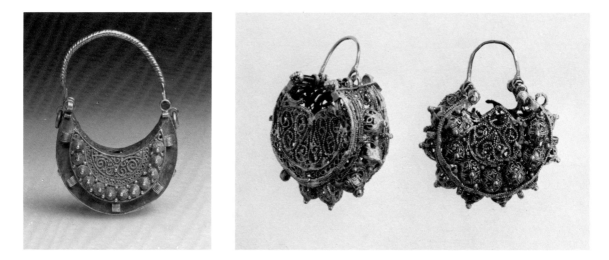

On the electrum earring and pair of gold earrings
above, the filigree and granulation can still be said to
be on an equal footing, but a small amount of larger
shot has been added to highlight the intricate designs.
The hemispheres on the side walls of 50b share an
unusual feature with the filigree beads found in the
Tunisian hoard: the uppermost lobe of the four
trilobed leaves forming each hemisphere is repoussé.

Thus, we feel safe in suggesting that they, like the
preceding five pieces, were manufactured at the same
location as the hoard material, most probably Egypt.

51a. Pair of Gold Earrings

Greater Syria, 11th century

Fabricated from wire and sheet, decorated
with granulation; originally outlined with
strung pearls and/or stones

Height 25.4 mm, width 33.3 mm, depth
12.5 mm

Purchase, Gifts in memory of Richard
Ettinghausen and Harris Brisbane Dick
Fund, 1979 (1979.278.2a,b)

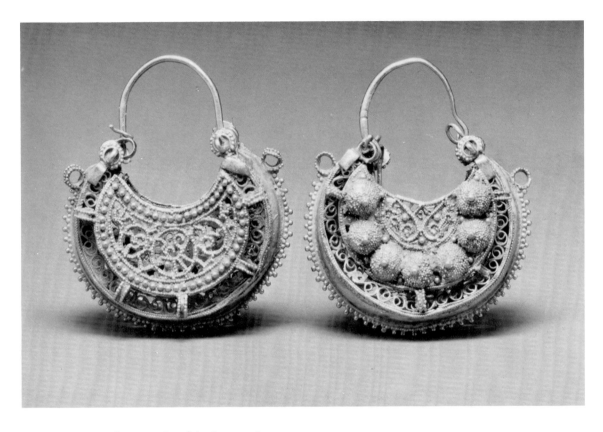

When we come to the examples of the finest and most
decoratively complex type of Fatimid goldwork,
represented in the collection by nos. 51a–51e, the
quality of their execution places them in a separate
category. Because of the great gap between these
objects and those found in the Tunisian hoard and
because their closest parallels were found in Syria or
Iraq, it seems likely that they were made in one of
these two areas—most probably Syria.

Granulation is not only more prominent on this
particular group of objects, but it also occurs in more
than one size and often in more than two sizes.

The pair of earrings no. 51a are the single most
elaborate example of Fatimid filigree and granulation
work in the Museum's collection; and indeed they
hold the same position among all the extant Fatimid
jewelry known to us. Only two other pairs, one in the
Museum für Islamische Kunst, Berlin (217), and the

51b. Gold Earring

Greater Syria, 11th century
Fabricated from wire and strips of sheet,
 decorated with granulation; originally
 hung with pearls and/or stones
22.2 x 23.8 mm
Purchase, Gifts in memory of Richard
 Ettinghausen and Harris Brisbane Dick
 Fund, 1979 (1979.278.3)

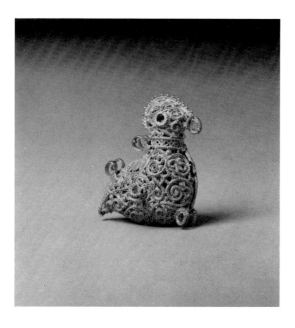

other, reportedly found near Mosul, Iraq, in the
Virginia Museum of Fine Arts, Richmond (Ross,
1978, fig. 42), share its peculiarity of construction, in
which there is a hollow tube bisecting the edge of
each earring to which has been attached a narrow
strip of gold bearing contiguous groups of three
grains forming a salient crenellation along the center
of the tube. The other exceptional construction
feature is the thickness of each earring in relation
to its overall size.

These earrings incorporate several features found
on Iranian objects, which further supports the likeli-
hood of an origin to the east of Egypt. The S-curves
formed of flat wire, which curl back on themselves,
were previously seen on armlet no. 16 and on the
three gold necklace elements no. 23. Also, the rather
spiky character of the arabesque on the reverse and
the one on either side of the hollow tube is dissimilar
to that on the Egyptian pieces but is seen on an ear-
ring found in Iran (New York art market, about
1980).

The single earring no. 51b, in the form of a bird,
shares the features of both salient grains and gran-
ulated flat loops with no. 51a. In addition to the
Museum's bird-shape earring, there is a larger but
very similar pair in the National Museum, Damascus
(30524), which still retains the ear wires and a pearl
pendant from the ring in the beak. Another single
earring of the type is also known (Schäfer, 1910,
no. 151, pl. 20).

The necklace centerpiece no. 51c is, for the type,
unique in our experience in being constructed to fit
within a necklace with three strands of beads or other
elements as opposed to being pendant from it, evi-
denced by the fact that it is provided with three pairs
of holes along the sides for stringing.

Also belonging to the finest and most decoratively
complex group of Fatimid goldwork are two beads,
one spherical and one biconical (see page 88). Un-
like earrings, pendants, bracelets, and rings, beads
made during the Fatimid period have survived in very
small numbers. There appear to be only five extant
filigree-constructed and granulated beads including
those in question, which also are illustrative of the
only two shapes in which these beads are known to

51c. Gold Necklace Centerpiece

Greater Syria, 11th century
Fabricated from wire and strips of sheet,
 decorated with granulation and cloisonné
 enamels
Maximum height 46 mm
Purchase, The Friends of the Islamic
 Department Fund, 1970 (1970.76)

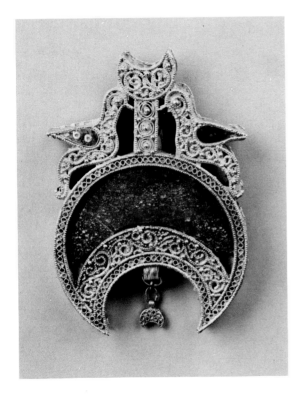
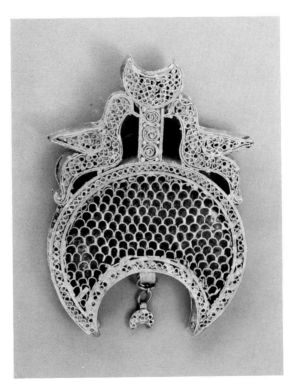

have been made. Two similar spherical beads and a similar biconical bead, now in the Israel Museum, Jerusalem, were found in Caesarea hidden with a number of other objects of personal adornment in a glazed pottery vase (Katz, Kahane, and Broshi, 1968, p. 131, fig. 111).

The five gold beads no. 51e, purported to have been found with the spherical and biconical beads, are, so far as we know, unique. However, the apparent attempt (at least in the case of the four large beads) to imitate in another technique the design of the spherical bead is not without parallel in the Fatimid period (Jenkins, in press, p. 7, fig. 18). The beads exemplify curious exceptions to the almost universal employment of dapping for the production of "spherical" beads; rather, they are formed by appropriately cutting and bringing together the edges of pieces of sheet to approximate the spherical form, resulting in a structure more like a domical vault

than a true dome, the shape of a dapped hemisphere. While no practical or artistic advantage can be seen to result from the procedure, it is difficult to imagine that workmen capable of this quality of work, which includes colloid hard soldering, would be unfamiliar with the dapping process.

51d. Spherical and Biconical Gold Beads

Greater Syria, 11th century

Fabricated from wire and strips of sheet, decorated with granulation

Diameter 19 mm; width 50.8 mm, maximum diameter 20.6 mm

Purchase, Sheikh Nasser Sabah al-Ahmed al-Sabah Gift, in memory of Richard Ettinghausen, 1980; Purchase, Mobil Foundation, Inc. Gift, 1980 (1980.456,457)

51e. Five Gold Beads

Greater Syria, 11th century

Fabricated from sheet, decorated with twisted wire and granulation

Four beads, length 19 mm; one bead, length 14.3 mm

Gift of Mr. and Mrs. Nasser D. Khalili, in memory of Richard Ettinghausen, 1980 (1980.474.1–5)

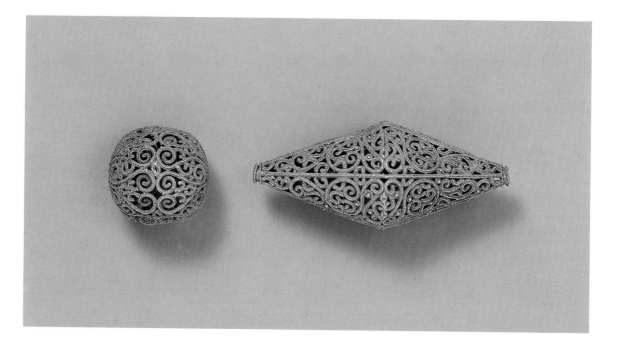

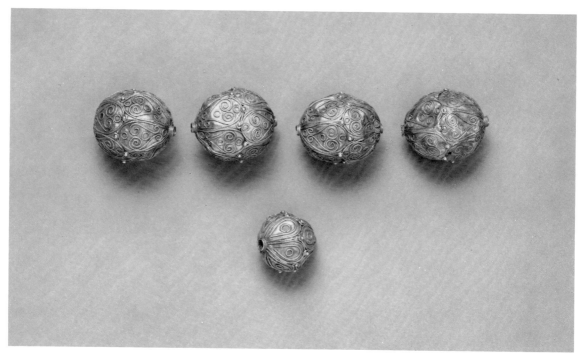

LATE MEDIEVAL JEWELRY
14th–17th Century

The situation that confronts us in dealing with late medieval jewelry is similar to that met with in the early Islamic period; namely, there are relatively few extant pieces from any part of the Muslim world datable to this period. We must often therefore rely heavily upon visual representations and literary descriptions to provide a picture of the jewelry of this important four-hundred-year period.

52. Elements from a Gold Necklace

Spain, probably 15th century

Fabricated from sheet and wire, pierced,
 decorated with granulation and cloisonné
 enamel

Circular element, maximum diameter 76.2
 mm; pendant elements, length 82.6 mm;
 beads, length 50.8 mm; 38.1 mm; 25.4 mm

Gift of J. Pierpont Morgan, 1917 (17.190.161)

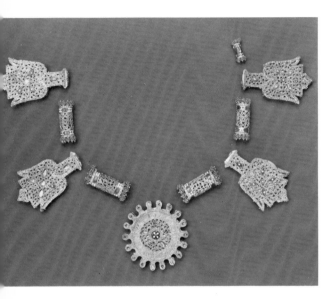

In the late medieval period Mamluk Syria and Nasrid Spain are better represented by extant jewelry than other regions of the Islamic world. The Nasrid necklace illustrated here consists of four pendant elements, one circular element, and five beads of three different sizes. The pendant and circular elements show a particular indebtedness to Fatimid jewelry in their boxlike construction, their combining of gold and cloisonné enamel as well as of filigree and granulation, and (on the four palmette-shape elements) the use of gold loops on their edges for stringing pearls or stones. There is an eleventh-century element from Greater Syria in the National Museum, Damascus (58804) that may very well exemplify the precursor of the central element in the Nasrid necklace. Instead of cloisonné enamel, the earlier piece bears two rubies and an emerald on the obverse, and each of the areas between its many "rays" retains a single pearl. As might be expected, the strong Fatimid influence on Spanish jewelry appears to have begun not in the Nasrid period but in the earlier, Spanish Umayyad period, when Baghdad was setting the vogue for most of the Islamic world (Jenkins, in press).

The closest parallels to these five elements, however, are to be found in six pieces of Mamluk jewelry, probably dating to the early fourteenth century:

two pendants in the National Museum, Damascus (Damascus, 1969, fig. 115, 1054/4, 1055/4), two pendants excavated in Iraq ('Umar al-'Ali, 1974, fig. 17), and two beads, also in Damascus (1057/4). On each of these pieces a flat wire laid on edge outlines the form of an animal or a calligraphic, geometric, or floral design; the background is filled with filigree, and the whole is supported by gold strips laid very close together, a structural feature that grew out of the Fatimid use of more widely spaced strips for the same purpose. One of several smaller elements similarly constructed, also in the National Museum, Damascus (15654), shows the principal areas bearing enamel. All of these appear to be closely related to a type represented by a pendant in the Museum of Fine Arts, Boston (65.248), that is identical to the four pendants mentioned above except that the filigree design is laid on sheet rather than on a strip support.

On the present pieces as well, the flat wires are laid not on a series of strips but on gold sheet. The background is handled in two ways: it is filled with randomly strewn grains, as on the outer areas of the circular element (see also Rosenberg, 1918, vol. 3, fig. 276), and, as in the center of the circular element as well as on the four leaf-shape pendants and four of the five beads, the areas between the flat wires are filled with granules, and the background is for the most part punched out.

The elements comprising the Nasrid necklace are not executed as laboriously as the best Fatimid pieces (or their progeny, the six Mamluk pieces), and the work involved has been further simplified by pouncing a gold sheet over the decorated front side of the pendant to produce a decoration on the back, a peculiarity of Nasrid jewelry. Granulation, however, which does not appear on the Mamluk objects, is an important feature of Nasrid work.

In spite of the Latin inscription on the circular element, which indicates that the necklace was made for the Christian market, the style of each of the elements, as well as the technique employed in the construction of this finest of all Nasrid jewelry pieces, is without doubt purely Islamic and specifically Nasrid. The original arrangement of these necklace elements is not known.

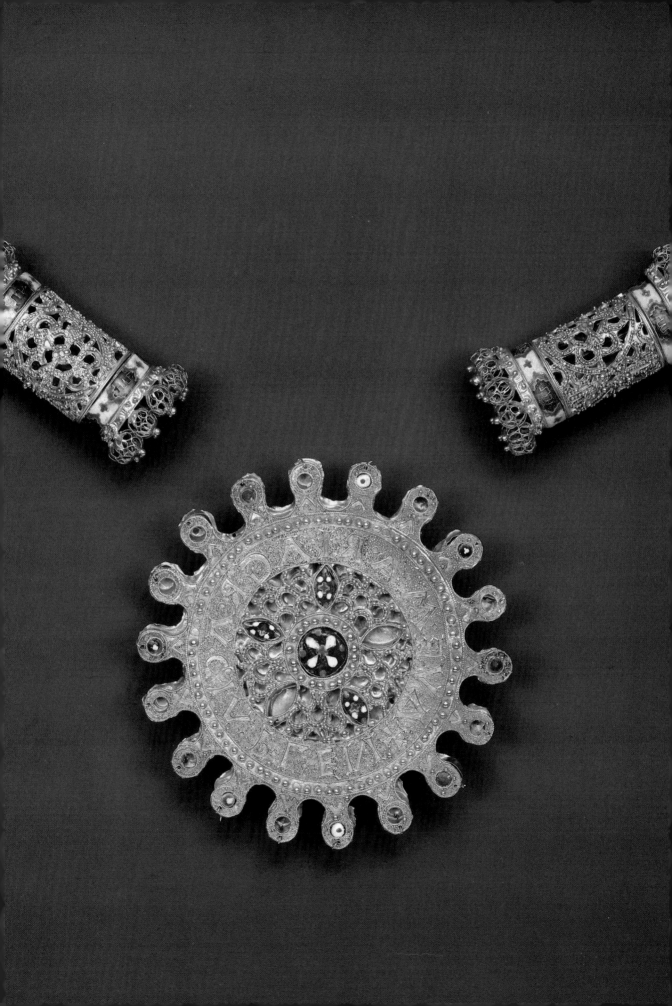

53. Gold Necklace

Spain, 15th century
Fabricated from sheet and wire, decorated
 with piercing
Length 22.6 cm
Gift of J. Pierpont Morgan, 1917 (17.190.152)

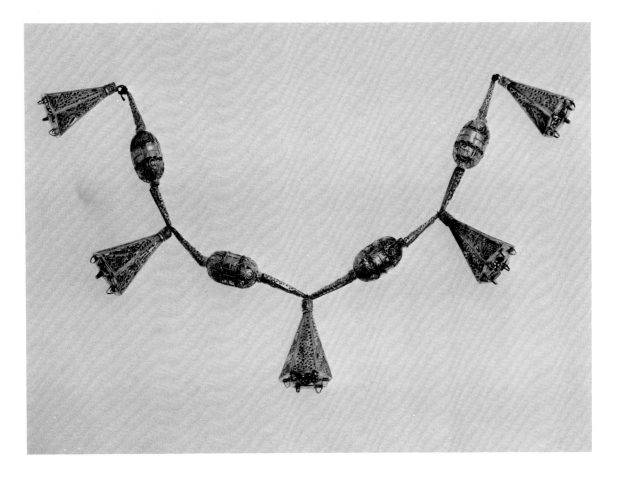

Another, less elaborate Nasrid necklace is illustrated here. The five hexagonal pyramid-shape elements, as well as the eight trumpet-shape ones, bear designs executed solely in paired twisted wire and highlighted with pierced areas. The indebtedness to Fatimid jewelry mentioned in connection with no. 52 is also seen here on the four blimp-shape beads, which are closely related to those found in the Tunisian hoard (see page 80), the ends being similarly constructed of hemispheres of wires soldered to a piece of gold sheet. Echoes of work we consider early medieval Iraqi, exemplified by a pair of earrings in the Metropolitan (MMA 95.16.2,3), can be seen here in the character of the twisted wire work on gold sheet and in another necklace from the Nasrid period, also in the collec-

tion (MMA 17.190.162). Whether the arrangement of elements is correct is not known; as with no. 52 it is highly likely that there are missing elements, perhaps beads of precious stone.

54. Pair of Gold Bracelets

Spain, 15th century
Fabricated from sheet, punched and engraved,
 decorated in repoussé
Height 44.5 mm, diameter 90.5 mm
Gift of J. Pierpont Morgan, 1917
 (17.190.157,158)

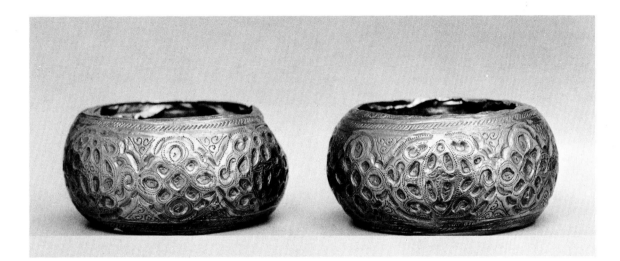

This pair of hollow repoussé bracelets, like necklaces
nos. 52 and 53, has an affinity to earlier Fatimid gold-
work. The repoussé design, consisting of a series of
interlaced cartouches outlined with punched dots, is
conceptually and technically the same as that of
no. 45.

In summary, it would appear that Nasrid jewelry
shows a strong dependence on Fatimid models, prob-
ably, on the one hand, through the intermediary of
earlier Spanish Islamic jewelry, such as that found
near Cordoba and now in the Walters Art Gallery,
Baltimore, and, on the other, through an infusion of
later, indirect influences, evidenced by its close
parallels with Mamluk (and perhaps as yet un-
defined Ayyubid) types. This dependence may there-
fore be seen as another probable example of styles
emanating from major fashion centers to more pro-
vincial areas, magnificent though styles from the lat-
ter may have been.

When we shift our attention to the eastern regions of the Islamic world in the late medieval period, we find even less extant material; we must therefore rely heavily on pictorial documentation for our idea of the jewelry of this area. Representations of jewelry in Persian miniatures do not, however, provide an adequate picture of the jewelry in vogue at the time, even that of the upper classes. This is inevitable given the scope and character of Persian miniature art, which is not concerned with the kind of specific depictions that would enable detailed reconstruction of otherwise unknown types. Furthermore, conventions of painting undoubtedly played some part in the jewelry the painter chose to depict on his figures, just as they had a part in the architectural forms and decoration he represented. In other words, rather than depict his immediate surroundings, the painter often copied from other paintings. Persian miniature art does, however, in a general way show some jewelry types in current use and even reflects changing styles. Representations in Mughal miniatures are of course more detailed and more specific in terms of time, place, and object.

There are only two pieces of fourteenth-century gold jewelry known to us from the eastern reaches of the Islamic world, one a series of necklace elements (Jenkins and Keene, 1982, fig. 24a,b) and the other a head ornament (Museum für Islamische Kunst, Berlin, 565). The shapes used in the wire and stone work on the obverse of the necklace's two principal elements, as well as the contours of these elements themselves, relate them closely to the early fourteenth-century Syrian pendants (Damascus, 1969, fig. 115, 1054/4, 1055/4) and to, for example, the crown of Nushirwan illustrated in the Demotte *Shahnameh* (Stchoukine, 1936, ms. XV, no. 24). The style

of the chased design and the motifs on the reverse of these elements clearly point to the same period. In addition, the overall Chinese feeling is in line with what we might expect at this time, on the basis of what we find in other mediums.

To return to the miniature in the Demotte *Shahnameh*, it is noteworthy that both principal figures wear simple gold hoop earrings, a fashion that appears in other representations of this and other periods. The wearing of earrings by men is a custom with a very long history in the Near East, as is well attested in, for example, Assyrian, Achaemenid, and Sasanian reliefs. We referred earlier to a wall painting from Samarra in which there is an image of a man wearing earrings (see page 15). There is also literary evidence that earrings were worn by pre-Islamic Arabs: al-Biruni, in his chapter on pearls (Krenkow, 1941, p. 407), quotes from al-Asward ibn Ya'fur, ". . . runs a man with two pearls [in the lobes of his ears]. . . ." This custom continued in the Islamic world until the beginning of the modern period, as is evident from paintings of the Timurid, Safavid, and Mughal schools, in addition to those of the Mongol period.

The detail from a fifteenth-century miniature (fig. 6) shows what was apparently a new fashion for women: strings of beads framing the face, secured by a headcloth, and passing under the chin. This type of ornament begins to appear in Persian miniatures of the last years of the fourteenth century and was still in vogue in Persia in the nineteenth century during the Qajar period.

Examples of Timurid earrings can also be seen in this detail: plain gold hoops are worn by the mustachioed gentleman, and hoops with a single pendant teardrop pearl, similar to those in the painting from Samarra, are worn by the kneeling figure.

Fig. 6. Detail from a garden scene
 Iran, c. 1470–80
 Colors and gold on natural colored silk
 21.6 x 30.2 cm (maximum)
 Bequest of Cora Timken Burnett, 1957
 (57.51.24)

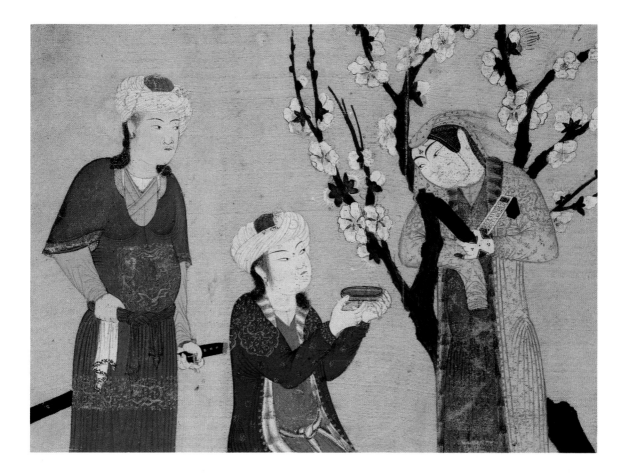

55. Pair of Silver Bracelets

Iran or Transoxiana, probably 15th century
Cast and chased
Diameter 73 mm
Fletcher Fund, 1964 (64.133.3,4)

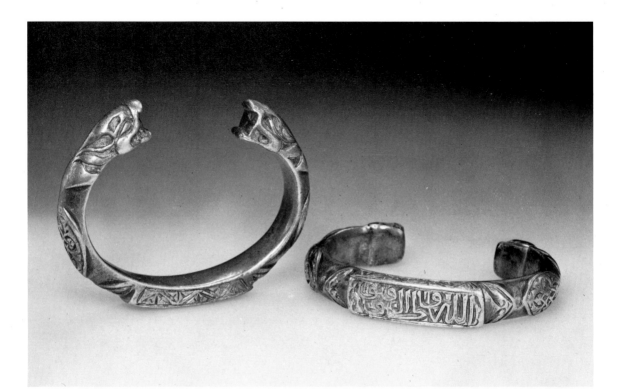

This pair of cast silver bracelets with dragon-head terminals and an Arabic inscription at the center of the shank are two in a group of at least four known examples of this type. Although less complex in design and of a later date, the bracelets seem related to a type of gold bracelet that can be placed quite securely in fourteenth-century Mamluk Egypt or Syria. The latter continues the tradition in that region of bracelets with hollow shanks—plain, compartmented, and inhabited by various plant, animal, and human motifs, or simply giving a twisted effect—that in the Mamluk examples terminate in animal heads (Segall, 1938, no. 319: Cairo, 1969, no. 20).

Additional if relatively insignificant information on bracelet types in the Timurid period is provided by a miniature from the *Haft Paykar* manuscript that shows bathing women wearing simple strings of beads at their wrists (Grube and Lukens, 1967, p. 325, fig. 16, MMA 13.228.13, fol. 47a).

56a. Gold Ring

Iran or Transoxiana, 15th–early 16th century
Cast and chased, set with nephrite sealstone
Maximum height 34.9 mm, diameter 25.4 mm
Rogers Fund, 1912 (12.224.6)

56b. Silver Ring

Iran or Transoxiana, probably 16th century
Cast, decorated with gilding and niello inlay,
 set with lapis lazuli sealstone
Maximum height 28.6 mm, diameter 25.4 mm
Bequest of William Gedney Beatty, 1941
 (41.160.280)

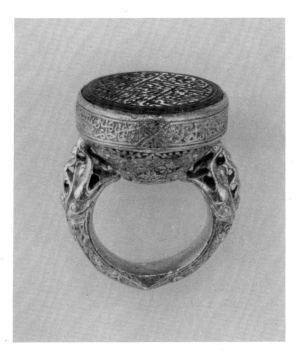

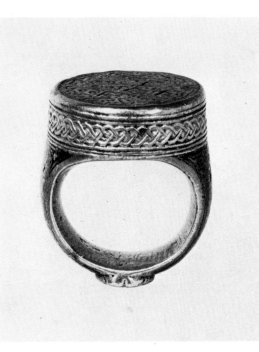

It is not improbable that the cast gold and jade seal rings illustrated here developed out of the type of ring represented by no. 31 since they have several important features in common: the technique of casting followed by a significant amount of chasing; shanks that have zoomorphic terminals and are decorated on two levels; and a lozenge adorning the exterior center of the shank. Rings with a large bezel whose lower section is in the form of an inverted cone were in vogue during this period (see the rings worn on the little fingers of each hand of the kneeling man, fig. 6, page 97). Furthermore, the great similarity of the dragons here flanking the bezel to those on the handles of a series of brass and jade jugs dated or datable to the fifteenth century and the first quarter of the sixteenth provides strong evidence for the dating of the ring to this period. Additionally, the inscription on the sealstone contains a prayer to 'Ali, nephew of the prophet Muhammad, that appears on several objects of the later fifteenth century and early sixteenth (including MMA 91.1.607, a brass jug of the above-mentioned type). The type of sealstone in this ring

Fig. 7. Detail from a miniature from a
manuscript of the *Khavar-nama*
Iran, 1450–51
Colors on paper
39.4 x 28.3 cm
Rogers Fund 1955 (55.125.2)

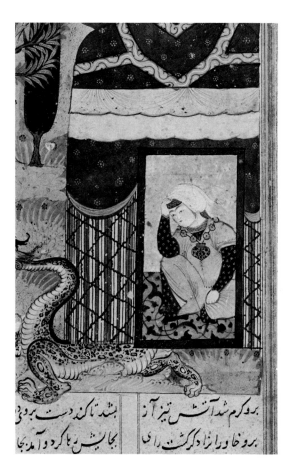

represents the earliest Islamic group made of jade,
and is associated with the fifteenth-century school of
jade vessel manufacture perhaps centered at Herat.
Also in the Metropolitan is another, isolated stone of
the type (MMA 1980.230).

The niello-inlaid, partially gilded silver ring (no.
56b) is a striking materialization of images of rings
worn on the fourth finger by men in many fifteenth-
and early sixteenth-century Persian miniatures (see
fig. 11, page 103); in addition, the stylistic similarity
to no. 56a, including the sealstone type, reinforces the
probability that both rings are of the same period.

The necklace worn by the woman in fig. 7, a detail
from a manuscript illustration dated 1450–51, points
both backward and forward in time. On the one hand,
the central element is related to an element on a four-
teenth-century Iranian gold necklace (Jenkins and
Keene, 1982, pp. 255–56, fig. 24a,b) and to the Mam-
luk pendants (no. 52). On the other hand, the overall
composition is identical to what we shall see is the
type of Safavid necklace most frequently represented
in miniatures; the rosettes, however, appear to be flat
—perhaps box-constructed—elements similar to a
number of Mamluk elements in the National Mu-
seum, Damascus (15654, 37394), rather than what
appear to be spherical beads in the Safavid represen-
tations.

As indicated earlier, the vogue for beads that frame
the face continued through the Safavid period and
into the Qajar period. Other types of head ornaments
—the ultimate sources for which are found in the
classical world—were also very popular during this
period and continued to be used in many parts of the
Islamic world until modern times. One example is il-
lustrated in fig. 8, which appears to be of gold set with
stones.

Taking into account the problems inherent in using
such paintings for documentation, one is tempted to
postulate that the necklace shown in fig. 7 was the
immediate precursor of that worn by the woman in
fig. 8. The elements and their arrangement are prac-
tically identical except that the seemingly flat rosettes
set with a single stone in the 1450–51 miniature have,
seventy-five years later, become what appear to be
granulated spheres set with multiple stones. The cen-

Fig. 8. Detail from "Bahram Gur in the Yellow Palace," page from a *Khamsa* of Nizami
Iran, 1524–25
Colors and gold on paper
32.4 x 22.2 cm
Gift of Alexander Smith Cochran, 1913
 (13.228.7, fol. 213a)

Fig. 9. Detail from "An old woman complains to Sultan Sandjar," page from a *Khamsa* of Nizami
Iran, 1524–25
Colors and gold on paper
32.4 x 22.2 cm
Gift of Alexander Smith Cochran, 1913
 (13.228.7, fol. 17a)

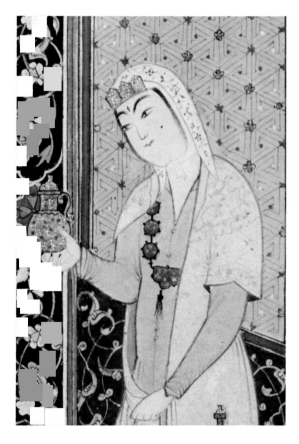

Fig. 10. Detail from a drawing of a youth
Iran, c. 1580
Colors and gold on paper
31.1 x 21.3 cm
Fletcher and Rogers Funds, 1973 (1973.92)

tral element has also changed—from a carved or painted piece to a gold pendant set with stones.

Another type of necklace represented in Safavid paintings, worn as a choker or close to the throat, consists of a central, triangular, sometimes jeweled gold element flanked by two smaller gold elements on a string of pearls. Paintings of this period also show Iranian women wearing strings of beads that are plain or that bear a single pendant (MMA 52.20.6, 1975.192.10; wall painting from the Chihil Sutun, Isfahan). Furthermore, these paintings indicate a continued vogue for bracelets that consist of simple strings of beads.

The belt most commonly represented in Safavid miniatures develops from a belt type consisting of a large gold roundel, or several roundels, on a cloth or leather strap, which first made its appearance in Iranian miniatures datable to about the year 1400. The older style discussed in connection with the Nishapur finds seems to have continued in general use through the fourteenth century but appears to have been superseded in the fifteenth by this new type that was to remain in vogue in Iran for centuries to come. This new belt type was further elaborated upon in the Safavid period. The number of elements on a given belt is increased, and the elements themselves are typically jeweled (see fig. 9). In the Topkapi Palace Museum, Istanbul, there are elements from the two known extant belts closely comparable to the representations just discussed (fourth salon, showcase 11; Pope, 1938, vol. 6, pl. 1394b,c). Also in the Topkapi Palace Museum are a number of jade elements inlaid with gold and stones that appear to be belt elements. Another related belt, of finely carved ivory, which seems slightly later, perhaps dating to the second half of the sixteenth century or early in the seventeenth, is in the Metropolitan's Department of Arms and Armor (MMA 36.25.2993). Certain more recent Iranian and Caucasian belts, which seem to continue the development of the type under discussion, show an even greater tendency for the nonflexible elements to be placed closer together, until finally they interlock, creating a total covering. In some instances the flexible understructure is completely concealed.

The observation of and dependence upon miniature

paintings leaves us with an impression of extraor-
dinary conservatism in earring fashion in the Safavid
period. We find plain gold hoops and gold hoops with
a single shot at the bottom, or at the bottom and two
sides. There are also variations on the type of earring
that consists of a gold hoop with a pendant pearl.
Fig. 10 illustrates the latter type and consists of three
pendant stones—blue, white, and red—that we can
safely assume are sapphire, pearl, and ruby (see also
pages 149–50). We also see more complex pendant
earring varieties of gold, pearls, rubies (or garnets),
and emeralds. Depictions of earrings in miniatures
are often not sufficiently detailed to permit an under-
standing of their structure.

Ring types represented in miniatures of this period
include seal rings, rings with white and green stones,
and archer's rings (usually indicated in black) of the
swept-back form most commonly associated with
Mughal India, but in fact known in ancient China
(see fig. 11). The ring with the white stone worn on
the right hand of the man to the right in this minia-
ture very much resembles no. 56a in style. That the
rings depicted in these miniatures are seal rings is
proven beyond any doubt by a miniature in the
Metropolitan (MMA 13.228.7, fol. 64r) in which a
ring is being inked for affixation to a document. We
also find gold thumb rings and plain gold rings with
rectangular bezels (see fig. 10).

Another Safavid fashion was the wearing of ban-
doliers. Fig. 10 shows one example that bears ele-
ments of three different shapes. The bandolier, a
type of body ornament of ancient and perennial pop-
ularity in India, was probably reintroduced from
India into Iran in the Safavid period. We find bando-
liers represented in Umayyad Syria that are perhaps
of classical inspiration based ultimately on Indian
prototypes (Jenkins and Keene, 1982, p. 6).

The wealth of highly detailed representations of
jewelry in Indian sculpture and paintings gives cre-
dence to the impression that in no other nation has
the development and use of jewelry been so extensive.
This impression is also confirmed by the study of
extant material, despite the fact that practically no
jewelry from India is known from about the third
century to the eighteenth.

Fig. 12. Detail from a painting of Shah Jahan as a young man with his son Shuja', from the Album of Shah Jahan
India, 1625–30
Colors and gold on paper
Full page 38.9 x 26.2 cm; detail 13.7 x 10.8 cm
Purchase, Rogers Fund and The Kevorkian Foundation Gift , 1955 (55.121.10.36)

The jewelry artists of India have been not only extraordinarily inventive, developing an impressive array of technical procedures, but also remarkably faithful to inherited traditions, preserving classical decorative formulas that have survived for millennia.

A detail from an early seventeenth-century Mughal miniature (fig. 12), which shows Shah Jahan as a young man with his son Shuja', is notable for what it shows of the timelessness of an ancient formula for arranging large precious stones and pearls: namely, that they are bored and strung and, on necklaces, separated from each other and hung with a central pendant (Keene, 1981, p. 27).

In addition to strands of pearls, which Indians in all ages have worn in lavish profusion, another ornament timeless in its appeal and usage is the simple pearl earring, by which we are again reminded of the passage from pre-Islamic Arabic poetry cited above in connection with Persian representations (see page 96). Mughal paintings generally constitute representations more faithful to reality than Persian ones, which makes them a better source of documentation; in addition, a considerable amount of other highly accessible supplementary information—particularly that in literary accounts—about the costumes and jewels worn in Mughal India provides descriptions that coincide strikingly with what is seen in the paintings.

Jahangir, for example, in his *Memoirs* (vol. 1, pp. 267–68), recounting the events of his ninth regnal year in August or early September 1614, explains that he began wearing "a shining pearl" in the lobe of each ear in gratitude for being restored to health after praying at the mausoleum of Khwaja Mu'in ad-Din, considering himself "inwardly an ear-bored slave of the Khwaja." The same passage gives the probable genesis of a fashion universally popular in India from the early seventeenth century until the reign of Aurangzeb (1658–1707) and later, namely, the wearing of earrings by men: "When the servants of the palace and my loyal friends saw this, both those who were in the presence and some who were in the distant borders, diligently and eagerly made holes in their ears, and adorned the beauty of sincerity with pearls and rubies which were in the private treasury, and were bestowed on them, until by degrees the in-

fection caught the Ahadis and others." According to Tavernier (part 2, book 2, p. 150), writing in the first half of Aurangzeb's reign, there is "no person of any quality that does not wear a Pearl between two color'd stones in his Ear." Such earrings are commonly seen in Mughal paintings, although more often the colored stone is placed between the two pearls (MMA 30.95.174, no. 11, from an *Akbar-nameh*, 1605, unpublished; MMA 55.121.10.29, from the Album of Shah Jahan, 1605–27, unpublished). Miniatures that predate Jahangir's adoption of this fashion (such as MMA 30.95.174, no. 11, cited above) indicate that his role was one of popularizing the style rather than one of initiating it.

Aside from its depiction of relatively simple bracelets, pendants, and rings—including a gold, stone-set archer's thumb ring of typical form—this painting detail also depicts extraordinary precious stones (in this case, rubies and emeralds), which is characteristic of Mughal paintings of this period. These accord well with such accounts as Jahangir's *Memoirs*, in which stones and pearls of great quality and value are mentioned in passages so numerous that they can only be described as legion. It would not, therefore, be farfetched to suppose that the great ruby in Jahan's middle necklace is one of those specifically mentioned in Jahangir's autobiography (where he relates that he gave several of these and other great stones to his son), particularly since this miniature seems to have been painted while Jahangir was still on the throne, or early in the reign of Jahan. It is possible that the ruby illustrated here is the one that was given to Jahangir's father, Akbar, by Jahangir's mother, Maryam-Makani, on the occasion of Jahangir's birth, and was worn by Akbar in his *sarpīch* (turban ornament). Jahangir in turn wore the ruby in his own *sarpīch* before giving it, in 1617 or 1618, to his own son Jahan (Jahangir, *Memoirs*, vol. 1, p. 409). The ruby depicted in the painting could also be the one that Shah Abbas sent to Jahangir (again, inserted in a *sarpīch*) late in 1620 or early in 1621. This ruby originally belonged to Ulugh-Beg and bore inscriptions with the names of both Ulugh-Beg and Shah Abbas. Jahangir, after it came into his collection, summoned Sa'ida, the "superintendent of the goldsmiths' department," to engrave "in another

Fig. 13. Zenana (harem) scene
India, 1615–30
Colors and gold on paper
12.7 x 20.3 cm
Gift of Alexander Smith Cochran, 1930
(30.95.174, no. 26)

corner" his name and the date, and gave it a few days later to Jahan following his conquest of rebellious factions in the Deccan (Jahangir, *Memoirs*, vol. 2, pp. 195–96).

This painting shows Jahan holding up one ruby from a group of five on a small tray, a gesture that alludes to his connoisseurship in jewelry. Both Tavernier (part 2, book 2, p. 149) and Jahangir (*Memoirs*, vol. 2, pp. 78–79) attest to this ruler's expertise. Tavernier describes how, during the reign of Aurangzeb, Jahan was consulted as the ultimate authority concerning the authenticity of a particular ruby, and writes of his being considered "the most skilful in Jewels of any person in the Empire." Much earlier, during the reign of Jahangir, Jahan was apparently himself a cutter of stones and designer, if not actually maker, of elaborate jewels.

Another classic form of Mughal jewelry (one shared by men and women alike) is the upper armband—*bazuband* in Persian, the language of the Mughal court—which was prevalent in pre-Mughal and even pre-Islamic India. Depictions of armbands, often with extremely elaborate centerpieces, in ancient and medieval India and later are too numerous to need citation. The typical flexible form having a three-element centerpiece, which came to be synonymous with the word *bazuband*, probably came to Iran from India, most likely in late Safavid times. The earliest Iranian depiction of this type of flexible armband—as distinct from annular or penannular types—is on the sculpted maidens at the edges of the pool of the Chihil Sutun, the Pavilion of the Forty Columns, Isfahan, of about 1647 (Pope, 1938, pl. 475; Jenkins and Keene, 1982, fig. 31). In any case, the fashion, for men at least, was certainly established in Iran by the time of the reign of Nadir Shah (1736–47), as indicated by the inscription on a 270-carat spinel ruby now in the Iranian National Treasure: "Armlet of the King of Kings, the Sultan Nadir, Lord of the Conjunction, a selected [piece from the] Jewel-Treasury of Hindustan 1152"(A.D. 1739–40) (Meen and Tushingham, 1968, pp. 46, 67). The flexible upper armband continued to enjoy great popularity in nineteenth-century Iran, as even the briefest survey of Qajar painting will show.

In Mughal India, as in earlier times, Muslim prayer beads were made of a wide variety of materials—seeds, wood, bone, ivory, coral, amber, carnelian, and lapis among them. We may assume that in earlier times precious stones and pearls were also included, but we know for a fact that pearls, emeralds, rubies, and sapphires of great value were used in Mughal India. To judge from Jahangir's *Memoirs*, pearl strands were the most common among the more expensive varieties; often they had precious stone beads as dividers and pendant elements, as is confirmed again by an inscription on a stone in the Iranian National Treasure, a 59.22-carat teardrop-shape emerald: "For the rosary of the King of Kings, Nadir, Lord of the Conjunction, at the conquest of India, from the Jewel-Treasury [this] was selected, 1152" (A.D. 1739–40) (Meen and Tushingham, 1968, pp. 46–47, 64–65). Thus, when we see in the *Glorification of Akbar*, a painting in the Album of Shah Jahan (Jenkins and Keene, 1982, fig. 35), a representation of Akbar holding a *sibha* of white beads interspersed with blue and red beads, we may justifiably assume they are pearls, sapphires, and rubies (although the last may be spinel rather than corundum rubies).

Some of the most spectacular stones in Mughal India, as in Ottoman Turkey and Safavid, Zandid, and Qajar Iran, were worn by men in the *sarpich*. Many relatively late examples survive and can be seen in the Topkapi Treasury and in the Iranian National Treasure, and there are many descriptions recorded in such accounts as Jahangir's *Memoirs* (in addition to the passage cited above, see vol. 1, p. 409) and descriptions by European travelers such as Tavernier (part 1, book 4, p. 178; part 1, book 5, p. 237; *The Description of the Seraglio*, p. 48).

The form of the turban ornament is often that of a stylized plume of feathers, and indeed, some ornaments are designed to hold real plumes (Tavernier, part 1, book 4, p. 237). Tavernier also describes some turban ornaments as tulip shape.

Pictorial representations and literary accounts of Mughal India are filled with descriptions of other jewels and of jeweled trappings, vessels, and implements too numerous to detail here.

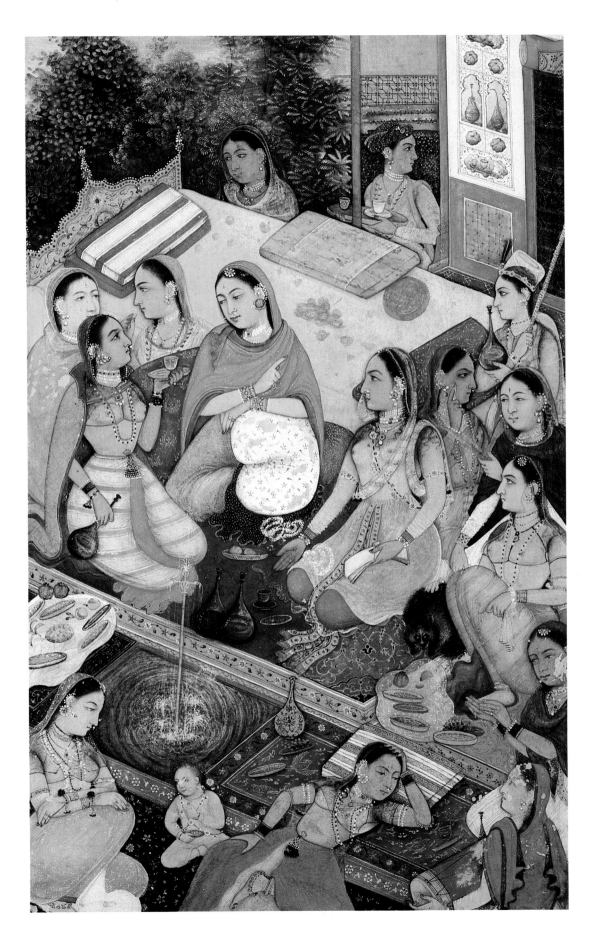

Less commonly depicted in seventeenth-century Mughal paintings than jewels worn by men are those worn by women. One of the pictures most richly detailed in its representation of women's jewelry is illustrated in fig. 13 (page 107). This *zenana* (harem) scene gives a marvelous sense of the profusion of forms assumed by women's jewelry during this period, as well as an indication of the variety of functions it served. Head ornaments, anklets, bandoliers, necklaces, armlets and elbow bracelets, rings for every finger, rings for the nose, earrings for the entire periphery of the ear as well as for the lobe, rings for the toes—adornment, in short, for every part of the body.

Few jewelry pieces of the quality we see in this painting have survived in their original form; gold has been remelted, pearls have been restrung or have "died," and stones have been remounted, restrung, or even recut. This process has been widespread and recurrent, occasionally taking place on a grand scale. The most notorious case of wholesale transformation occurred after the capture of the Mughal treasure in 1739, when Nadir Shah, having removed the stones and pearls, melted down enormous quantities of gold jewelry. These events do not, however, entirely explain the dearth of known earlier Indian jewelry, the discovery of which should by all means be pursued.

FINAL PHASE
18th–20th Century

The eighteenth, nineteenth, and twentieth centuries are abundantly represented by extant jewelry pieces made not only for the middle classes but also for the aristocracy and for royalty. Insofar as they preserve earlier forms, they shed light upon the function and appearance of body ornament from earlier times; and insofar as they represent new fashions that evolved both from local and national styles and from the infusion of new forms from neighboring or distant regions, they embody the creative process.

Little in the way of jewels identifiable as seventeenth-century royal Mughal has come down to us, aside from the famous cameo of Shah Jahan slaying the lion, now in the Cabinet des Médailles, Bibliothèque Nationale, probably by a European artist working at the Mughal court (Paris, 1977, no. 702; see also Jahangir, *Memoirs,* vol. 2, p. 80), a few carved emeralds, inscribed spinels, and large quantities of (uninscribed) stones and pearls in the Iranian National Treasure (Meen and Tushingham, 1968).

Great numbers of Indian pieces, however, have survived from the eighteenth and nineteenth centuries. Again, like so much of the extant jewelry from earlier periods, the major part of what survives is comprised of jewelry made for the middle classes. One of the largest collections of eighteenth- and nineteenth-century Indian jewelry is in the Museum's collection. For this volume, we have selected several of the finer and more characteristic pieces and have attempted to illustrate relationships that exist both between these pieces and Islamic traditions in other regions and between these pieces and representations of jewelry in Mughal miniatures.

57. Gold Necklace

Northern India, 18th–19th century
Fabricated from sheet and wire, set with
 diamonds, rubies, and imitation emeralds
 (colorless rock crystal over green foil), and
 outlined with strung pearls
Diameter of central pendant 44.4 mm
John Stewart Kennedy Fund, 1915 (15.95.77)

Published: Dimand, 1940, fig. 13

The striking way in which this piece, with its circular
stone-set gold elements surrounded by small pearls,
is stylistically reminiscent of the miniature of the
zenana scene (fig. 13, page 107) suggests that it dates
to the first half of the seventeenth century. However,
the style of the "inscriptions" on the coinlike backs of
the circular elements would seem to indicate a some-
what later date. The word شاه ("shah") can be
deciphered on some of them, but whether the "in-
scriptions" as a whole are meaningful is doubtful.
They appear in any case stylistically degenerate,
which itself points to a late date.

Indian jewelers cling to tradition with enormous
tenacity. Their adherence to tradition is exemplified
by the sailor's-knot chain, a type common during
the Hellenistic period, if not indeed earlier. By way
of contrast, the peculiar pushed-down type of setting
seen here is especially evident in Indian pieces of the
seventeenth century to the twentieth, although a
related technique is also seen in eighteenth- and
nineteenth-century Persian and Bukharan pieces
(Persian: Meen and Tushingham, 1968, pp. 71, 75,
83, 86, 87, 92, 95, 97, 111; Bukharan: Rosenthal,
1973, colorpl. on p. 76; Katz, Kahane, and Broshi,
1968, pl. 187; Jerusalem, 1967, nos. 5.1, 5.2, 5.3,
5.4, 5.10). Although its origins are obscure, one
suspects that this type of setting did not originate long
before the seventeenth century. The complete
absence of extant fifteenth-, sixteenth-, and seven-
teenth-century pieces appropriate for comparison
makes resolution of this question unfeasible.

The great importance in so much of Indian jewelry
of flora as inspiration for design is also evident. More-
over, the artistry of the jewelry is clearly manifested
in the transformation of the floral form into a jeweled
form that respects the intrinsic nature of the material
from which it is made and the function for which it
was intended.

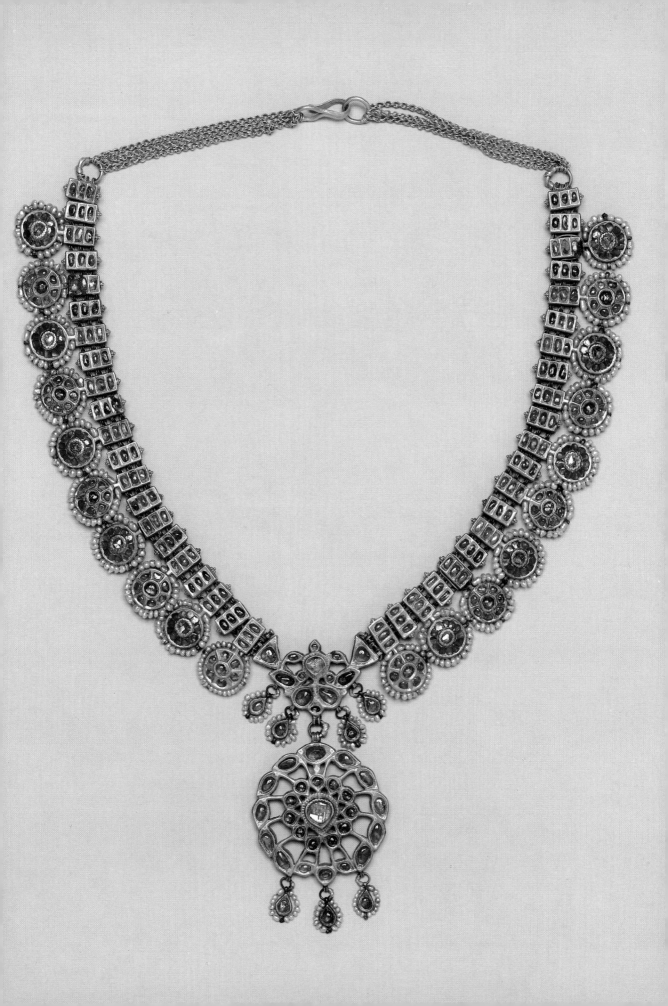

58. Gold Necklace

Northern India, 18th–19th century
Fabricated from sheet and wire, set with rubies,
 imitation rubies, and imitation emeralds
 (colorless rock crystal and/or white sap-
 phires over red and green foil)
Width of central pendant 42.9 mm
Rogers Fund, 1919 (19.111.1)

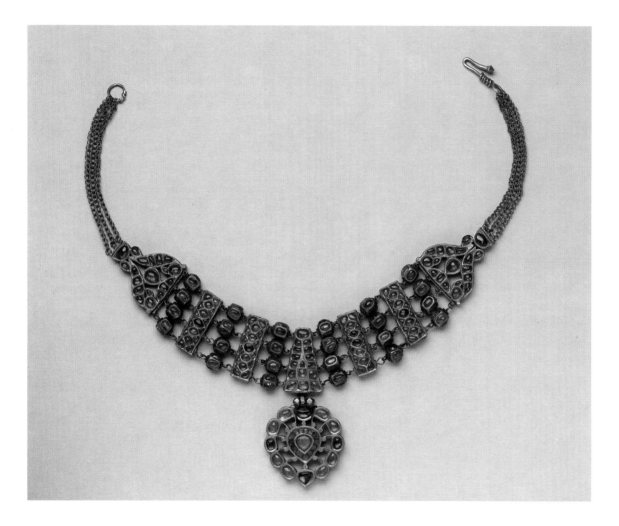

Structurally, technically, and decoratively similar to no. 57, this piece may in fact be of more or less the same date. The bird protomas worked into the design of the terminals harmonize with the floral character of the centerpiece, as well as with the more geometric spacer elements. The chains are of the single loop-in-loop type, which goes back to at least the third millennium B.C. at Ur, where some of the densest single loop-in-loop chains ever woven were found (Higgins, 1961; Wooley, 1934, nos. U.13794,

U.13796A, U.13793, U.13796B, pl. 146 [c], and no. U.8002, pl. 159b; London, 1976, no. 13b; Gregori-etti, 1969, colorpl. on pp. 38–39).

Intermediate-length necklaces such as these, to judge from the *zenana* scene (fig. 13, page 107), would usually have been worn with one or more chokers and a much longer necklace, often a strand of beads or a chain of gold.

59. Gold Necklace

Northern India, 18th–19th century

Fabricated from sheet, set with white sapphires and/or rock crystal, rubies, emeralds, and imitation emeralds (foiled rock crystal), enhanced with red, green, and blue enamel; reverse enameled in red, green, blue, and opaque white; strings of crimson silk whipped with gold-wrapped thread

Width of central pendant 50.8 mm

Rogers Fund, 1919 (19.111.3)

Published: Dimand, 1940, fig. 16 (shows enamel on back)

Giving the effect of being more heavily encrusted with stones than either nos. 57 or 58, this necklace also has a beautifully abstracted floral design, this time with a crescent worked into the composition of the element from which the pendant hangs. An additional drop, probably of pearl or precious stone, is missing from the suspension ring at the bottom of the large pendant element.

The manner in which the articulated parts of the semicircle interlock with one another to form a visually solid band in this and many other relatively late Indian pieces is reminiscent of Hellenistic pieces and, more significantly, of those from the first and second century A.D. excavated at Taxila (London, 1947–48, fig. 180).

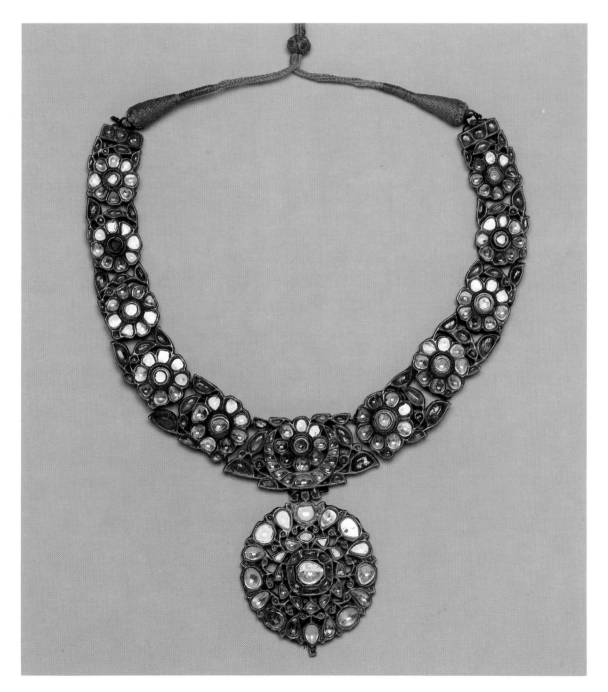

60. Necklace

Northern India, 18th–19th century

Fabricated from sheet and wire, set with rock crystal and other precious stones, the rock crystal foiled in red, blue, and green (most of the foil deteriorated) and inlaid with gold into which other stones are set; back enameled in floral designs in white, red, and green, and accented with opaque powder blue; settings enhanced with red enamel; fibers, including gold-wrapped thread; gold wire bearing pendant pearls and tipped with green enamel

Height of pendants, exclusive of pearls, 31 mm

John Stewart Kennedy Fund, 1915 (15.95.73)

This is the first piece we have encountered with the typical Indian cord slide-and-tassel, which takes the place of a clasp. This arrangement was already well established by the first half of the seventeenth century, to judge by a number of bracelets and armlets, and, one suspects, necklaces depicted in our *zenana* scene (fig. 13, page 107).

This is also the first piece we have seen that incorporates the enamels (in this case, mostly on the reverse) for which Mughal Indian jewelry is so justly famous (see also pages 148–49 and no. 66). The knowledge that fine enameling was done at Jaipur has led scholars to assume that the finest enamel work was done *solely* at Jaipur; this could lead one into the trap of deducing that all pieces which incorporate this kind of work must necessarily post-date 1728, the year in which Jaipur was founded (Meen and Tushingham, 1968, p. 81). We know unequivocally, however, that fine enameling was being done in Mughal India by 1617; indeed, such a piece was sent by Jahangir to Shah Abbas (Jahangir, *Memoirs*, vol. 1, p. 374).

Another typically Indian technique—one that was also, to a limited extent, practiced in the sixteenth and seventeenth centuries in Iran and Turkey—is the inlaying of gold and precious stones into objects made of other hardstones. These are most often jade, although this type of inlaying has been known even in stones such as emeralds. The origins of the technique, like the origins of many stylistic and technical elements of Mughal jewelry, are unknown; however, the earliest known examples of gold or silver inlay into hardstone in precisely this manner are jade vessels, where one would in fact expect it to have been developed.

The present piece exemplifies the work of a master jeweler highly cognizant of the intrinsic physical properties and decorative potential of a variety of materials who orchestrated them into a unified totality.

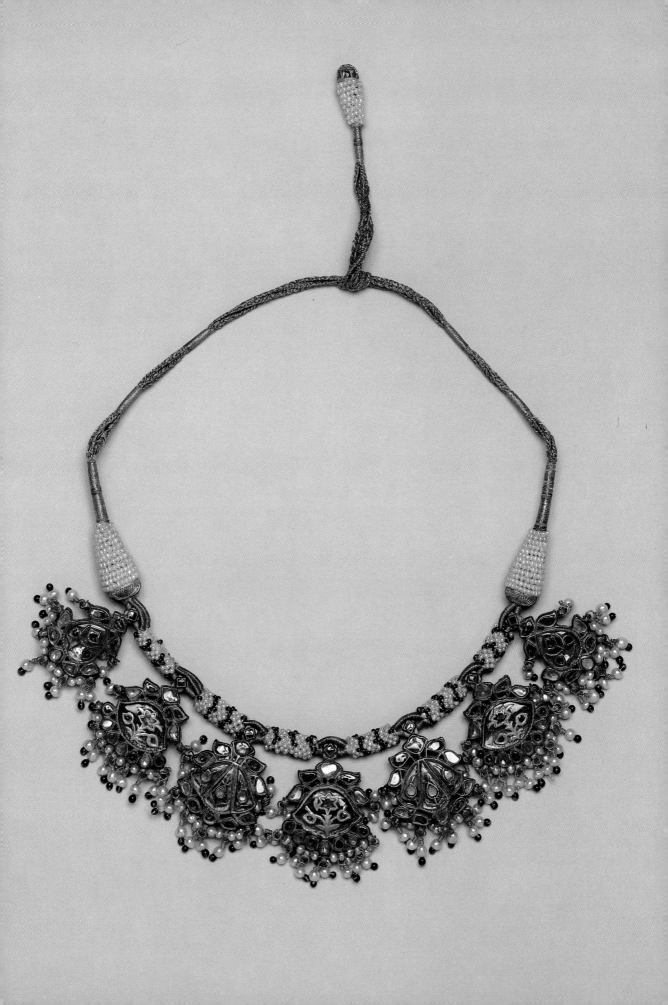

61. Gold Pendant

Northern India, 17th–19th century

Fabricated from sheet and wire and set with spinel(?) rubies and green glass(?); filigree section decorated with grains and set over a sheet of glass(?) or mica(?); back of repoussé floral design

Height 85.7 mm

John Stewart Kennedy Fund, 1915 (15.95.134)

62. Gold Necklace

Northern India, 18th–19th century

Fabricated from sheet and wire; set with precious and imitation precious stones; outlined with pearls; pendant pearls and ruby and emerald beads; strung with emerald beads; colored silk cord and tassel

Width of middle section, as shown, 17.8 mm

John Stewart Kennedy Fund, 1915 (15.95.55)

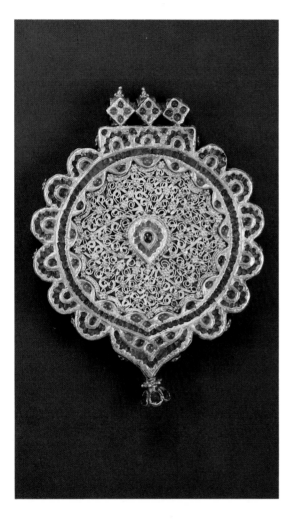

Related to no. 61 through the filigree technique, to no. 57 in its outlining by small pearls, and to no. 58 in the character of the settings—including the incorporation of avian motifs—this necklace nevertheless gives, with its three-dimensional blimp-shape major elements, a very different effect. This basic form has an ancient history in Islamic and in pre-Islamic Indian jewelry, having often been used on bandoliers as amulet cases or ornaments resembling amulet cases. A jeweled example can be seen on the bandolier worn by the lady nearest the center in the *zenana* scene (fig. 13, page 107).

Clusters of elements like those seen here, which are often encountered in the form of lac-filled hollow gold balls arranged in essentially the same manner as the round emerald beads, is a feature typical of and exclusive to several types of Indian jewelry, numerous examples of which are in the Museum's collection.

The only piece of jewelry in which, to our knowledge, a slab of reflective material is overlaid by a network of filigree, this pendant nevertheless shares with necklace no. 57 the linear, channel-set ruby chips and something of the decorative character. Great beauty and richness of effect have been achieved with relatively little expenditure of material.

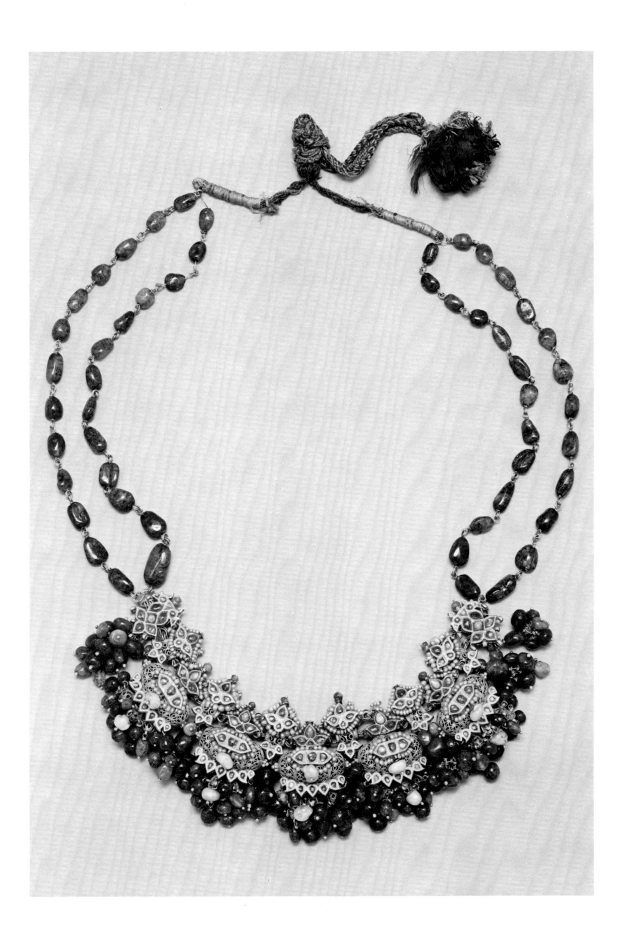

63. Two Gold Necklets

India, 18th–19th century
Fabricated from sheet and wire, set with
 precious stones
Diameter 10.8 cm; 12 cm
John Stewart Kennedy Fund, 1915
 (15.95.47,49)

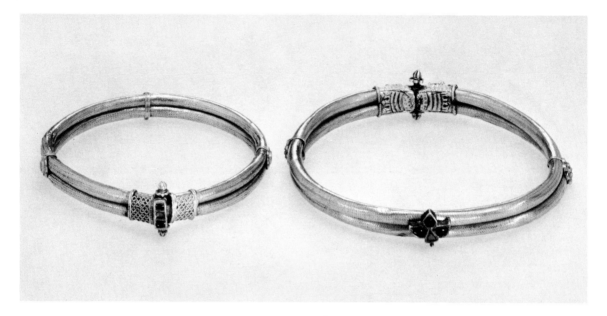

One of the most important traditions in jewelry making in India is that of flexible chains and plaited and knitted structures. Not only were all the major types of loop-in-loop chains (single, double, quadruple—see TA 1a–1e, page 144) known in ancient times, but certain knits which give an effect similar to that of a woven loop-in-loop chain were also known; the latter are, however, more economical in the expenditure of effort involved and in the use of material, being made of a continuous wire rather than of hundreds of discrete and separately made links, and being typically hollow (see TA 2, page 144; see also, for a fourth-century B.C. Etruscan example, Gregorietti, 1969, pl. p. 59). The present pieces—hollow, finely knit, and drawn through a drawplate—have such dense surfaces they almost belie their method of manufacture.

Another typically Indian feature is the screw-post clasp. All non-Indian Islamic jewelry in our experience, with the exception of two fourteenth-century tubular bracelets also with dragon-head terminals, uses the friction-held split-pin keeper post (Segall, 1938, no. 319; Rosenberg, 1908, vol. 1, fig. 141). It seems likely that these bracelets are of Golden Horde Mongol origin, especially in light of parallels with

material from the Simferopol Treasure (Moscow, n.d., middle illus. on p. [10]). Indeed, the only other historical jewelry known to us that uses the screw arrangement is from the late Roman and Tribal Migrations period, which is known from finds in Europe and includes not only fibulas but also bracelets with affronted dragon-head terminals (e.g., Feldhaus, 1931, fig. 252, nos. 4, 5; Rosenberg, 1908, vol. 1, fig. 142).

It is notable that the Indian jewelry screws are constructed exactly as those in late Roman and fourteenth-century examples—that is, by soldering a tight coil of wire to the post and inside the cylindrical element that receives it. Precisely when the screw-post principle was first used in Indian jewelry is unknown, but one is lead to suspect, partly on the basis of its virtual absence in medieval Islamic material, that it was known in India from ancient times.

64. Gold Head Ornament

Northern India, 18th–19th century

Fabricated from sheet and wire, ornamented with granulation, and set with turquoise, red- and green-foiled rock crystal

Maximum dimensions as shown 26.6 x 22.8 cm; detail, diameter 23.8 mm

John Stewart Kennedy Fund, 1915 (15.95.105)

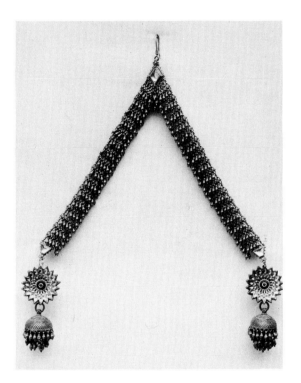

On this gold head ornament workmanship of unusually high quality is evident in the granulation, another technique inherited from ancient and medieval times. The detail shows a feature uncommon to work of this kind. Granulation, however complex its pattern, is almost invariably arranged on one plane; in this example, however, each group of four grains, which together constitute the precisely controlled pattern on the band around the bottom of the hemispherical element, has an additional grain stacked on its top.

The profusion of small spherical drops also bespeaks a high level of technical proficiency in dapping. Such head ornaments are hooked at the top of the head; the bands frame the face, and the rosettes are fixed so that the hemispherical pendants hang near the ears.

The similarity in handling is striking between these hemispherical elements and elements excavated at Taxila that date to the first and second centuries A.D. (Calcutta, 1916, no. 5, pl. XXIb; London, 1947–48, pl. 22, fig. 185).

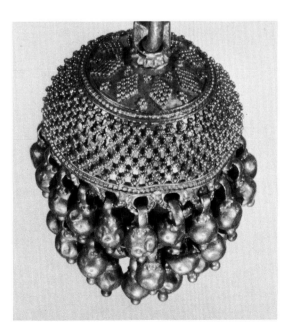

65. Gold Hand Ornament

Northern India, 18th–19th century
Fabricated from sheet and wire and set with
rubies, emeralds, and colorless sapphires;
engraved on reverse with design similar to
that on obverse
Width of central rosette 38.1 mm
Gift of George Blumenthal, 1941 (41.100.116)

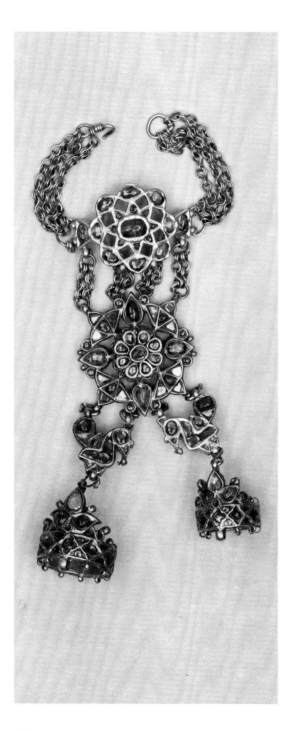

Design, settings, and chains relate this piece to nos.
57, 58, and 62. Although in design and technique this
hand ornament is characteristically Indian, the form
of hand ornament, consisting of a series of finger rings
attached to chains around the wrist, dates to the eighth
or seventh century B.C. (Maxwell-Hyslop, 1971, pl.
181; Paris, 1961–62, no. 508, pl. XLIV; Essen, 1962,
no. 221).

Despite an almost overly ornate opulence, great
sophistication of design in the best Indian tradition
is achieved here in the wedding of the stylized floral
and animal motifs with motifs that are purely
geometric.

66. Pair of Nephrite, Gold, and Enamel Bracelets

Northern India, 18th–19th century

Jade rings cut from massive block, channeled with grooves, and inlaid with gold set with precious stones; gold terminals cast and fabricated, encrusted with champlevé enamels and set with precious stones

Maximum diameter 82.6 mm

Gift of Heber R. Bishop, 1902 (02.18.770,771)

Published: Bushell, Kunz, and Lilley, 1906, nos. 770, 771

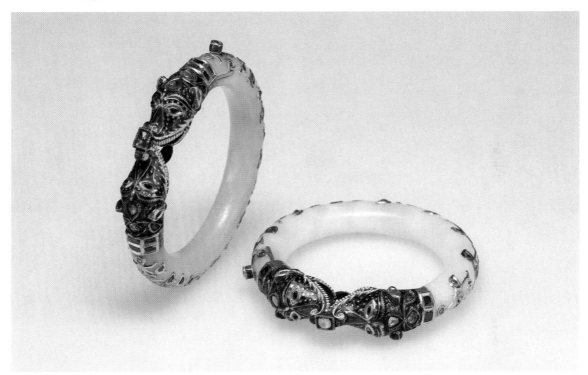

These two bracelets from northern India, originally part of the fabulous Heber R. Bishop collection of jades, are *tours de force* of the jeweler's art. Each is provided with a screw post fitted into the jade shank that allows for the removal of the gold and enamel dragon-head section, thus enabling the wearer to remove the bracelet.

Both the quality of the transparent red and green enamels and the overall control in execution indicate a relatively early date; and while dragon terminals are commonly found on jewelry from many areas (they are particularly popular in India) and many periods, the presence in a Mughal miniature of about 1620 (Freer Gallery 42.15b; Ettinghausen, 1961, pl. 14; Ettinghausen, 1965, no. 7/8; Bussagli, 1969, pl. 51) of a pair of dragon-head-terminated bracelets provides a valuable background against which to consider this pair of bracelets and other closely related pieces.

Also in the Museum's collection is a bracelet sim-

ilar to this pair but made entirely of enamel and stone-set gold (MMA 32.20).

Although seldom rivaled, the art of fine enameling in Mughal and later India is another feature of Indian jewelry whose formative phases are not documented. It is not, however, unlikely that an infusion of European influence, by way of European jewelers employed at the Mughal court, was responsible for the spread of the technique (see also pages 148–49). In his account Jahangir writes of a wonderful throne, presented to him by I'timad ad-Dawla on the occasion of the fourteenth New Year's feast after his accession to power, that was made by "a skillful European, one 'Hunarmand' [skillful], who had no rival in the arts of a goldsmith and jeweller, and in all sorts of skill [*hunarmandī*]. He had made it very well, and I gave him this name" (*Memoirs*, vol. 2, p. 8).

67. Pair of Gold Bracelets

Northern India, 17th–19th century

Fabricated from sheet and wire, enameled, and
set with chrysoberyl, coral, diamond, emerald, pearl, ruby, sapphire, topaz, and
turquoise

Length of each 20.3 cm

John Stewart Kennedy Fund, 1915
(15.95.21,22)

Similar in general appearance to bracelets in many
seventeenth-century Mughal miniatures, this pair displays the familiar screw-post closure, fine enameling,
and stone settings. The stones themselves constitute
a particularly straightforward presentation (except
for the repetition of the diamond) of the "nine gems"
already canonized by the sixth century A.D. (Keene,
1981, pp. 24, 27).

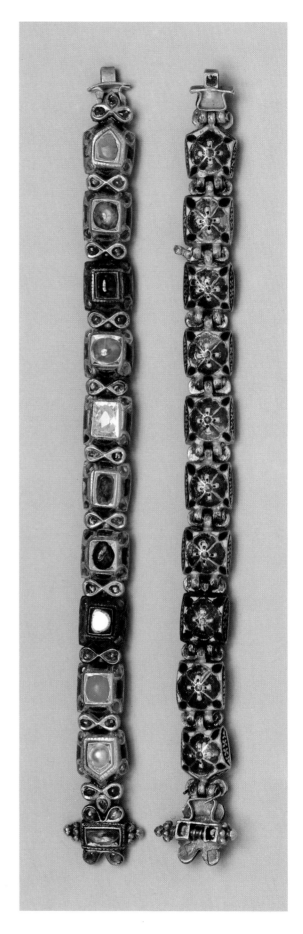

68. Gold Centerpiece of an Armband

Northern India, 17th–19th century

Cast and fabricated from sheet, set with rubies, emeralds, pearls, diamonds, and colorless sapphires; originally completed by chain or cord

50.8 x 95.2 mm

Gift of George Blumenthal, 1941 (41.100.118)

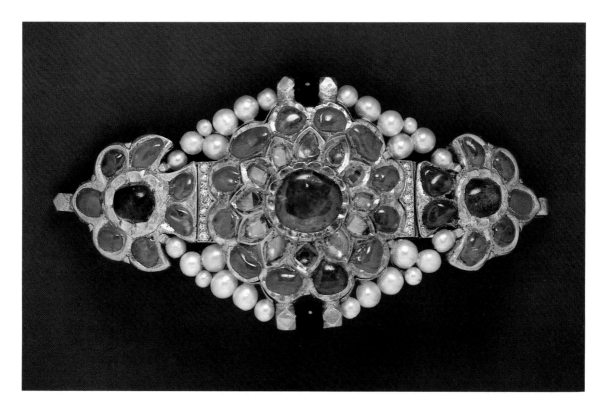

The rubies on this piece are regal in color and of the finest quality. The small brilliants closely set in silver or platinum strike a dissonant note, having been inserted when the piece was remounted as a brooch (by Cartier, Paris, as indicated by the inscription on the back of the mount). The clusters of pearls and the black beads at top and bottom were added at the same time and must be "thought away" to restore the true image, a beautiful example of the classic style. We are strongly inclined to place this piece in the seventeenth century.

69. Part of a Gold Armband (centermost
 of three elements), converted into a brooch
 India, Partabgarh, 19th century
 Fabricated from sheet and wire, and decorated
 with granulation; monochrome green enamel
 fired in cup and refired to fix thin sheet gold
 overlay
 Maximum width 98.4 mm
 Gift of Mr. and Mrs. Harry G. Friedman, 1953
 (53.167)

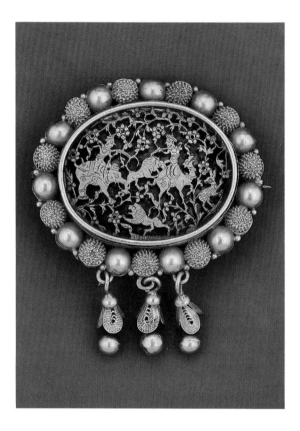

The ingenious technique used in this piece, which cre-
ates a richness of decorative effect that far exceeds the
labor necessary to produce it, is, as far as we know,
limited to a group of enamels associated with Partab-
garh, northwest India. Extant pieces of this type all
appear to have been made in the nineteenth century,
although the technique—which has been used also
for larger objects, such as boxes and trays, and in
other colors, such as red and amber—may in fact
have existed earlier.

The spiky, hollow balls, with closely packed conical
(rather than the more common spherical) elements
projecting outward to give a hedgehoglike effect, con-
stitute another uncanny echo of an ancient form, an
echo we have noted repeatedly in connection with In-
dian jewelry: the parallel between this technique and
that used in goldwork of the second century B.C. is
striking, although the two are possibly unrelated
(Paris, 1960, no. 67; Deneck, 1967, colorpl. 3).

70. Nephrite Belt Hook

Northern India, 18th–19th century

Each half cut from block of nephrite, inlaid
with gold, and set with rubies, diamonds, and
imitation emeralds (rock crystal set with
green foil)

Length as shown 82.6 mm

Gift of Heber R. Bishop, 1902 (02.18.793)

Published: Bushell, Kunz, and Lilley, 1906,
no. 793

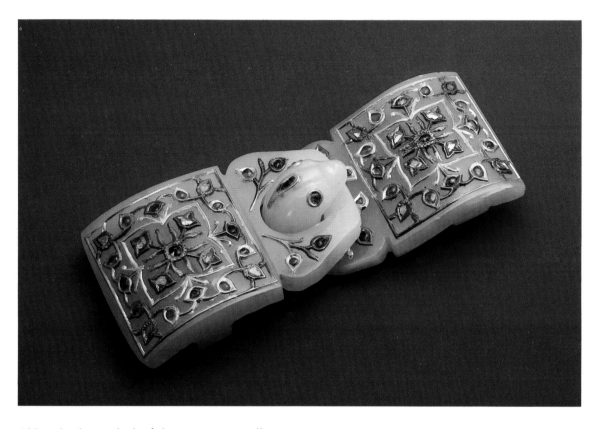

Although other methods of closure were generally
employed on Indian belts—Roman loop-and-tongue,
simple hook-in-hole, and screw post, among others
—there was in the inlaid-jade industry a vogue for
Chinese-style hooks such as this, which exploited the
extraordinary toughness of this particular stone. Here
again the jade is a fine, translucent white, embel-
lished with gold inlay and set with precious stones.

71. Silver Necklace

Yemen, 19th century

Fabricated from sheet, wire, and shot, decorated with granulation, filigree, and tiny plates of silver, set with green glass

Overall dimensions as shown 25.4 x 19.0 cm

Bequest of Edward C. Moore, 1891

(91.1.1126)

Another region that, like India, has retained very old traditions with remarkable fidelity is the Arabian Peninsula. This fine example of a well-represented type suggests that certain elements that have survived from medieval Islamic times have combined with other elements to yield a newly orchestrated form.

Probably the most interesting single feature, present also on other pieces of the same type (e.g., MMA 91.1.1127 and MMA 91.1.1136), is that of the shot-constructed bead, seen here in great profusion (see TA 7, page 146). We have already observed two types of shot-constructed configuration, on earrings nos. 21a and 40. Another jewelry type in which such configurations appear is from the region of Bukhara in the nineteenth century (Jenkins and Keene, 1982, figs. 41a, 41b; Jerusalem, 1967, figs. 5.9, 5.10; Katz, Kahane, and Broshi, 1968, fig. 187; Rosenthal, 1973, p. 76, illus. in color).

The tradition of shot construction can be traced back at least to Eighteenth Dynasty Egypt. The so-called Treasure of the Three Princesses, reportedly found at Wadi Gabbanet al-Qirud, Thebes, apparently contained several thousand tiny rings, each consisting of five shot (MMA 26.8.62; Minneapolis Institute of Arts; Museum of Islamic Art, Cairo). Although

there appear to be few extant examples of shot construction from the long interval between Early Dynastic Mesopotamia and New Kingdom Egypt, an uninterrupted tradition seems likely, if only on the basis of a single ringlet excavated at Ur (Maxwell-Hyslop, 1977). A further perspective on the early history of closely packed shot construction is provided by consideration of the stacking of hollow gold balls into geometric configurations in Early Iron Age northwest Iran and in the Urartrean culture (Negahban, 1964, fig. 79; Ghirshman, 1964, fig. 27 [from Hasanlu]; Pforzheim, 1974, nos. 13–15; Urartrean examples in the Archaeological Museum, Ankara). It is notable that the tradition of hollow-ball stacking did not continue, while that of stacked shot did; by classical Greek and Roman times stacked shot construction was being used in combination with, among other things, cylindrical and hemispherical sheet construction, as well as simple shot construction, as in our nineteenth-century Yemeni necklace (Segall, 1938, no. 90 center; Gerlach, 1906, pl. 102 center) and an early twentieth-century Persian forehead ornament in the National Decorative Art Museum, Tehran.

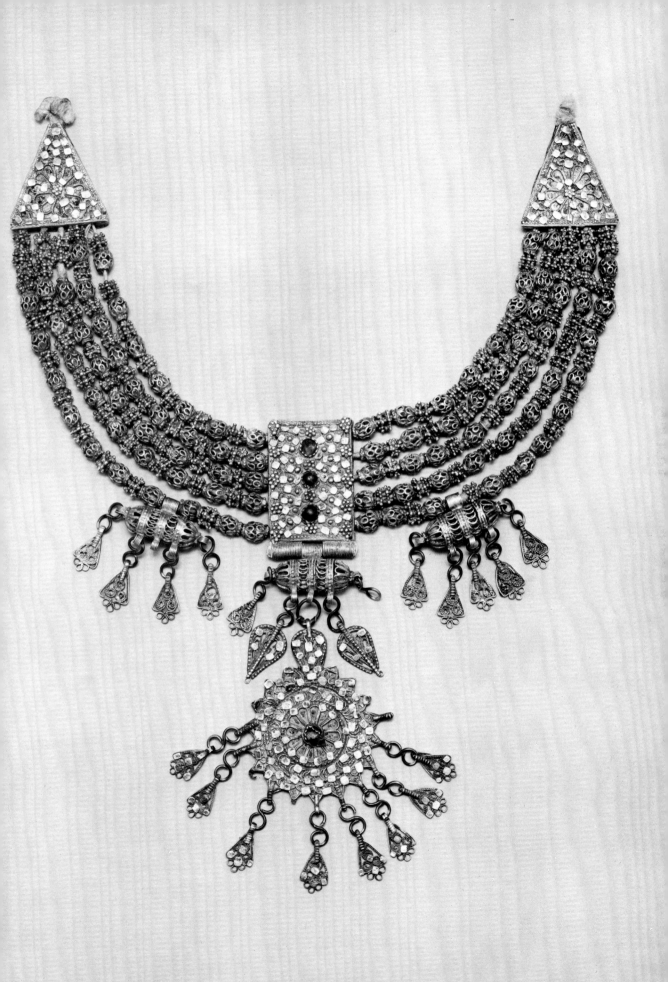

72. Gold Beads from a Necklace

Saudi Arabia, 19th–early 20th century
Fabricated from sheet, wire, and swaged wire,
 decorated with granulation, set with tur-
 quoise
Maximum length of largest square-section bead
 40.5 mm; maximum diameter 20 mm
Purchase, Mobil Foundation Inc. Gift, 1980
 (1980.306a–e)

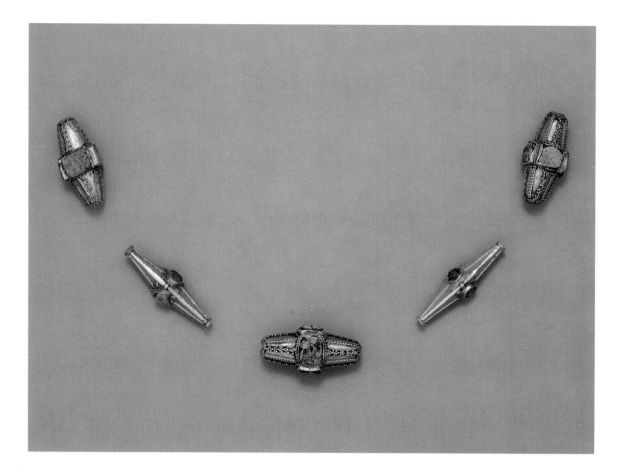

Further confirming the Arabian Peninsula as a region
rich in the tradition of jewelry art are these remark-
able hollow beads from a necklace that was probably
completed by additional sections of beads, most likely
of turquoise and coral, somewhat irregularly shaped.

The beads might have been considered medieval
were it not for their place of origin and the corrobo-
rating evidence of the origin of related types (e.g.,
those in a private collection, reportedly from Ri-
yadh). Ross (1978, pls. on pp. 92, 104) illustrates
several pieces that share features with the Metropoli-
tan beads, such as the prominence and type of the
turquoise settings and the use of a swaged wire that
resembles a line of granulation. While our beads have
distinctive individual features not known on medie-

val pieces (most notably, the large set turquoises),
analogies—particularly of form—with the fine bi-
conical filigree bead (no. 51d) are obvious. Further-
more, the approach to granulation exemplified partic-
ularly on the larger, four-sided beads resembles that
on certain sheet-constructed beads from the eleventh-
century Caesarea hoard (Katz, Kahane, and Broshi,
1968, fig. 111; see also no. 51d).

The granulation work and the overall technical
control of these beads are of such high quality, and
their design of such classical proportions, that we
may well wonder whether they represent the survival
of an as-yet-unknown medieval type.

73. Two Enameled Gold Pendants

Iran, 19th century
Fabricated from sheet and half-round wire,
 enameled on obverse and reverse
Diameter 33.3 mm; 20.6 mm
Gift of Mrs. Frederick F. Thompson, 1920
 (20.106.2,5)

The enamels of Qajar Iran are figurative, and closely resemble in style oil paintings produced in Iran during the same period; other Iranian arts differ from those of India by being more abstract and symmetrical—i.e., less realistic. (See also pages 148–49.) Scenes of youths and lovers are typical of these enamels, as they are of the oil paintings, and both are valuable documents of style in costume and jewelry. Round or elliptical enamel plaques such as these are commonly set into water pipes or other utilitarian objects; seven such plaques on copper, originally from the same collection, are in the Museum's collection.

The enamel on the back of the smaller pendant is an undecorated opaque turquoise blue; that on the larger pendant is counter-enameled—in a somewhat muddy translucent green—over ten horizontal lines of engraving. The top line of engraving consists of a series of arrowlike signs separated by vertical strokes;

the next six lines consist of an uninterrupted series of from nine to sixteen numbers, probably of occult significance; and the bottom three lines contain the inscription: "Allah! Allah! (God! God) Muḥammad [the] Prophet/'Alī ibn Abi-Ṭālib/ (Qulī 2?)" Invocations to God, to the prophet Muhammad, and to his nephew 'Ali are ubiquitous in Iran during this period, and this one does not indicate anything about the piece beyond its having been made for a Muslim. Whether or not the bottom line is a signature (the word "qulī" means "slave" and was a common name in Iran) is not known.

74. Four Chalcedony Sealstones and a Seal Ring

Iran and Ottoman Empire(?), 18th–20th
century
Stones cut from rough stone and engraved with
rotary abrasive points; ring cast and fabri-
cated from silver and gold
Maximum dimensions of largest stone
22.2 x 17.5 mm
Gift of Dr. and Mrs. Lewis Balamuth, 1971
(1971.105.3,30,45,27)
Bequest of William Gedney Beatty, 1941
(41.160.633)

Published: Kunz, 1917, pl. opp. p. 42, no. 5

We have seen examples of sealstones from early
Islamic times and seal rings from the fifteenth and
sixteenth centuries. The stones and ring illustrated
here bring us, in effect, to the end of the tradition,
showing an evolution of form as well as of script
style.

The earliest and calligraphically the finest of these
stones is no. 74d. The inscription on this large yel-
low chalcedony stone proclaims: "There is no God
but Allah, the Evident Truth," to which is added the
name of the owner, Yusuf 'Abduh, and the date,
1158 A.H./A.D. 1745.

The next in date is the oval carnelian stone at
center right, no. 74c, again with the name of the
owner ('Abd al-Wahhab al-Husayny) and the date
(1234/1818–19).

A form not known in sealstones before the nine-
teenth century is the teardrop, here illustrated by
no. 74e. In the nineteenth century, however, and early
in the twentieth, it enjoyed considerable popularity.
The teardrop shape is particularly suited to and most
often found in stones inscribed, as here, with a deco-
rative form of the word "correct," apparently the
stamp of an inspector. Typically, the name of the
owner (here, one Mirza Aqa) is enclosed in the tail

of the last letter of the word "correct." The stone
bears the date 1288/1871–72. It is interesting to note
that the word "correct," similarly written and prob-
ably also indicating approval (this time on the part of
an anonymous atelier master), occurs on the bottom
of a tenth-century Egyptian luster-painted earthen-
ware bowl (Hasan, 1937, pl. 26)

Another distinctive form of calligraphic flourish is
seen on the elliptical yellow chalcedony stone no. 74b,
and was copied from the *tughras* (monograms) of
Ottoman sultans. This stone, however, was not neces-
sarily made in the Ottoman Empire, since the flourish
was on occasion also used in Iran. The name here is
Husayn ibn Abd al-Haqq, and the date inscribed is
1317/1899–1900. The stone was evidently used
again at a later date, at which time it was inscribed on
the reverse with the name Ghulam Reza and the date
1338/1919–20.

The inscription on the dark carnelian or sard stone
of the ring is undeciphered but bears no date; its
style, however, as well as that of the ring itself (par-
ticularly the radially ribbed bottom of the bezel), ap-
pears to indicate that it dates to the first half of the
nineteenth century.

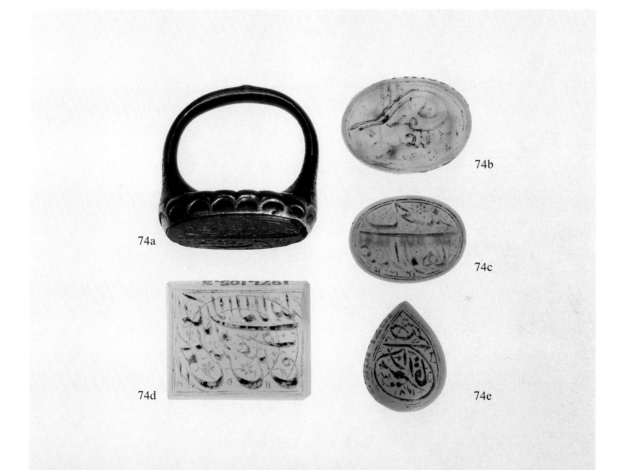

74a

74b

74c

74d

74e

75. Pair of Gold Earrings

Morocco, 17th century
Fabricated from sheet and wire, engraved,
 enameled, and set with rubies and emeralds
Height 78 mm; 82 mm
Gift of Marguerite McBey, 1981
 (1981.5.16,17)

Although of relatively recent vintage, these earrings
have several features that are reminiscent of Roman
and even earlier types. The hoop ear wire, with the
stone set at the front and the hinge connecting it to
the stone-set box element, is perhaps the most telling
of these features, since the wrapped-wire method
of suspending pearls and stones was in almost universal
practice since ancient times (for a pair of late
Hellenistic earrings see Greifenhagen, 1974, pp.
44, 45).

The method by which the second and third levels
(those with the small rubies and the large central
emerald) are attached is a natural outgrowth of the
fact that the box elements are hollow and filled—
most likely with resin or lac: they are held in place by
a rivet that pierces the center from the emerald-set
element to the back.

The function—if any—of the two extra rivets or
posts that run transversely through the ear wire of the
earring at the left is not known. Perhaps they are
replacements for attachments to other elements,
such as headgear.

The settings, in which the gold is cut away and
pushed up over the edge of the stones, are not unre-
lated to those on jewelry from Iran, India, and
Europe during this period. The emeralds (particularly
those on the earring at the left) are of good quality
and probably reflect their relative availability after
the influx into the East of material from Colombia
following the Spanish Conquest.

Historical antecedents and contemporary parallels
to the enameling on this earring type seem to elude us.
That it is champlevé relates it in the broadest sense
to most Mughal and later Indian enameling; there
appears, however, to be little close similarity between
them. Nor can we relate the technique to fourteenth-
and fifteenth-century Nasrid Spanish work or to the
little that remains of earlier North African work (see
also Marçais and Poinssot, 1952, pp. 475–93; Golvin,
1965, figs. 105–7, pls. CII, CIII; Algiers, 1969, figs.
on pp. 25, 27; Paris, 1977, nos. 370, 371, 513).

76. Pair of Gold Beads

Morocco, 18th century
Fabricated from sheet and set with emeralds
 and rubies and/or fine garnets
24.5 x 20.6 mm
Gift of Marguerite McBey, 1981
 (1981.5.18,19)

Because these are the only beads of their type known
to us, we can only speculate as to how they were used
in combination with other elements; it is likely,
however, that they were strung as a necklace and
separated by small pearls in multiple strands, as was
common on many seventeenth-, eighteenth-, and
nineteenth-century Moroccan necklaces (e.g., Paris,
1977, no. 371).

 Although this type of pushed-up setting on a
repoussé ground of thin metal is typical of Moroccan
jewelry (see no. 78), the fine workmanship and
design, including the dense setting of stones in
graduated rows on the mellonlike form, create an
effect unparalleled in the work of this school (see
also Paris, 1977, no. 368).

77. Pair of Gold Head Ornaments

Morocco, 18th–19th century

Fabricated from sheet and wire, chased, and
 set with rubies, emeralds, topazes(?), pearls,
 and glass

Maximum diameter of larger circular element
 88.9 mm

Gift of Dr. Charles A. Poindexter, 1965
 (65.265.1,2,6,7)

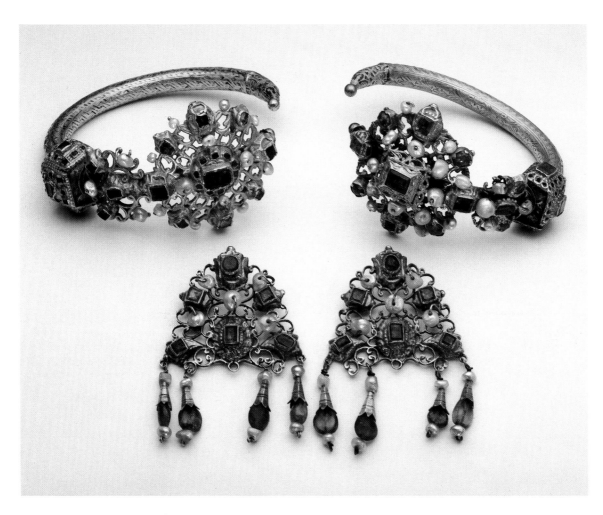

These head ornaments in technique and design are
related to pieces probably made in Istanbul (e.g.,
Collection Hélène Stathatos, vol. 2 [1957], no. 79,
pl. XI), and thus may be considered representative of
the western reaches of Ottoman style.

 The ornaments with the pendant elements were
hooked, near the top of the head, to a headdress; from
these were suspended by chains the large circular
elements, the most decorative parts of which were
seen from the front, at approximately ear level.

78. Gilded Silver Necklace

Morocco, 19th century
Fabricated from sheet and wire, set with red,
 green, and yellow glass; amber beads at ends
Maximum width as shown 30.5 cm
Gift of Mrs. Paul Cauvin, 1967 (67.145.12)

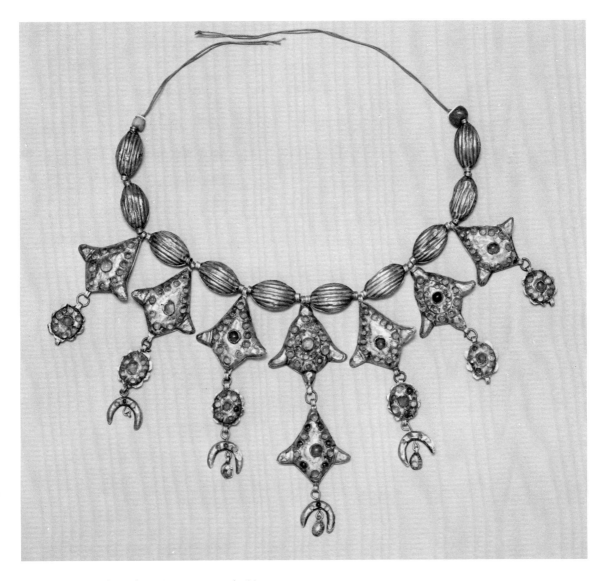

Representative of another Moroccan type is this
gilded silver necklace with its peculiar, turtlelike
pendants (probably descended from the type of
Nasrid pendant exemplified by no. 52). Gold exam-
ples of the type are known—including several with
fine champlevé enamels on the reverse—in essentially
the same style as earrings no. 75 (Jenkins and Keene,
1982, figs. 46, 47).

79. Silver Bracelet (one of a pair)

Algeria, 19th century
Fabricated from sheet and wire and set with
 carnelians
Diameter 63.5 mm, height at hinge 23.8 mm
Bequest of Helen W. D. Mileham, 1954
 (55.111.23a,b)

80. Silver Breast Ornament

Algeria, 20th century
Fabricated from sheet and wire, enameled, and
 set with imitation corals (plastic)
Overall length 62.2 cm
Bequest of Helen W. D. Mileham, 1954
 (55.111.53)

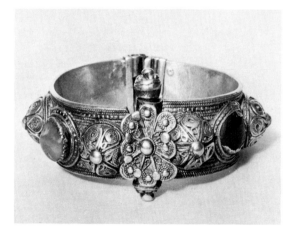

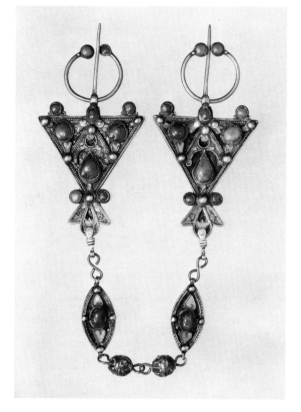

This type of bracelet is to some degree technically
and stylistically reminiscent of the twelfth-century
gold bracelet no. 37. It is closely reated to nineteenth-
and early twentieth-century Moroccan, Jordanian,
Arabian, and Indian types (Jerusalem, 1973, no. 460;
Hanau, 1974, no. 193 [pl. 12]; Gerlach, 1906, pl. 28,
nos. 20, 106, no. 4). In light of these widespread par-
allels, it would appear that the general type was pop-
ular in medieval times and that it continued in favor
—although perhaps only in relatively provincial cen-
ters—throughout the following centuries.

A singular feature of North African Berber costume
is the use of the fibula, an ancient article of jewelry
that holds capes and other garments in place. The
form seen here is characteristic of this particular type
of fibula, as are the imitation corals (more often they
are genuine) and the opaque blue, green, and yellow
enamels separated by twisted and plain round wires.

It is notable that sawtooth bezels, such as those in
which the corals are set, were common in Hellenistic
jewelry but less frequently seen in early and medieval
Islamic work.

81. Silver Fibula

Morocco, 19th century

Fabricated from sheet and wire, engraved
 (terminals of chain), enameled, and set with
 red and green transparent glass

Overall length 118 cm, maximum thickness of
 chain 14.3 mm

Gift of Marguerite McBey, 1981 (1981.5.2)

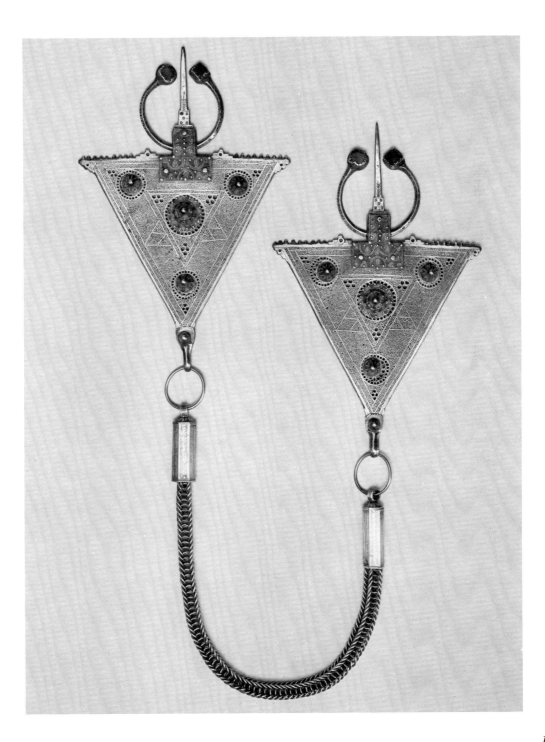

The largest fibula in our experience, this piece in silver is an imposing example of a relatively rare type. A related piece is in the Musée National des Arts Africains et Océaniens, Paris (Paris, 1977, no. 561), and a very similar pair of triangular end-pieces, with garnets set in enameled bosses but without a chain and considerably smaller than these, are in the Metropolitan Museum (MMA 1981.5.3,4). The focal areas of the fibula proper are made up of short sections of tubing that have been soldered together. These areas are set off by heavy wire and/or thick strips of sheet set on edge. Shot also are prominent.

The central bosses—their green, blue, and pale yellow enamel compartments separated by applied twisted wires—are affixed by rivets that run through the center of the triangular elements.

The massive double loop-in-loop chain (see TA 1b, page 144), the largest such chain known to us, is remarkable—almost heroic—in effect, even from the point of view of the physical effort that was necessary to weave it.

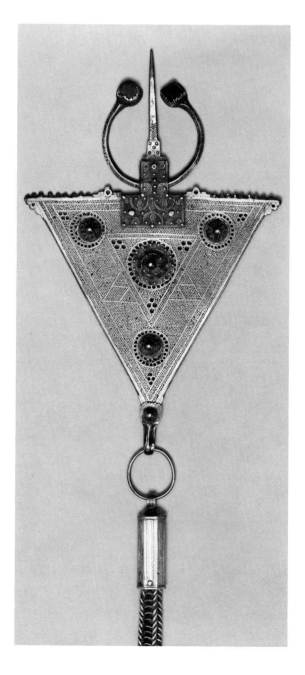

Technical Appendix

Technical Appendix

Terms set in SMALL CAPITALS are included in the Glossary.

METAL TECHNIQUES: THE FUNDAMENTAL ELEMENTS OF PRECIOUS METAL FABRICATION

In the making of the jewelry under consideration, the predominant ways of dealing with precious metal have been to FORGE it into sheet and wire and then to FABRICATE the desired forms, mostly or entirely from these two basic elements. An additional element (which usually but not invariably is in a subordinate role, if present at all) is small solid spheroids of metal, designated as either grains or shot depending upon their size.

Sheet

The term "sheet" is used to refer to stock that is relatively thin in one dimension and extended in the other two. It is produced by hammering on a flat slab or, in recent times, by MILLING between steel rollers. It is the major component of most of the precious metal pieces dealt with here, with the exception of fine openwork FILIGREE and shot-constructed pieces. Its applications range from the simple use of a single-thickness sheet with reinforcement at the edges (as in pendant no. 26) to tubular elements, which can occasionally assume a major structural role (see the large silver fibula no. 81), and DAPPED hollow spheres, which may be used singly or in combination to produce a variety of effects and structures. More often it is used for different types of hollow construction, often boxlike but not uncommonly of a more complex nature (see the crescent-shape pendant no. 5).

Sheet-constructed pieces are ornamented in a variety of ways, including ENGRAVING, REPOUSSÉ, GRANULATION (and the related applied-wire FILIGREE), enameling, and, of course, setting with stones.

Wire

This is the term generally applied to any strip of metal in which the shape of the cross section is radially symmetrical or nearly so, such as round, square, and triangular (special forms, such as elliptical ones, have no place in the jewelry dealt with here). In practice, the term is also often applied to strips that are rectangular in section; the distinction between this "flat wire" and a narrow strip of sheet is at best one of origin, since the former may be a piece of round wire that has been flattened, and the latter may be cut from a larger piece of sheet. However, no such implication as to origin is usually intended, and the terminology may be taken as interchangeable.

Historical methods of wire manufacture involve several fundamentally different processes. Generally starting from a cast ingot, the maker may take one or more of several paths, depending upon the relative fineness or heaviness of wire desired and the traditions and tools available to him. These include:

1) hammering to the desired diameter, length, and configuration;

2) hammering into sheet of the required thickness, then cutting off strips of the desired width. This can produce a square or rectangular section if cut with SHEARS, whereas if the strips are narrow and cut with a chisel, the section tends to be triangular;

3) hammering into thin sheet, cutting off a strip, pointing one end, and drawing it through a DRAWPLATE. This results in the rolling up of the edges of the strip, ultimately producing a tube, which can, if desired, be further drawn down to a nearly solid wire (see also Carrol, 1972);

4) hammering into thin sheet, cutting off a strip and twisting. Depending upon the manner in which the twisting is done, this can produce either a simple spiral of more or less tight turns (as in the wire coiled onto the large hemispherical bosses of the gold "sunburst" roundel no. 24) or a hollow tube very similar to modern, industrially manufactured cardboard tubes (common in classical jewelry and apparently present also in certain Islamic pieces, such as the Fatimid pendant no. 49a), which can then be drawn down in much the same manner as the tubing described immediately above;

5) hammering or milling down to a diameter from which this solid wire may be drawn through a drawplate to the desired size.

Aside from the more straightforward uses, such as stringing beads and making simple hoop earrings, nose rings, toe rings, bracelets, torques, and the like, wire is also used in more complex structural and decorative ways. It can be wound on a cylindrical rod or large wire, producing a coil that can then be FUSED or SOLDERED into a unitary piece. This results in yet another kind of tubing that can be used, for example, as a wide loop for the attachment of other elements; it is seen on many Fatimid pieces, particularly as loops for holding the outlining of threaded pearls or beads (e.g., nos. 47, 48, 49a, 50a, and 51c). This type of tubing can also be used in practically any way that one made from sheet is used (see, for example, the hinge elements on the pair of bracelet elements no. 30).

Vastly more fruitful than the use of coils of wire as tubular elements has been the making of rings of wire

by cutting up one side of such a coil (unsoldered), thus producing a perfect circlet of wire for each revolution of the coil. The circlet serves as a universal connector of elements, usually with the ends fused or soldered together. When linked together in various ways, such circlets of wire can produce a variety of chain types. Historically, the most important group of such chains—one whose development is progressive and traceable—is a series of types known as "loop-in-loop." These are chains in which stretched circlets of wire are folded and linked together in different series (see TA 1 and discussion of necklace no. 58). The ends of circlets to be used as loop-in-loop chain links are best fused, since application of solder to each contact point for the hundreds or even thousands of links that are sometimes present would considerably increase the already substantial time and effort necessary to make such chains.

By the fourth century B.C. these marvelously flexible link-made chains were on occasion replaced by hollow KNITTED tubes (Gregorietti, 1969, pl. on p. 59); a first-century A.D. example from Egypt is in the Museum's collection (MMA 35.6.6, a bracelet with a repoussé-worked snake-head terminal). Such knitted structures visually resemble loop-in-loop chains and are more economical of time and material, but they lack the chains' fluid flexibility and near-indestructibility in normal wear. Although the history of precious wire knitted structures is more difficult to trace than that of loop-in-loop chains (partly because of the difficulty in making a positive identification without first-hand scrutiny), one must presume a real historical connection among these above-cited ancient examples, a series of medieval northern European hollow tubular pieces (Norwick, 1971; idem, 1977; idem, 1980; Graham-Campbell and Kidd, 1980, nos. 287, 212, 86), the structurally similar, probably Islamic fragment from the tenth- and eleventh-century Chemkent hoard (Arne, 1914, pp. 96–98, fig. 52), and the abundant and varied late (eighteenth- and nineteenth-century) Indian examples (see TA 2 and TA 3). Related to the hollow tubular knits but more properly termed a PLAIT is the structure of the so-far unique (in origin as well as structure) medieval Iranian necklace elements no. 23 (see also TA 4 and TA 5).

Another important use of wire is FILIGREE. Both fun-

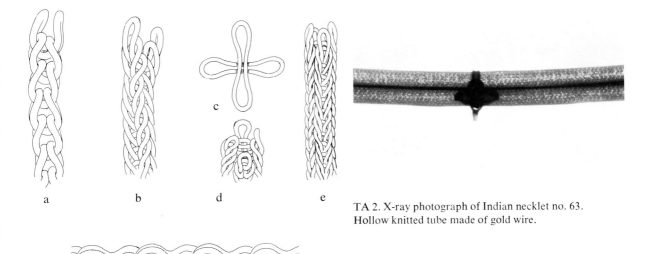

TA 2. X-ray photograph of Indian necklet no. 63. Hollow knitted tube made of gold wire.

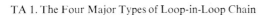

TA 1. The Four Major Types of Loop-in-Loop Chain

a. Single loop-in-loop. Used at least as early as the fourth millennium B.C. (see no. 58).
b. Double loop-in-loop. Used in Egypt in the Middle Kingdom (Wilkinson, 1971, pls. XIV, XXIIIa).
c. Initial stage in the weaving of a quadruple loop-in-loop. Instead of folding a single link, as with the single and double loop-in-loop, two links that are soldered together in a cruciform configuration are folded; weaving is then done on both axes.
d. The upper end of a quadruple loop-in-loop in the process of being woven.
e. Quadruple loop-in-loop. Used in Egypt at the beginning of the New Kingdom (Vernier, 1925, pl. L).
f. "Sailor's knot" chain. A modified single loop-in loop, in which long links are squeezed in opposite axes at the center point; the ends of the loops are held open by a mandrel. Used as early as the fourth century B.C., after which it was quite common.

TA 3. X-ray photograph of Indian silver belt (MMA 15.95.13). Bordered at each side by hollow knitted wire tubes; center section also knitted, simulating band of side-by-side, link-made chains.

TA 4. Gold necklace element no. 23, detail.

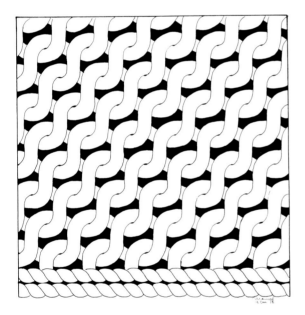

TA 5. Schematic drawing of structure of necklace element no. 23 (see TA 4).

modern stringing alternate with every three beads. These beads prefigure later Islamic types in a most dramatic way.

Some development of the openwork variety occurs in the Greek, Roman, and Byzantine schools, but it is in early medieval Islamic work that the discipline is taken to supreme heights of technical mastery and artistic beauty. Perhaps the very best of this work is from the Syro-Egyptian school of the tenth and eleventh centuries, in which fine doubled twisted wire filigree tracery is highlighted by a central line of fine granulation, creating a most exquisite effect. Perhaps the Metropolitan's finest representative of the type, which stands at the apex of the filigree world, are the two beads no. 51d. Although the openwork filigree of this school is typically laid up on a support of strategically placed strips visible only from the back (see TA 6), the two beads in question have practically no strip support at all, thus approaching openwork filigree in its purest form, a matter not made easier by their three-dimensional nature. The descendants of the Syro-Egyptian school seem, largely through Spain, to have given rise to various types of openwork filigree in Europe, as well as in different parts of the Islamic world, including India—these more directly through Egypt and Syria.

TA 6. Gold pendant no. 49a (detail), showing granulated openwork filigree and system of strip supports where crescent-shape enamel jewel is missing.

damental types (i.e., wire applied to sheet and wire standing alone) are already present in the Early Dynastic goldwork excavated at Ur (Wooley, 1934, pls. 146a, 128). A remarkable New Kingdom Egyptian necklace in the Metropolitan Museum, dating to the thirteenth century B.C. (Wilkinson, 1971, pl. CVIIa), features spherical beads of pure openwork filigree construction in which each hemisphere is composed of a series of plain wire circles and is joined to the other hemisphere at the "waist" by a large circle of BEADED WIRE. Identical beads are furnished with wire-circle-constructed bases and sheet-constructed "necks" to form bottlelike pendants that in the

The medieval period saw a great flowering of complex decorative wire twisting, and although most of the extant material is from finds in eastern Europe, southern Russia, and the Viking lands, many of these same twists are known in Islamic examples, and it is likely that there was a great repertory in Islamic regions as in the above areas. In fact, not only is some of this northern material probably Islamic because of the penetration of that culture into those areas (e.g., what may have been produced by the Volga Bulgars) but some of the finds, like so many of the coins, must be of Islamic heartlands origin. The sophisticated and beautiful "triangle twist" may be seen on a pair of earrings and a pair of bracelets from Iran, nos. 21d and 22 respectively. This twist continued in the Islamic repertory into modern times.

Grains and Shot

The choice of terms, although determined by the size of the spheroids, is somewhat arbitrary. Grains (the smaller) and shot (the larger) are elements usually encountered in decorative rather than structural roles, but there are important and historically widespread exceptions. The strengthening of joints of assembled sheet and/or wire elements with shot is both decoratively and structurally important in much Byzantine jewelry. The earliest known example of colloid hard SOLDERING, dating to the Early Dynastic period at Ur (Maxwell-Hyslop, 1977), is one in which a small ring of grains stands alone as the entire structure. This probably represents the initial phase of a development that can be traced to New Kingdom Egypt, as well as to the classical and Islamic worlds, in which beads and spacers are formed entirely or almost entirely of grains and/or shot in a wide variety of natural configurations and stacks, often complex and of a high decorative and sculptural value (see discussion of necklace no. 71, and TA 7). In addition to no. 71, pieces that feature stacked configurations are earrings nos. 21a and 40.

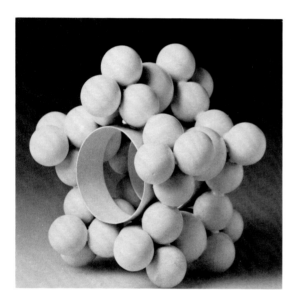

TA 7. Marble model of structure of beads in silver necklace no. 71. (On the beads themselves, the inner rings of shot are arranged around a ring of wire rather than a strip of sheet.)

These spheroids of solid metal are made by melting a small amount of metal, which, once molten, draws up into spherical form due to surface tension. There is a natural limit to the size of shot, since after it reaches about 3 mm in diameter the effect of gravity tends to overcome the surface tension, resulting in a form that is excessively oblate. Spherical forms larger than this can be made hollow by the process of DAPPING.

Gold: Joining Procedures

With the exception of such mechanical processes as riveting and crimping, joints in goldwork—whether of sheet, wire, or shot—are almost invariably made by means of hard SOLDERING by either the colloid or the alloy method. Whether the earliest discovery of hard soldering involved the added alloy or the colloid method, the advantages of the latter, once known, were so obvious that the method seems to have become the overwhelming favorite, remaining so until the later Middle Ages and the Renaissance in Europe; it was apparently the predominant method in much of Asia, from Arabia and Iran eastward, until the present.

Much of the difficulty in making precise statements about the history of soldering arises from the fact that there is very little published about joining techniques. A few important historical landmarks may, however, be mentioned to give a background for the technique. It has been shown that the small ringlet of gold grains mentioned above (Maxwell-Hyslop, 1977) was joined by colloid hard soldering. Indeed, wherever there is fine, crisp filigree and granulation, we may assume that it was accomplished by colloid soldering, an assumption supported by other material from the Ur excavations (H. J. Plenderleith. "Metals and Metal Techniques." In Wooley, 1934, especially p. 296).

Colloid soldering is well attested in ancient Egypt in the form of granulation. The most famous examples occur on the suite of jewelry belonging to the princess Knumet from Dahshur, now in the Cairo Museum (Aldred, 1971, p. 15). Another Middle Kingdom group that shows resolute and masterful use of granulation is a series of cylindrical amulets which have inverted truncated-cone-shape ends, one of which is in the Metropolitan Museum (MMA 22.1.61, excavated by the Museum at Lisht; for others, see Wilkinson, 1971, pl. I, D and E). Aldred (1971, pp. 26–27) points out not only a Fourth Dynasty example of copper being joined by silver alloy solder but also a group of Middle Kingdom gold fish-form pendants that demonstrate the use of gold solders of different melting points, chosen specifically for the nature and sequence of the job to be done.

Both colloid hard soldering and soldering by means of adding alloyed metal to the joint were therefore part of the regular repertory in the region long before the advent of Islam, and both were employed throughout Islamic times, each bringing its own advantages and its own constraints. For example, colloid hard soldering cannot be done on a piece after added-alloy soldering; thus, no joint that is to have fine granulation or other crisply applied decoration can be soldered with added alloy. Granulation work must be completed before any soldering is done with added alloys, and it must be done in areas that are away from joints filled with alloy. On the other hand, alloy solder flows more freely and fills joints more fully, and at temperatures well below the dangerously high level necessary for colloid soldering. This means that where there is no need to have discrete tiny elements attached to the surface, alloy solder provides a much easier method of attachment. Typically, this might occur when one wants to join heavy, solid (such as cast) elements, perhaps decorated by engraving; or when a box construction is made of elements decorated with engraving or repoussé. One often finds, however, particularly with finely made gold elements—even when granulation or other ornamentation is not present—that colloid soldering is used exclusively. Its simplicity, once mastered, and the lack of color change at the joint are two outstanding advantages. It could also be that in certain workshops the fundamental construction was done by the colloid

method in order to leave the options open; that is to say, if one uses colloid soldering routinely, one can decide at any point to decorate with granulation, to provide additional strength with added alloy, and so forth.

Silver

Much of what has been said about gold applies, to an appropriately scaled-down degree, to silver; it is a precious metal—but considerably less precious than gold—so that there is, for example, here as well a tendency toward hollow boxlike construction made from thin sheet and often filled with some stiffening material, whether it is thermoplastic (such as lac or hard wax or resin) or thermosetting (such as plaster). As far as we know, there was on the whole less tendency toward openwork filigree construction with silver than with gold and a greater tendency toward sheet and cast construction. For not only is silver considerably less expensive than gold and thus less likely to have the more labor-intensive processes expended upon it, but many of the more sophisticated processes are less easily accomplished in silver than in gold. The great common denominator in these more sophisticated processes is, again, colloid hard soldering. This can be done with silver in the same manner as with gold—i.e., by the application of finely (usually chemically) divided copper, which combines with the silver to form solder at these points. Another method of extremely high-temperature joining in present-day use involves the FUSION of fine (pure) silver. Its use in the past, however, cannot be demonstrated and seems unlikely.

Thus, while relatively fine filigree and granulation are possible to achieve in silver, the metal has considerably less ability than gold to withstand the repeated heating to near white heat that is usually involved; either it becomes progressively overfired and "puddled," with attendant loss of fine detail and crispness of effect, or, with enough refiring, its molecular structure may actually alter, resulting in its becoming hopelessly brittle and unusable. It is therefore quite predictable, in terms of both its value and its intrinsic nature (including the tendency to tarnish), that we would not see in silver the most laborious and meticulous techniques, such as the type of filigree and granulation work seen in the better gold pieces (e.g., nos. 24, 49a, 49b, 50a, 50b, and 51a–51d).

There are, however, historical schools in which silver granulation is prominent, perhaps most notably the tenth- and eleventh-century eastern European and southern Russian schools, where, in types that bear the closest relation to Islamic styles, silver granulation is practiced with a vengeance (Benda, 1966, pls. 48, 70, 71, 73, 76, 78; Jakimowicz, 1933; Artamonov, 1974, pls. 96–98; Graham-Campbell and Kidd, 1980, pls. 19, 55).

Whatever may be said about silver jewelry must be taken in light of the knowledge that when it is compared to gold, there is a much smaller percentage of what once existed, since silver is highly susceptible to oxidation and ultimate disintegration, whereas gold is unaffected by natural chemicals, and its resistance to corrosion is usually imparted to most gold alloys.

Copper

Were it not for the ease with which it oxidizes and the unpleasant results (brown, green, or black corrosion), copper would be a wonderful metal from which to make jewelry. It possesses the necessary combination of strength, DUCTILITY, MALLEABILITY, and beauty of color

and luster. And indeed, one school apparently overcame the inherent difficulties and succeeded in the colloid hard soldering of this metal. It is represented by a group of objects made in the Muslim kingdom of Granada, at least some of them dating to the second half of the fifteenth century. A beautiful belt in the Metropolitan Museum (MMA 17.190.962) is part of this group. When gilded, as was customary with the type, a very satisfactory stand-in for gold resulted, since the granulation was often quite finely executed, as in the aforementioned belt. Aside from this group, copper (as opposed to bronze) jewelry is quite rare, because the metal, unalloyed, does not lend itself well to the technique of casting, usually used for the less costly metals. There are several types of copper vessels and implements—in which the techniques of milling or hammering the metal into sheets and then raising, sinking, or spinning them into the requisite form—that take advantage of the malleability of the material.

Bronze, Brass, Lead, and Tin

Bronze, brass, lead, and tin, because they are less valuable than gold and silver and because of the technical possibilities and limitations inherent to their nature, are usually worked in the less laborious techniques. Certainly the most important of these techniques was CASTING, probably most often in molds of clay or plaster made from models executed in wax or clay, among other materials; the model was perhaps sometimes executed in metal.

Another common casting technique involved the use of stone molds. One example of this technique was apparently thought good enough by its maker to be signed (see TA 8). Such a mold could, of course, have been used for casting silver as well as one of the less expensive metals, and we have seen on the antiquities market a pair of earrings not dissimilar in design to this mold, probably of high-copper silver alloy. Among the jewelry pieces in the Metropolitan's collection that were perhaps produced in stone molds is the decoratively curious early Islamic tin pendant no. 6. A lead pendant set with blue glass, from the Nishapur excavations (MMA 40.170.260), was probably cast with the glass in place in a clay mold.

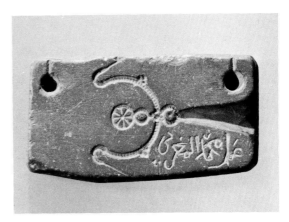

TA 8. Stone mold for an earring (MMA 1975.32.4), signed "Work of Muḥammad al-Maghribī" ("Muhammad of the [Islamic] West," indicating North Africa west of Egypt). Probably 12th–15th century.

DECORATIVE ENHANCEMENTS:
ENAMEL AND STONES

Many of the decorative processes applied to jewelry are dealt with in the Glossary, but two methods of decorating the basic metallic component of jewels and jeweled articles are such important and complex phenomena that they must be dealt with in greater detail. The first of these, related in significant ways to NIELLO, is enamel. Of course, when enamel is fused directly to the principal metal element, it bears greater resemblance to niello than when it is fired in a separate "cup" and then set in the manner of a cut stone.

The use of stones is the second great decorative mode we shall discuss.

Enamel

The term "enamel," as used here, refers to decoratively applied heat-fused glass, usually of a relatively low-firing variety. Because it is ground to a powder and applied wet, as an aqueous paste, it is capable of controlled application. Each batch is prepared by first combining the raw materials, including the appropriate colorants, by melting them together, and then allowing the mixture to cool to a solid mass. This mass is then broken up into chunks and ground to a granular or powder form. It may be applied directly and without special preparation to sheet, wire, or cast elements, to either limited or more extensive areas. Usually, however, it is employed in specially prepared areas, even when it covers an entire object or large sections of an object, as in encrusted enamels. Historically, the most prevalent types are champlevé, in which a depression is created for the acceptance of the enamel in the metal base by such techniques as engraving and casting; cloisonné, in which compartments are created by wires or strips of sheet set on edge; and painted enamels, in which colors are applied to the surface of a previously fired base coat of a higher melting point and fired just to the point of fusing. In those cases where enamel is fused onto thin metal, cracking has often been sustained in the enamel owing to the different rate of expansion and contraction for each material. This difficulty is to a great extent avoided by the application of a thick coating of enamel to the back of the metal, which stabilizes and neutralizes the effect of its expansion and contraction.

The art of enameling has a long if somewhat checkered history. Maryon (1971) cites examples from Cyprus dating to about the thirteenth century B.C. that he interprets as representing the formative stages, since the enamel is set in large chunks rather than in a fine powder. Whether or not these are the earliest extant examples, they appear to be the earliest documented. Although Aldred (1971, pp. 32, 33) asserts the presence of enamel on a pectoral from the tomb of Tutankhamun, at least two specialists at the Metropolitan Museum who have examined the pectoral in question (Christine Lilyquist, curator of Egyptian art, and Yale Kneeland of the conservation department) are of the opinion that all the glass is of the usual Egyptian cold-set variety. Despite the early date of Maryon's examples, the use of enameling in Greek jewelry is quite restrained, not to say tentative. It is considerably more prominent in Bronze Age Celtic work by at least as early as 400 B.C. (London, 1976, p. 11). By the third century A.D. certain types of metalwork in Europe are at times almost totally covered with enamels. This development is well exemplified by a series of champlevé-enameled bronze objects in the Metropolitan Museum, all dating to the third century A.D. (e.g., MMA 47.100.5–8, 17.192.19, 17.194.1918, 66.16; Forsyth, 1950, pp. 296–307).

But despite a millennium and a half of prior development, it is with the Byzantines that the art of enameling (particularly cloisonné) reaches its greatest early flowering; and it seems that it was from Byzantium that Islam's first known school of enameling—the tenth- to twelfth-century Fatimid school of cloisonné—received its initial incentive. In subsequent centuries the work of this school not only had successors in its original venue but also seems to have influenced fourteenth- and fifteenth-century Nasrid Spanish cloisonné. This said, it should also be noted that tenth-century Spain may have received from Byzantium independent stimulus in the art of enameling, especially since there are known to have been significant art-historical contacts, including the well-known exportation of Byzantine mosaicists and tesserae to Umayyad Spain (Creswell, 1940, p. 142).

Aside from the Egyptian, Syrian, and Spanish pieces dating from the tenth century to the fifteenth, we know of no groups of Islamic enameled jewels until we come to Mughal India and Ottoman Turkey, and later to eighteenth- and nineteenth-century Iran and Morocco. Of these later schools, the first three employ, among other elements, painted enamels that in important aspects are of a decidedly European character, leading us to the conclusion that, rather than developing out of earlier local or even transplanted Islamic traditions, they almost certainly developed out of a European tradition (as did the roughly contemporaneous Chinese school of painted enamels). The presence in India in the early seventeenth century of European jewelers is well attested in Jahangir's *Memoirs*.

The enamels of eighteenth-century Iran make a sudden appearance and do not, it would seem, follow an Iranian tradition but rather bear a striking resemblance to European enamels (particularly certain Russian types), which have a long, unbroken, and well-documented history. Tavernier (book 2, chap. 16, p. 144) seems to be referring to the art of enameling in his phrase ". . . of which the Persians are altogether ignorant." In any case, the author was himself engaged in 1665 by Shah 'Abbas II to send designs in the shah's own hand to France to be executed; some, including a dagger, were to be "goldsmith work enamel'd" (book 4, chap. 17, pp. 183–84). And as we pointed out in the discussion of necklace no. 59, works with enamel were sometimes (in this case, in 1617) sent from India to Iran as gifts; this also points strongly to the likelihood that Iran, probably as late as the second half of the seventeenth century, had no tradition of fine enameling.

We cannot as yet show precedents for the Moroccan school of champlevé enameling of the seventeenth, eighteenth, and nineteenth centuries, although one must suspect here as well some kind of European involvement (see no. 75).

To round out the picture of Islamic enameling, we should note the technically low grade of work that continued into the twentieth century, particularly in North Africa (see no. 80); work of a very similar style is encountered in other distant parts of what was formerly the Ottoman Empire (e.g., the Balkans; Gerlach, 1971, no. 5, pl. 61) and in Syria (ibid., nos. 4, 5, pl. 6). All this

work is characterized by crude enamels, more or less opaque, fired into compartments created by decorative wire work applied to a background of sheet. One is intrigued by the possibility that this is a degenerated outgrowth of earlier types exemplified in fourteenth-century Mamluk (Syrian and/or Egyptian) work (unpublished examples in the National Museum, Damascus, 1565/A; and the Museum of Islamic Art, Cairo, 9451). That there was a continuity in the sort of enamel work seen in these Mamluk pieces is shown by Russian enamels of the sixteenth century through the nineteenth (Postnikova-Losseva, Platonova, and Oulianova, 1974).

Stones

One can hardly think of jewelry without thinking of gemstones, so strongly are they associated both intrinsically and historically. Indeed, the use of ornamental stones for jewelry is far older than the use of metal. Both the range of stones available and the technical means for working them increased steadily with time, and by the beginning of the Islamic era, most of the great precious and semiprecious stones, including diamond (Haschmi, 1935, pp. 27, 28), were in use in the regions that became part of the Islamic empire. Indeed, Pliny must have been referring to the gemstone status of diamond (*adamas*) when he wrote that it was the most precious of substances and that it had "for long" been known only to kings (book 37, paragraph 55). On balance, the likelihood is that the earliest diamonds were imported from India already cut, for not only was India the great source for diamonds until the eighteenth and nineteenth centuries, but the evidence furnished by a sixth-century A.D. Indian work on stones strongly suggests that diamonds were being cut in India by that time (Keene, 1981, p. 24).

Thus, on the one hand, early Islam was the beneficiary of a great, ages-long, practical tradition—probably at its most highly developed in India—of working with these hard and beautiful minerals; and on the other, as in so many areas of endeavor, it inherited the scientific pursuits that had been most rigorously followed in the classical Greco-Roman civilization. Ample contemporary literary evidence exists for the early Islamic use of diamonds in the cutting of stones (ibid., 1981, pp. 24–25) and for the use of the hydrostatic balance to distinguish between stones according to specific gravity. The latter was in fact a very important impetus for the high level of early Islamic development in this branch of the discipline of making scientific instruments (ibid., 1981, pp. 25–26; Hall, 1973, especially p. 340).

In the literature of the earlier Islamic centuries, the pearl, the ruby, and the emerald are mentioned as being the stones of the highest value. This hierarchy must be understood in light of the fact that from very early on, if not indeed from the beginning, the ruby was understood to be merely the red variety of corundum, the wide range of the other colors of this mineral (which today we designate as sapphires) also having been recognized, categorized, and valued. Furthermore, as indicated above, the diamond had, even in the early period, a place among the most valuable of stones, as shown by the fact that in the tenth century at least two Iranian kings had rings set with large diamonds (Haschmi, 1935, p. 13). Later, of course, especially from the seventeenth century on, the prevalence of diamonds is well documented.

Despite the wealth of documentary evidence, we know of no jewelry pieces with significant precious stones that have survived from before the sixteenth century, although a large number of the stones in such collections as the Topkapi treasury in Istanbul and the Iranian National Treasure in Tehran (formerly the Crown Jewels)

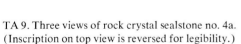
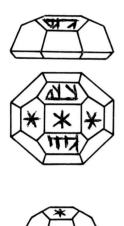

TA 9. Three views of rock crystal sealstone no. 4a. (Inscription on top view is reversed for legibility.)

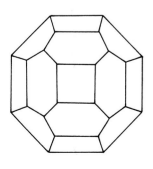
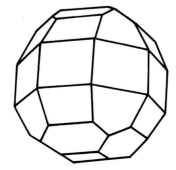
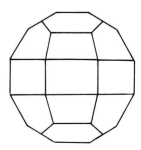

TA 10. Three perspective views of bronze coin weight from Nishapur (MMA 40.170.282).

have surely been used and reused over the centuries. An even larger number of stones must have been recut and fill not only these two treasuries but adorn collections all over the world.

The vast preponderance of fine Islamic jewelry extant may be regarded as representing the middle to upper-middle level of society and is most often made of thin gold that has been elaborately worked and set with the smaller precious stones and with semiprecious stones. While it is apparent that even in jewelry which features stones of fabulous size and quality consideration of the individual stone or group of stones is always subordinated to the overall artistic effect, the de-emphasizing of a stone's intrinsic value is even greater in this "middle level" jewelry (see, for example, no. 25).

In addition to the traditional semiprecious stones (which were particularly popular for sealstones), there was in Islam a whole world of stones used for ornamental purposes; they ranged from rock crystal and the chalcedonies and jaspers down to a variety of colorful but soft stones. These too exhibit a wide range in the quality of the stone and in the sophistication of lapidary technique. (See no. 11.)

Most of the stones in the jewelry presented here (with the exception of sealstones) are not cut to symmetrical form; rather, they are cut just enough to remove undesirable areas, after which they are polished to preserve and to show as much as possible of the stone's beauty. Nevertheless, we should not conclude that this is the only approach in the East or that cutting to regular form (especially faceting) was the exclusive province of Europe. It is clear that a great deal of faceting was done in the Islamic world in the later periods; but early medieval Islam also, especially Iran, was home to some remarkable faceting (see TA 9–TA 11). This school of faceting was part of a general interest in and exploration of polyhedral forms in art (see discussions for nos. 4a–4c, 8b–8d, 11, 20b, 20c; and Keene, 1981, pp. 30–39).

It is impossible to say whether the cutting of these early Islamic faceted stones involved mechanical aids for the establishment of radial divisions or of angles of elevation in any way analogous to the present-day "faceting machine," although the obvious tendency is to argue against it, especially in light of the high precision achieved by

TA 12. Carnelian bead MMA 48.101.82 from Nishapur (see no. 11), having 23 faces: 2 heptagonal, 7 hexagonal, and 14 pentagonal. Maximum dimensions 8 x 9 mm. Iran, 10th–11th century.

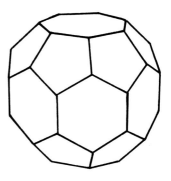

TA 13. Structure of bead in TA 12 based on construction of model approximately six times actual size (Keene, 1981, p. 32, figs. 8a–8c).

modern cutters with only the aid of the JAMB PEG. In any case, we may be sure that a number of faceted stones were cut with some sort of flat LAP, either horizontal or vertical (see the reflecting facet on the carnelian bead MMA 48.101.82, no. 11, right center, TA 12, and TA 13). More important, perhaps, than the instrument used is the high level of skill and the intellectual awareness of regular and semiregular solids. The cutter of the dark carnelian bead—like so many other artists whose work is presented here—deserves better than the anonymity that is his fate.

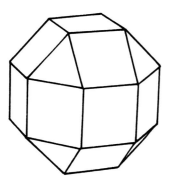

TA 11. Perspective drawing of the (small) rhombi-cuboctahedron, one of the "Archimedean" semiregular solids, having 26 faces: 18 square and 8 triangular. Compare with TA 9 and TA 10 for forms probably inspired by it, resulting from further truncation of the edges.

Glossary

ADDED-ALLOY HARD SOLDERING: see SOLDERING

ANNEALING: The process of relieving in metal the internal stresses that have built up during "work hardening," in which metal becomes brittle through hammering, drawing, bending, and coiling. The metal is usually brought to a dull red heat and then quenched, or cooled in a liquid. Ferrous metals, glass, and so forth, are cooled slowly to achieve this relaxation, whereas the DUCTILITY and MALLEABILITY of the precious metals (including copper) used in jewelry are improved by rapid quenching.

BEADED WIRE: Type of wire so called for its similarity to a string of spherical beads in miniature. In practice resembles a line of granulation work, for which it is often substituted because less technically demanding. Common in classical and medieval European jewelry but practically unknown in Islamic work.

CASTING: Well-known process in which molten metal is poured into a cavity, or mold, the conformation of which the metal assumes and then retains upon cooling. In practice, it is difficult to cast into an open mold, primarily because of the surface tension of the molten metal, which prevents the metal from flowing out against the cavity. Therefore, nearly all casting is done in enclosed molds, which necessitates the use of a gate—a channel into which metal is poured—and vents—smaller channels for the escape of the displaced air. A variety of approaches to the making of molds are known. Of the two most common, the first involves making a model of metal, wax, or clay around which is formed the mold, usually of clay or plaster, and the second involves carving molds in flat slabs of stone, usually soapstone or steatite.

COLLOID HARD SOLDERING: see SOLDERING

DAPPING: The process of producing domical forms from sheet, either by striking with a spherical-headed punch against a material with an appropriate balance of resistance and softness (such as pitch or lead) or, more effectively, by forcing the sheet into hemispherical depressions in a wood or metal block with appropriately sized punches. Once the bases are trued up, the resultant hemispheres or sphere sections are placed together and FUSED or SOLDERED to form spheres, spheroids, and so forth, which may then be decorated in any of the number of ways possible with other sheet-constructed elements.

DOP: Rod on which a stone to be cut is affixed with cement or hard wax ("dop wax"), greatly facilitating the work through the control it affords the cutter.

DRAWPLATE: A plate or slab, generally of iron or steel (the tougher stones are also used for their resistance to wear), with conical holes through which wires are drawn. The end of a wire is inserted into the larger side of a tapered hole until it protrudes through the other side far enough to be gripped and pulled through, reducing the diameter of the wire to the smallest diameter of the hole. Because only a small reduction in the diameter of the wire is possible with each pass, drawplates are usually made with a series of progressively smaller holes, through which the wires are drawn in succession. When gold or silver contains appreciable amounts of copper, the wire must be frequently ANNEALED.

Drawplates are used not only for the production of wire but also for that of tubing, in which a long narrow strip of sheet is pulled through the holes in the plate and rolled until its edges meet or overlap.

DUCTILITY: Capacity of a metal to be drawn out into thin filaments (wires) while retaining strength and resiliency. Possessed in a high degree by the three most important metals in jewelry making—gold, silver, and copper. The addition of copper to gold or silver, while it increases hardness, decreases ductility. Associated with MALLEABILITY.

ENGRAVING: Decoration of a metal surface that involves the removal of metal using a sharp implement. May be used in combination with other decorative techniques, such as ENAMELING, NIELLO, and REPOUSSÉ.

FABRICATION: Construction of pieces of jewelry by MILLING, drawing (through a DRAWPLATE), FORGING, filing, SOLDERING, etc., or a combination of these processes. Opposed to CASTING.

FILIGREE: Wire, either twisted or plain, made into decorative configurations. The two major types are that in which wire is applied to a sheet structure, and openwork filigree, in which wire is the only (or most important) structural element, standing alone with no solid sheet backing.

FORGING: The working of metal by such means as hammering and bending. Contrasted with construction by assemblage, CASTING, simple cutting out, and decoration by application or removal of material. Although the term grows out of the practice of the blacksmith, where the forge is necessary for a large part of the plastic working of the iron and steel, relatively very little precious metal work in jewelry involves manipulation while the metal is hot. Heat is of course necessary to the process of "forg-

ing" precious metals, due to the necessity of frequent ANNEALING.

FUSING (or WELDING): Process of joining metal by heating to a fluid state the area of the joint, causing the metal to flow together. In jewelry making the process is used primarily in the joining of closed forms, such as two hemispheres or the ends of a circlet of wire, since the extremities tend to flow before the rest of the piece. Thus the joint is more filled and therefore stronger than with COLLOID HARD SOLDERING, and the process is quicker and easier. There is no line of color change, and spheres so joined can later be decorated by colloid soldering (as in GRANULATION), whereas spheres soldered together with batch-alloyed solder cannot. Major elements of pieces made of fine (pure) silver may be joined by fusion because its surface flows in a controllable manner at a temperature below that at which collapse takes place.

GRANULATION: Decoration of a metal surface with tiny spheroids, usually of the same composition. For crispness of effect, the joining should be done by COLLOID HARD SOLDERING. Fine (pure) silver can be decorated with granulation by FUSING the elements to the base. This type of ornamentation tends naturally to produce patterns, particularly those of the sixty-degree (triangle/hexagon) family.

JAMB PEG: Device used in conjunction with a horizontal LAP for the purpose of controlled faceting of stones. Consists of a vertical member, usually in the form of an inverted bell or a flat slab, with holes at various levels into which the upper end of the DOP stick is inserted, thus giving the angle of elevation at which the facet is to be cut. This method requires considerable skill, particularly for the control of the radial angle.

KNIT: Structure formed by the interlooping in series of rows of a single continuous filament. Practiced with precious metal wire since ancient times, and often resembles loop-in-loop, link-constructed forms, such as chains.

LAP: Flat disk charged with abrasive and provided by an attached shaft with rotary motion that is used for grinding stones to shape. Particularly useful in making relatively true flat surfaces such as those required for facets.

MALLEABILITY: Capacity of a metal to be beaten, MILLED, etc., from one form into another without cracking and then to hold its form. Possessed in a high degree by the three most important metals in jewelry making—gold, silver, and copper—and in large measure accounts for the great variety of jewelry forms and techniques. Associated with DUCTILITY.

MILLING: The reduction in thickness of sheet or wire by passing between the steel rollers of a mill. Mills for wire usually have machined into the rollers opposed, ninety-degree notches of progressively smaller size (and thus produce square wire), whereas those for sheet have smooth rollers. The rollers are slowly brought closer together by means of a screw press. As with other working, this process requires periodic ANNEALING. Mills, having come into use in relatively recent times, probably play no part in the manufacture of most of the pieces dealt with here.

NIELLO: A heat-fused black metallic compound used decoratively to contrast with the color(s) of the metal(s) from which the piece is made (see, for example, no. 56b).

The composition of niello varies, but the elements typically used are silver, copper, lead, and sulphur, most often in the form of fine grains or powder, which are melted together and cooled before application. Niello is usually applied to depressions (such as engraved decoration), fused in place, and then smoothed to the level of the surrounding surface. In Islamic jewelry one commonly encounters varieties of imitation niello, where the engraved decoration is filled with a black substance such as bitumen, which is simpler to use although less permanent and less beautiful than the metallic variety. The latter has been known since the early Eighteenth Dynasty in Egypt (Rosenberg, 1908, vol. 2, pp. 2–3, figs. 1, 2).

PLAIT: Structure formed by intertwining several elements into a single network. The early history of plaiting with precious metal wire is more obscure than that of KNITTING, which it somewhat resembles. Plaits in wire tend to be somewhat less flexible than knits, as are the latter in relation to the loop-in-loop, link-made structures they often mimic.

REDUCING ATMOSPHERE: Refers to a condition of incandescent heat in which there is a shortage of oxygen. In such a condition the heated materials tend to be reduced by losing their chemically combined oxygen. In jewelry work such a condition is especially conducive to colloid hard soldering since it favors copper in an unoxidized state, in which it can then alloy with adjacent silver or gold to produce solder.

REPOUSSÉ: Manner of working up sheet into relief decoration by placing it face down on a relatively yielding but dimensionally stable material (usually pitch) and pushing out, usually with a mallet and variously shaped punches. Once the masses are sunk, the piece is turned over, still supported by the pitch, and details are added, contours sharpened, and so forth. The back-and-forth working is often repeated several times.

SHEARS: Common implement for cutting metal, analogous in form and function to scissors. Standard tool for cutting sheet and most wire for jewelry use throughout Islamic times.

SOLDERING: Process of joining two or more pieces of metal by heating them to the melting point of some lower-melting alloy that when molten locks molecularly into their surfaces. With the exception of crude repairs, "soft" solder (used by sheet-metal workers and composed chiefly of lead and tin) is not used in the material discussed here. Rather, when the term "solder" is used, some variety of "hard" solder is understood. This involves the use of an alloy with a melting point much nearer that of the metals to be joined than soft solder, and for silver or gold normally involves the use of the same metal the piece is made of, but with the added presence of metals that lower the melting point to the desired level, the most common temperature-lowering element being copper.

There are two fundamentally different approaches to the creation of hard solder. In the more well known added-alloy hard soldering small pieces of the lower-melting alloy are placed along the joint, and the heat is raised until the solder melts. In colloid hard soldering a finely divided copper compound such as an oxide is applied; when heated in a REDUCING ATMOSPHERE, the compound gives up its oxygen, reverts to a pure metallic state,

152

and at the critical temperature combines with the gold or silver, thereby creating solder. The finely divided copper may be in the form of either a ground-up, high-copper mineral or an artificially produced solid compound, or it can be suspended in a liquid (e.g., dissolved in vinegar).

Colloid soldering generally works better with a high-karat gold, and it is especially useful for pieces decorated with grains or other tiny elements, since the solder forms only where the finely divided copper is applied—at the points of contact, however small—and there is no large amount of molten metal to flood the grains or other decorative details and spoil the crispness of effect. An additional advantage of colloid soldering is that there is no perceptible difference in color between the joints and the pieces joined, as is often seen in added-alloy soldered joints.

SWAGING: A process of shaping metal into a desired form by forcing it into pre-cut depressions in a block or the point of a punch, such that it conforms to the shape in the tool. A common form of swage block has grooves or notches that serve for bending long sections of sheet longitudinally, as in the initial stage of making tubing. More specialized types of swage blocks and swage punches are made of heavy iron into which a design has been cast or carved, and which is then forced against a piece of malleable metal that takes on the exact configuration of the swage (see no. 72).

WELDING: see FUSING

Bibliography

WORKS CITED

Aldred, 1971
 Aldred, Cyril. *Jewels of the Pharaohs*. London, 1971.
Algiers, 1969
 Guide to the Museum of Saṭīf, in Arabic. Algiers [?], 1969.
Allan, 1978
 Allan, James. "Khātam, Khātim." *The Encyclopaedia of Islam*, new ed., vol. 4. Leiden, 1978.
Allan, 1982
 Allan, James. *Nishapur Metalwork of the Early Islamic Period*. The Metropolitan Museum of Art, New York, 1982.
Almagro et al., 1975
 Almagro, Martin; Caballero, Luis; Almagro, Juan Zozaya; and Almagro, Antonio. *Qusayr 'Amra*. Madrid, 1975.
Al-Qadi al-Rashid ibn Zubayr, 1959
 Al-Qadi al-Rashid ibn Zubayr. *Kitāb al-Dhakhā'ir Wa'l-Tuḥaf* (*Book of Treasures and Gifts*), in Arabic. Kuwait, 1959.
Arne, 1914
 Arne, T. J. *La Suède et l'Orient*. Uppsala, 1914.
Artamonov, 1974
 Artamonov, M., ed. *The Dawn of Art*. Leningrad, 1974.

Beck, 1933
 Beck, H. C. "Etched Carnelian Beads." *Antiquaries Journal* 13 (1933): 384–98.
Benda, 1966
 Benda, Klement. *Mittelalterlicher Schmuck: Slawische Funde aus tschechoslowakischen Sammlungen und der Leningrader Eremitage*. Prague, 1966.
Berlin, 1971
 Museum für Islamische Kunst Berlin. Berlin, 1971.
Bhushan, 1958
 Bhushan, Jamila Brij. *The Costumes and Textiles of India*. Bombay, 1958.
Bier, 1979
 Bier, Carol Manson. "The Work of al-Ḥasan b. Muhammad, Die Engraver at Iṣfahān and al-Muḥammadiyya." American Numismatic Society *Museum Notes* 24 (1979): 243–56.
Bloomington, 1973
 Ancient Jewelry from the Collection of Burton Y. Berry, exhibition catalogue. Indiana University Art Museum, Bloomington, 1973.

Böhner, Ellmers, and Wiedemann, 1972
Böhner, K.; Ellmers, D.; and Wiedemann, K. *Das frühe Mittelalter.* Mainz, 1972.

Brunner, 1978
Brunner, Christopher J. *Sasanian Stamp Seals in The Metropolitan Museum of Art.* The Metropolitan Museum of Art, New York, 1978.

Bushell, Kunz, and Lilley, 1906
Bushell, Stephen W.; Kunz, George F.; Lilley, Robert; et al. *The Bishop Collection: Investigations and Studies in Jade.* New York, 1906.

Bussagli, 1969
Bussagli, Mario. *Indian Miniatures.* London and New York, 1969.

Cairo, 1969
Islamic Art in Egypt 969–1517, exhibition catalogue. Semiramis Hotel, Cairo, 1969.

Calcutta, 1916
"Excavations at Taxila." *Annual Report of the Archaeological Survey of India, 1912–13.* Calcutta, 1916.

Carrol, 1972
Carrol, Diane Lee. "Wire Drawing in Antiquity." *American Journal of Archaeology* 76 (1972): 321 ff.

Collection de Clercq, 1911
Collection de Clercq, vol. 7. Paris, 1911.

Collection Hélène Stathatos
Collection Hélène Stathatos. 4 vols. Strasbourg, 1953; Limoges [1957]; Strasbourg, 1963; Athens, 1971.

Creswell, 1940
Creswell, K. A. C. *Early Muslim Architecture,* vol. 2. Oxford, 1940.

Damascus, 1969
Al-'Ush, Abû-l-Faraj; Joundi, A.; and Zouhdi, B. *Catalogue du Musée National de Damas.* Damascus, 1969.

David-Weill, 1931
David-Weill, Jean. *Les bois à épigraphes jusqu'a l'époque mamlouke.* Cairo, 1931.

Deneck, 1967
Deneck, Marguerie-Marie. *Indian Art.* London, 1967.

Dimand, 1940
Dimand, M. S. *Near Eastern Jewelry: A Picture Book.* The Metropolitan Museum of Art, New York, 1940. Reprinted 1944.

Essen, 1962
7000 Jahre Kunst in Iran, exhibition catalogue. Villa Hügel, Essen, 1962.

Ettinghausen, 1961
Ettinghausen, Richard. "The Emperor's Choice." *Essays in Honor of Erwin Panofsky.* New York, 1961.

Ettinghausen, 1965
Ettinghausen, Richard. "Paintings of the Sultans and Emperors of India in American Collections." Lalit Kala Akademi, New Delhi [1961].

Fehérvári and Safadi, 1981
Fehérvári, Géza, and Safadi, Yasin. *1400 Years of Islamic Art: A Descriptive Catalogue.* London, 1981.

Feldhaus, 1931
Feldhaus, Franz M. *Die Technik der Antike und des Mittelalters.* Potsdam, 1931.

Forsyth, 1950
Forsyth, William. "Provincial Roman Enamels Recently Acquired by The Metropolitan Museum of Art." *The Art Bulletin* 32 (Dec. 1950): 296–307.

Fukai and Horiuchi, 1972
Fukai, S., and Horiuchi, K. *Taq-i-Bustan.* Tokyo, 1972.

Gerlach, 1906
Gerlach, Martin. *Völkerschmuck.* Vienna and Leipzig [1906]. Reprinted as *Primitive and Folk Jewelry.* New York, 1971.

Ghirshman, 1964
Ghirshman, Roman. *The Arts of Ancient Iran.* New York, 1964.

Golvin, 1965
Golvin, Lucien. *Recherches archéologiques à la Qual'a des Banû Hammâd.* Paris, 1965.

Graham-Campbell and Kidd, 1980
Graham-Campbell, James, and Kidd, Dafydd. *The Vikings.* London and New York, 1980.

Gray, 1938–39
Gray, Basil. "A Seljuq Hoard from Persia." *British Museum Quarterly* 13 (1938–39): 73–79.

Gregorietti, 1969
Gregorietti, Guido. *Il gioiello nei secoli.* Milan, 1969.

Greifenhagen, 1970
Greifenhagen, Adolf. *Schmuckarbeiten in Edelmetall,* vol. 1. Berlin, 1970.

Greifenhagen, 1974
Greifenhagen, Adolf. *Schmuck der alten Welt.* Berlin, 1974.

Grube and Lukens, 1967
Grube, E. J., and Lukens, M. G. "The Language of the Birds." *The Metropolitan Museum of Art Bulletin* NS 25 (May 1967): 317–52.

Hall, 1973
Hall, Robert E. "al-Khāzinī." *Dictionary of Scientific Biography,* vol. 7. New York, 1973.

Hamilton, 1959
Hamilton, R. W. *Khirbat al-Mafjar: An Arabian Mansion in the Jordan Valley.* Oxford, 1959.

Hanau, 1974
Schmuck aus islamischen Ländern. Hanau, 1974.

Harper, 1966
Harper, Prudence Oliver. "Portrait of a King." *The Metropolitan Museum of Art Bulletin* 25 (Nov. 1966): 137–46.

Hasan, 1937
Hasan, Z. M. *Kunūz al-Fātimiyīn (Treasures of the Fatimids).* Cairo, 1937.

Haschmi, 1935
Haschmi, Mohammed Jahia. *Die Quellen des Steinbuches des Bērūnī.* Bonn, 1935.

Hauser, Upton, and Wilkinson, 1938
Hauser, W.; Upton, J. M.; and Wilkinson, C. K. "The Iranian Expedition, 1937." *The Metropolitan Museum of Art Bulletin* section 2, 33 (Nov. 1938): 3–23.

Hauser and Wilkinson, 1942
Hauser, W., and Wilkinson, C. K. "The Museum's Excavations at Nishapur." *The Metropolitan Museum of Art Bulletin* 37 (April 1942): 83–119.

Hawary, Rached, and Wiet, 1932–42
Hawary, H.; Rached, H.; and Wiet, G. *Catalogue*

général du Musée Arab du Caire: stèles funéraires,
vols. 4, 7, 9–16. Cairo, 1932–42.

Heath, 1921
> Heath, Thomas. *Greek Mathematics.* Oxford, 1921.

Herzfeld, 1927
> Herzfeld, E. *Die Ausgrabungen von Samarra,* vol. 3.
> Berlin, 1927.

Higgins, 1961
> Higgins, R. A. *Greek and Roman Jewellery.* London,
> 1961.

Hobson, 1912
> Hobson, R. L. "On Chinese Cloisonné Enamel." *The
> Burlington Magazine* 21 (1912): 138.

Hoffman and Davidson, 1965
> Hoffman, Herbert, and Davidson, Patricia. *Greek
> Gold: Jewelry from the Age of Alexander.* Boston,
> Brooklyn, and Richmond, 1965.

ibn al-Zubayr, 1959
> ibn al-Zubayr al-Kadi al-Rashid. *Kitāb al-Dhakha'ir
> wa'l-Tuḥaf (Book of Treasures and Gifts).* Kuwait,
> 1959.

Jahangir, *Memoirs*
> Jahangir. *The Tuzuk-i-Jahangiri, or Memoirs of Ja-
> hangir.* Edited by Henry Beveridge. Translated by
> Alexander Rogers. London, 1909.

Jakimowicz, 1933
> Jakimowicz, Roman. *Sur l'origine des parures d'ar-
> gent trouvées dans les dépôts du Moyen Age,* in Pol-
> ish, with French summary. Warsaw, 1933.

Jenkins, 1972
> Jenkins, Marilyn. "An Eleventh-Century Woodcarv-
> ing from a Cairo Nunnery." In *Islamic Art in The
> Metropolitan Museum of Art,* edited by Richard Et-
> tinghausen, pp. 227–40. New York, 1972.

Jenkins, in press
> Jenkins, Marilyn. "Fatimid Jewelry, Its Sub-Types
> and Influences." *Kunst des Orients* 13.

Jenkins and Keene, 1982
> Jenkins, Marilyn, and Keene, Manuel. "Djawhar."
> *The Encyclopaedia of Islam,* supplement to vol. 2,
> fasc. 3–4. Leiden, 1982, and forthcoming.

Jerusalem, 1967
> *Bokhara,* exhibition catalogue. Israel Museum, Jeru-
> salem, 1967.

Jerusalem, 1973
> *La vie juive au Maroc,* in Hebrew. Jerusalem, 1973.

Katz, Kahane, and Broshi, 1968
> Katz, Karl; Kahane, P. P.; and Broshi, Magen. *From
> the Beginning: Archaeology and Art in the Israel
> Museum, Jerusalem.* New York, 1968.

Keene, 1981
> Keene, Manuel. "The Lapidary Arts in Islam: An
> Underappreciated Tradition." *Expedition* 24 (Fall
> 1981): 24–39.

Korzukhina, 1954
> Korzukhina, G. F. *Russkie Klady IX–XIIIvv.* Mos-
> cow, 1954.

Krenkow, 1941
> Krenkow, F. "The Chapter on Pearls in the Book on
> Precious Stones by al-Bērūnī," part 1. *Islamic Culture*
> 15 (Oct. 1941): 399–421.

Lepage, 1971
> Lepage, C. "Les Bracelets de luxe romains et byzan-
> tins du IIe au VIe siècle. Etude de la forme et de la
> structure." *Cahiers archéologiques* 21 (1971): 1–23.

London, 1947–48
> *The Art of India and Pakistan,* exhibition catalogue.
> Royal Academy of Arts, London, 1947–48.

London, 1976
> *Jewellery Through 7000 Years,* exhibition catalogue.
> The British Museum, London, 1976.

London, 1977
> *Wealth of the Roman World: Gold and Silver A.D.
> 300–700,* exhibition catalogue. The British Museum,
> London, 1977.

Lucas, 1934
> Lucas, *Ancient Egyptian Materials and Industries.* 2d
> ed. London, 1934.

Lucas, 1936
> Lucas, A. "Glazed Ware in Egypt, India and Meso-
> potamia." *The Journal of Egyptian Archaeology* 22
> (Dec. 1936): 141–64.

Mackay, 1933
> Mackay, Ernest. "Decorated Carnelian Beads." *Man*
> (Sept. 1933): 143–46.

Marçais and Poinssot, 1952
> Marçais, G., and Poinssot, L. *Objets kairouanais IXe
> au XIIIe siècle.* Tunis, 1952.

Marshall, 1907
> Marshall, F. H. *Catalogue of the Finger Rings, Greek,
> Etruscan and Roman, in the Department of Antiqui-
> ties.* The British Museum, London, 1907.

Maxwell-Hyslop, 1971
> Maxwell-Hyslop, K. R. *Western Asiatic Jewellery.*
> London, 1971.

Maxwell-Hyslop, 1977
> Maxwell-Hyslop, K. R. "Sources of Sumerian Gold,"
> part 1. *Iraq* 39 (Spring 1977): 83–86.

Meen and Tushingham, 1968
> Meen, V. B., and Tushingham, A. D. *Crown Jewels
> of Iran.* Toronto, 1968.

Miles, 1938
> Miles, George Carpenter. "Note on a Die Engraver of
> Iṣfahān." *Ars Islamica* 5 (1938): 100–3.

Miles, 1939
> Miles, George Carpenter. "Epitaphs from an Iṣfahān
> Graveyard." *Ars Islamica* 6 (1939): 155–56.

Moscow, n.d.
> *The Simferopol Treasure.* Moscow, n.d.

Negahban, 1964
> Negahban, Ezat O. *Preliminary Report on the Exca-
> vations at Marlik.* Tehran, 1964.

Norwick, 1971
> Norwick, Braham. "The Origins of Knitting." *Knit-
> ting Times* (May 10, 1971): 26–31, 67.

Norwick, 1977
> Norwick, Braham. "The Origins of Knits: The Ar-
> dagh Chalice and Wire Knitting." *Knitting Times*
> (Oct. 10, 1977): 35–36.

Norwick, 1980
> Norwick, Braham. "The Origins of Knitted Fabrics."
> *The Bulletin of the Needle and Bobbin Club* 63, nos.
> 1, 2 (1980): 36–50.

Oberlin, 1961
 "Melvin Gutman Collection of Ancient and Medieval Gold," exhibition catalogue. *Allen Memorial Art Museum Bulletin* 18, nos. 2, 3 (May 23, 1961).
Otto-Dorn, 1967
 Otto-Dorn, Katharina. *L'Art de Islam.* Paris, 1967.

Paris, 1960
 Trésors de l'art de l'Inde, exhibition catalogue. Palais des Beaux-Arts, Paris, 1960.
Paris, 1961–62
 Sept mille ans d'art en Iran, exhibition catalogue. Petit Palais, Paris, 1961–62.
Paris, 1977
 L'Islam dans les collections nationales, exhibition catalogue. Grand Palais, Paris, 1977.
Pforzheim, 1974
 Jewelry from Persia: The Collection of Patti Birch, exhibition catalogue. Schmuckmuseum, Pforzheim [1974].
Pinder-Wilson, 1962
 Pinder-Wilson, R. H. "A Silver Ladle and Amulet Case from Persia." *British Museum Quarterly* 25 (1962): 32–34.
Pliny, 1962
 Pliny. *Natural History,* vol. 10. Translated by D. E. Eichholz. Cambridge, Mass., and London, 1962
Pollak, 1903
 Pollak, L. *Klassisch-Antike Goldschmiedearbeiten.* Leipzig, 1903.
Pope, 1938
 Pope, A. U., ed. *A Survey of Persian Art.* 6 vols. London and New York, 1938.
Pope, 1945
 Pope, A. U. *Masterpieces of Persian Art.* New York, 1945.
Postnikova-Losseva, Platonova, and Oulianova, 1974
 Postnikova-Losseva, M.; Platonova, N.; and Oulianova, B. *Les émaux russes: XII–XIXe s.* Moscow, 1974.

Rice, 1958
 Rice, D. S. "A Drawing of the Fatimid Period." *Bulletin of the School of Oriental and African Studies* 21 (1958): 31–39.
Rosenberg, 1908
 Rosenberg, Marc. *Geschichte der Goldschmiedekunst auf technischer Grundlage,* vols. 1, 2. Munich, 1908.
Rosenberg, 1918
 Rosenberg, Marc. *Geschichte der Goldschmiedekunst auf technischer Grundlage,* vol. 3. Munich, 1918.
Rosenthal, 1973
 Rosenthal, Renate. *Jewellery in Ancient Times.* London, 1973.
Ross, 1940
 Ross, M. C. "An Egypto-Arabic Cloisonné Enamel." *Ars Islamica* 7 (1940): 165–67.
Ross, 1978
 Ross, Heather Colyer. *Bedouin Jewellery in Saudi Arabia.* London, 1978.
Ross, 1968
 Ross, Marvin C. "Jewels of Byzantium." *Arts in Virginia* 9 (Fall 1968): 12–31.

Schäfer, 1910
 Schäfer, H. *Agyptische Goldschmiedearbeiten,* vol. 1. Berlin, 1910.
Schlumberger, 1952
 Schlumberger, D. "Le palais ghaznévide de Lashkari Bazar." *Syria* 29 (1952): 251–70.
Segall, 1938
 Segall, Berta. *Museum Benaki, Katalog der Goldschmiede-Arbeiten.* Athens, 1938.
Stchoukine, 1936
 Stchoukine, I. *La peinture iranienne sous les derniers 'Abbâsides et les Il-Khâns.* Bruges, 1936.
Stillman, 1973
 Stillman, Norman. "The Eleventh Century Merchant House of Ibn 'Awkal (A Geniza Study)." *Journal of the Economic and Social History of the Orient* 16 (1973): 15–88.
Suter, 1927
 Suter, H. "Handasa." *The Encyclopaedia of Islam,* vol. 2. Leiden and London, 1927.
Swarup, 1957
 Swarup, S. *The Arts and Crafts of India and Pakistan.* Bombay, 1957

Tavernier, 1678
 Tavernier, J. B. *The Six Voyages of John Baptista Tavernier . . . To which is added The Description of the Seraglio.* Translated by J. Phillips. London, 1678.

'Umar al-'Ali, 1974
 'Umar al-'Ali, Z. "Islamic Jewelry Acquired by the Iraq Museum," in Arabic. *Sumer* 30 (1974): 681–94.

Vernier, 1925
 Vernier, Emile. *Catalogue générale des antiquités égyptiennes du Musée du Caire,* vol. 77, "Bijoux et orfèvreries." Cairo, 1925.

Webster, 1962
 Webster, Robert. *Gems: Their Sources, Descriptions and Identification,* vol. 1. Washington [D.C.], 1962.
Wellesz, 1959
 Wellesz, Emmy. "An Early al-Ṣūfī Manuscript in the Bodleian Library in Oxford: A Study in Islamic Constellation Images." *Ars Orientalis* 3 (1959): 1–26.
Wiedemann, 1911
 Wiedemann, Eilhard. "Über des Wert von Edelsteinen bei des Muslimen." *Der Islam* 2 (1911): 345–58.
Wooley, 1934
 Wooley, C. L. *Ur Excavations,* vol. 2. London and Philadelphia, 1934.

WORKS CONSULTED

Ackerman, P. "Jewellery in the Islamic Period." In *A Survey of Persian Art,* vol. 3, edited by A. U. Pope. Oxford, 1938–39, pp. 2664–72.
Aga-Oglu. "Remarks on the Character of Islamic Art." *The Art Bulletin* 36 (Sept. 1954): 175–202.
Allan, James. "Khātam, Khātim." *The Encyclopaedia of Islam,* vol. 2. Leiden and London, 1927.
The Arts of Islam, exhibition catalogue. Hayward Gallery, London, 1976.
Atasoy, N., and Cagman, F. *Turkish Miniature Painting.* Istanbul, 1974.

Ball, V. "The True History of the Koh-i-Nur." *The English Illustrated Magazine* 8 (1891): 538–42.

———. "A Description of Two Large Spinel Rubies, with Persian Characters Engraved upon Them." *Proceedings of the Royal Irish Academy* 3 (1894).

Beck, H. C. "Classification and Nomenclature of Beads and Pendants." *Archaeologia* 77 (1927): 1–76.

Besancenot, Jean. *Bijoux arabes et berberes du Maroc.* Casablanca, n.d.

Bhushan, J. B. *Indian Jewellery, Ornaments, and Decorative Designs.* Bombay, 1964.

Birch, P. C. *Ancient Persian Necklaces.* Pforzheim, n.d.

Born, Wolfgang. "Small Objects of Semiprecious Stone from the Mughal Period." *Ars Islamica* 7 (1940): 101–4.

Boyer, M. *Mongol Jewellery.* Copenhagen, 1952.

Breitling, G.; Divo, J.-P.; Friedmann, J.; et al. *Das Buch vom Gold.* Lucerne and Frankfurt am Main, 1975.

Cahen, Claude. "Documents relatifs à quelques techniques iraqiennes au début du onzième siècle." *Ars Islamica* 15–16 (1951): 23–28.

Charles, A. P. *A Monograph on Gold and Silver Ware Produced in the United Provinces.* Allahabad, 1905.

Dalton, O. M. *Catalogue of Early Christian Antiquities and Objects from the Christian East.* The British Museum, London, 1901.

———. *Franks Bequest: Catalogue of the Finger Rings, Early Christian, Byzantine . . . and Later, Bequeathed by Sir Augustus Woolaston Franks.* The British Museum, London, 1912.

Deny, J. "Muhr." *The Encyclopaedia of Islam*, vol. 3. Leiden and London, 1936.

Dimand, M. S. *A Handbook of Mohammedan Decorative Arts.* New York, 1930.

———. "Persian Miniatures of the Fourteenth Century." *The Metropolitan Museum of Art Bulletin* 23 (1934): 58–60.

———. *A Handbook of Muhammadan Art.* 2d ed. New York, 1944.

———. "New Accessions of Islamic Art." *The Metropolitan Museum of Art Bulletin* NS 17 (1958): 227–35.

Dunlop, D. M. "Sources of Gold and Silver in Islam According to al-Hamdānī." *Studia Islamica* 8 (1957): 29–49.

Ehrenkreutz, A. S. "Dhahab." *The Encyclopaedia of Islam*, new ed., vol. 2. Leiden, 1965.

Ettinghausen, Richard. *Arab Painting.* New York, 1962.

———. "Originality and Conformity in Islamic Art." In *Individualism and Conformity in Classical Islam*, edited by A. Banani and S. Vryonis. Wiesbaden, 1977.

Eudel, Paul. *L'orfèvrerie algérienne et tunisienne.* Algeria, 1902.

———. *Dictionnaire des bijoux de l'Afrique du Nord.* Paris, 1906.

Falk, S. J. *Qajar Paintings.* London, 1972.

Falke, Otto von. *Der Mainzer Goldschmuck der Kaiserin Gisela.* Berlin, 1913.

Fehérvári, Géza. *Islamic Metalwork of the Eighth to the Fifteenth Century in the Keir Collection.* London, 1976.

Finot, L. *Les Lapidaires Indiens.* Paris, 1896.

Gomez-Moreno, Manuel. "Joyas árabes de la Reina Católica." *al-Andalus* 8 (1943): 473–75.

Gonzales de Clavijo, Ruy de. *Embassy to Tamerlane, 1403–1406.* Translated by Guy Le Strange. London, 1928.

Goudard, J. "Bijoux d'argent de la 'Tache de Taza.'" *Hesperis* 8 (1928): 285–94.

Grabar, Oleg. "The Umayyad Dome of the Rock in Jerusalem." *Ars Orientalis* 3 (1959): 33–62.

Grube, E. J. *Muslim Miniature Paintings from the XIII to XIX Century*, exhibition catalogue. Asia House Gallery, New York, 1962.

Herber, J. "Note sur l'influence de la bijouterie soudanaise sur la bijouterie marocaine." *Hesperis* 37 (1950): 5–10.

Hildburgh, W. L. *Medieval Spanish Enamels.* London, 1936.

———. "A Hispano-Arabic Silver-gilt and Crystal Casket." *The Antiquaries Journal* 21 (1941): 211–31.

Ipsiroglu, M. S. *Painting and Culture of the Mongols.* New York [1966].

Ismail, B. K., and Tosi, M. "A Turquoise Neckstone of King Ninurta-Apal-Ekur." *Sumer* 32 (1976): 105–13.

Jacob, S. S., and Hendley, T. H. *Jeypore Enamels.* London, 1886.

Kahle, Paul. "Die Schätze der Fatimiden." *Zeitschrift der deutschen morgenländischen Gesellschaft*, NF 14 (1935): 329–62.

Kipling, J. L. "The Industries of the Punjab." *The Journal of Indian Art* 2 (1888): 57–63.

Krenkow, F., ed. *Kitāb al-Djamahir fī Ma'rifat al-Djawāhir* by al-Biruni. Hyderabad (Dn), 1936.

———. "The Chapter on Pearls in the Book on Precious Stones by al-Bērūnī," part 2. *Islamic Culture* 16 (Jan. 1942): 26–27.

Kunz, George F. *The Curious Lore of Precious Stones.* Philadelphia and London, 1913.

———. *Rings for the Finger.* Philadelphia and London, 1917.

Lamm, C. J. "Billawr, Ballūr." *The Encyclopaedia of Islam*, new ed., vol. 1. Leiden, 1960.

Lane, Edward William. *An Arabic-English Lexicon.* 4 vols. London and Edinburgh, 1863–85.

———. *An Account of the Manners and Customs of the Modern Egyptians.* 5th ed. London, 1871. (See especially vol. 2, app. A, "Female Ornaments.")

Lane-Poole, S. *A History of Egypt in the Middle Ages.* 4th ed. London, 1925. (See especially pp. 110–11, 145–49.)

Laufer, Berthold. *Notes on Turquois in the East.* Chicago, 1913.

Lucas, A. *Ancient Egyptian Materials and Industries.* 4th rev. ed. London, 1962.

Maryon, Herbert. *Metalwork and Enamelling: A Practical Treatise on Gold and Silversmiths' Work and Their Allied Crafts.* 5th rev. ed. New York, 1971.

Mehta, R. J. *The Handicrafts and Industrial Arts of India.* Bombay, 1960.

Moore, N. F. *Ancient Mineralogy*. New York, 1859.

Mukharji, R. N. *Art-Manufacturers of India*. New Delhi, 1974.

Notton, J. H. F. "Ancient Egyptian Gold Refining: A Reproduction of Early Techniques." *Gold Bulletin* 7 (April 1974).

Perdrizet, Paul. "Le jeu alexandrin de l'icosaèdre." *Bulletin de l'Institut Français d'Archéologie Orientale du Caire* 30 (1930): 1–16.

Ponti, M. Negro. "Jewelry and Small Objects from Tell Mahuz (North Mesopotamia)." *Mesopotamia* 5/6 (1970–71): 391–425.

Ritter, H. "Orientalische Steinbücher." In *Orientalische Steinbücher und Persische Fayencetechnik*. Istanbul, 1935.

Rosen-Ayalon, Myriam, ed. "A Silver Ring from Medieval Islamic Times." In *Studies in Memory of Gaston Wiet*. Jerusalem, 1977.

Ruska, J. *Das Steinbuch des Aristoteles*. Heidelberg, 1912.

_____. "Die Mineralogie in der arabischen Literatur." *Isis* 1 (1913–14): 341–50.

_____. "Uber Nachahmung von Edelsteinen." *Quellen und Studien zur Geschichte der Naturwissenschaft und der Medizin* 3 (1933): 108–19.

Schefer, Charles, trans. and annot. *Sefer Nameh: Relation du voyage de Nassiri Khosrau*. Paris, 1881.

Smith, Reginald Alexander. *A Guide to Antiquities of the Early Iron Age in the Department of British and Medieval Antiquities*. The British Museum, London, 1925.

Tavernier, J. B. *Travels in India*. Translated by V. Ball. London, 1889.

Theophilus. *An Essay Upon Various Arts*. Translated with notes by Robert Hendrie. London, 1847.

_____. *On Divers Arts: The Treatise of Theophilus*. Translated by J. G. Hawthorne and C. S. Smith. Chicago, 1963.

Theophrastus. *History of Stones*. Edited and translated by Sir John Hill. London, 1774.

Untracht, Oppi. *Metal Techniques for Craftsmen*. New York, 1968.

Weidemann, E. "Zur Mineralogie bei den Muslimen." *Archiv für die Geschichte der Naturwissenschaften und der Technik* 1 (1909): 208–11.

_____. "Zur Mineralogie im Islam." *Sitzungsberichte der Physikalisch-medizinischen Sozietät in Erlangen* 44 (1912): 205–56.

_____. "Beiträge zur Mineralogie usw. bei den Arabern." In *Festgabe Lippmann*. Berlin, 1927, pp. 48–54.

Weir, Shelagh. *The Bedouin*. London, 1976, pp. 59–72.

Wensinck, A. J. *A Handbook of Early Muhammadan Tradition*. Leiden, 1927.

_____. "Subha." *The Encyclopaedia of Islam*, vol. 4. Leiden, 1978.

Wilkinson, Alix. *Ancient Egyptian Jewellery*. London, 1971.

Williams, Leonard. "Gold, Silver and Jewel Work." In *The Arts and Crafts of Older Spain*, vol. 1. London and Edinburgh, 1907.

Wulff, H. E. *The Traditional Crafts of Persia*. Cambridge, Mass., and London, 1966.

Zahn, R. *Sammlungen der Galerie Bachstitz*, vol. 2. Berlin, 1921.

ISLAMIC MINERALOGY, GEMOLOGY, AND THE LAPIDARY INDUSTRY

Creswell, K. A. C. *A Bibliography of the Architecture, Arts and Crafts of Islam to 1st Jan. 1960*, cols. 837–62. Cairo, 1961.

_____. *A Bibliography of the Architecture, Arts and Crafts of Islam: Supplement Jan. 1960 to Jan. 1972*, cols. 257–64. Cairo, 1973.

Lamm, Carl Johan. *Mittelalterliche Gläser und Steinschnittarbeiten aus dem Nah n Osten*. Berlin, 1929 and 1930.

Pearson, J. D. *Index Islamicus, 1906–1955*. Cambridge, England, 1958.

_____. *Index Islamicus, Supplement, 1956–1960*. Cambridge, England, 1962.

_____. *Index Islamicus, Supplement, 1961–1965*. Cambridge, England, 1967.

_____. *Index Islamicus, Supplement, 1966–1970*. London, 1972.

_____. *Index Islamicus, Supplement, 1971–1975*. London, 1977.

Skelton, Robert. "The Relations Between the Chinese and Indian Jade Carving Traditions." In *The Westward Influence of the Chinese Arts*, edited by William Watson. London, 1972.